P9-DTE-949

GOTHIC PAINTING

GOTHIC PAINTING

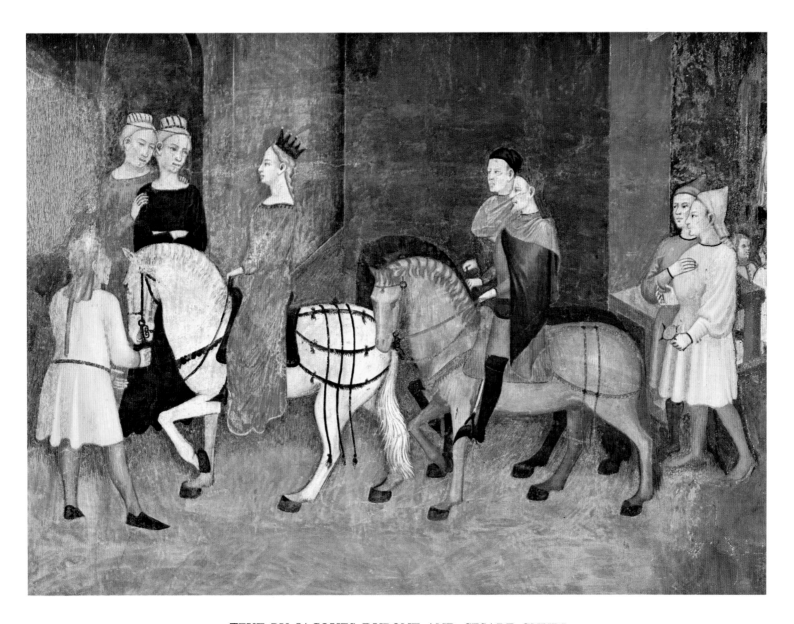

TEXT BY JACQUES DUPONT AND CESARE GNUDI

RIZZOLI
NEW YORK

Color plate on the title page:
Ambrogio Lorenzetti (?-1348). The Effects of Good Government, detail.
Fresco, 1337-1340. Palazzo Pubblico, Siena.

*

© 1979 by Editions d'Art Albert Skira S.A., Geneva
First edition © 1954 by Editions d'Art Albert Skira, Geneva

This edition published in the United States of America in 1979 by

Rizzoli INTERNATIONAL PUBLICATIONS, INC.
712 Fifth Avenue/New York 10019

Translated by Stuart Gilbert

All rights reserved
No parts of this book may be reproduced in any manner
whatsoever without permission.

Library of Congress Catalog Card Number 79-64728
ISBN: 0-8478-0226-4

PRINTED IN SWITZERLAND

THE epithet "Gothic" is used to describe not the art of any single school or country but all the manifestations of a spirit which permeated the works of art produced in many parts of Western Europe from the end of the 12th century on. Largely conditioned by developments in the domain of architecture and by the social evolution of the period, these works took various forms: stained-glass windows, illuminated books, frescos, tapestry and painting. Each new discovery, technical or formal, in any of these fields, reacted on other, often seemingly quite independent forms of art, the general trend being towards a fuller, richer expression of human emotions. The Gothic artist looked to life itself for inspiration, saw the world through new eyes and depicted it with amazing freedom, using a language that was at once impassioned, ironical and naïve. Thus the old legendary or sacred themes were modernized, revivified, while the elegant refinement of an age of chivalry was reflected in visions of a world half realistic, half make-believe, full of strange enchantments. At the beginning of the 15th century the ultimate, most sophisticated manifestations of the Gothic spirit synchronized with the robust creations of the new humanism that led up to the Renaissance.

★

The making of this book, which owes so much to the erudition and enthusiasm of Monsieur Jacques Dupont, Curator of Historical Monuments in France and President of "Les Amis du Louvre," and Signor Cesare Gnudi, Superintendent of Fine Arts in Emilia, Italy, has been rendered possible by the good offices of many persons in authority and institutions. We tender our most grateful thanks to the Curators and Directors of museums, galleries and libraries; to the civil and ecclesiastical authorities in France, Italy, England, Spain, Belgium, Austria, Germany, Czechoslovakia and the United States; and to all whose enlightened understanding and unfailing good will have so greatly facilitated our work. We would also express our gratitude to Monsieur François Mathey for his invaluable collaboration and his assistance in the ascertaining and verification of essential facts.

CONTENTS

THE GOTHIC AGE . 9

 The Rise of Secular Art 13

 Evolution of the English Miniature 19

 Stained Glass and Miniatures in France 27

 TEXT BY JACQUES DUPONT

ITALIAN PAINTERS OF THE GOTHIC AGE 47

 Giotto: A Re-appraisal of the Visible World 55

 Duccio, Reformer of Tradition 73

 Simone Martini and Pure Form 78

 Pietro and Ambrogio Lorenzetti 89

 New Trends in Florence and North Italy 106

 TEXT BY CESARE GNUDI

COURT ART . 125

 The Avignon Interregnum 130

 Mural Decoration and Tapestries 134

 French Art under the Valois 141

 The Court Painters of the Dukes of Burgundy 145

 The Duke of Berry and his Illuminators 150

 The Royal Domain 157

 Court Art in England 165

 Rise of the Schools of Valencia and Barcelona 168

 The Court of Charles IV at Prague 175

 The German and Austrian Schools 181

 TEXT BY JACQUES DUPONT

 Italian Manifestations of International Gothic Art 185

 TEXT BY CESARE GNUDI

BIBLIOGRAPHY . 203

INDEX . 206

LIST OF COLORPLATES 210

THE GOTHIC AGE

THE RISE OF SECULAR ART
EVOLUTION OF THE ENGLISH MINIATURE
STAINED GLASS AND MINIATURES IN FRANCE

TEXT BY JACQUES DUPONT

THE GOTHIC AGE

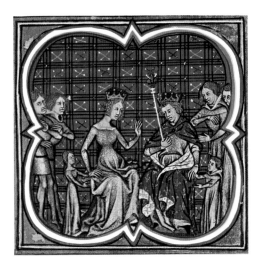

For most of us the word "Gothic" conjures up, almost automatically, memories of Saint Louis, the great cathedrals, the Amiens nave, the spire of Chartres. Yet when we limit the significance of an era so momentous in the history of European culture to such functional achievements as the pointed arch, ribbed vaulting or the flying buttress, we are centering our attention on but one aspect of an infinitely wider subject, rich in spiritual, aesthetic and plastic intimations. True, there is no denying the supremacy of architecture in the 13th and 14th centuries, but are we justified in magnifying its prestige at the expense of other arts incorrectly styled "minor," which none the less have their importance? Painting is one of these. Architecture doubtless took the lead, but sculpture too made prodigious strides and, though always linked up with the edifice where it figured, achieved the status of an independent art. The same is true of the stained-glass window, which transfigured the sacred edifice and gave it, so to speak, its soul. This first incarnation of Gothic painting, though underrated in the past and hitherto regarded as an auxiliary technique, was none the less the earliest manifestation of the genius of the Gothic artist. The current notion of primitive French art is, chronologically speaking, singularly limited, being confined to the first signs of a realistic, personal art that emerged at the close of the 14th century, i.e. only a few decades before the revelation of the art world of the Van Eycks. Actually, however, the origins of this humanistic approach to visual experience, in which some have thought to see a foretaste of the Renaissance, can be traced, in all the arts employing color, as far back as the 13th century.

One of the reasons why Giotto overshadowed all the other artists of his time in Italy may well be that his art owed its new humanity to sculpture; that his angel in the Uffizi *Madonna* could hold converse with the *Angel* of Rheims on equal terms. But are we justified in assuming that in the rest of Europe no other painters were worthy of their then prestige; that none of them had Giotto's keen sense of tactile values, or broke with the formalism of the past? To this question it is easier to reply.

The artist needed walls to decorate and the "new architecture" north of the Alps, wholly Gothic in conception, abhorred unbroken wall spaces. In short, painters had no support to paint on. Romanesque art—compact, abstract and subject to an hieratic rigorism, stemming as it did from the age-old Byzantine tradition described as "Roman," and flourishing above all in the south of Europe, where the fresco reigned supreme—was now confronted by a modern, vital, individualist art that found its architectural expression in soaring arches and vaulted roofs which did not lend themselves to large-scale painting. Nevertheless painting held its ground, and so effectively that it proliferated everywhere; so conspicuously that people failed to see it. For those poly-chrome, highly colored statues in the tympana were, in fact, three-dimensional paintings. Set out like "genre" pictures, they implemented lively scenes in which the spectator, too, played a part. It is our heritage of classicism and Jansenism, coupled with the emphasis on archaeology we find in most appraisals of Gothic architecture, that makes us so incapable today of appreciating that wealth of vivid colors—red, blue, white, black, pink and gold—which was the glory of a cathedral such as that of Lausanne, whose "Painted Portal" still bore traces of the original colors as late as 1880. These colors, garish to the modern eye, no longer exist; all that remains is the cold skeleton of stone—which satisfies our "refined" contemporary taste.

Only the stained-glass windows, which have lost little or nothing of their original color, remain to give us an idea of that well-nigh "Fauve" polychromy. In a Gothic church the window acts as the setting of a source of light but tends to absorb it to such an extent that the bay has constantly to be enlarged. And the larger this becomes the more the wall recedes, the result being a sort of race between architect and painter, in the quest of an ever ampler light, an ever more precarious equilibrium. The most conspicuous example of this is the Sainte-Chapelle in Paris, which achieves the pro-digious feat of being, in effect, a vast glass tent upheld by a slim armature of stone, concealed by gilding and painted decorations. This amazing multicolored shrine is the first impressionist venture on the monumental scale; all the decorations, whether painted or translucent, and even the cunningly placed incrustations of gilt or colored glass in the spandrels, break up the light into elements that merge in the beholder's eye and from this haze of broken lights emerges an atmosphere befitting the House of God, Light of the World.

Venerated both for its purpose as the sanctuary window and for the extreme costliness of its production, this form of painting is less an ornament than the lyrical expression of a transcendent world. The color forms part of the edifice, one might even say it is the edifice itself, just as it is a gorgeous sublimation of everyday human activity at its best; passionate, active, idealistic. The painter's art was not yet hampered by conventions; any notion of academicism was totally alien to the spirit of the age. Indeed painting, though as yet unrecognized as a self-sufficient art, was basic to mediaeval aesthetic, a source of inspiration for all the other arts, particularly those of tapestry, stained glass, enamel-work, miniatures, and as diverse in its forms of expression as were the various techniques.

THE RISE OF SECULAR ART

Any attempt to sort out and classify the pictorial art of the early 13th century, by countries or (better) by schools and ateliers, would be unprofitable. At most we can discern certain main trends, though we should be hard put to it to define them. For this perplexing mediaeval world, struggling to find its destined path, eludes all simple classifications. The concept of nationality was vague, almost non-existent. The one common denominator was Christianity, but, even so, political or economic conditions often did more than religion to determine the course of events. Until the 13th century, the Faith (another elusive concept, conveying something other than the meaning ascribed to it by the theologian) had played a directive part in European politics. But from the 13th century on, new factors, economic and dynastic, shaped the course of international affairs. There was constant friction between the waning authority of the Holy Roman Empire and that of the new-born western monarchies, while France and England joined issue in a struggle for hegemony, each seeking to obtain control of the English Channel and the Atlantic coast. The Holy Roman Empire itself was rent by internecine conflicts between the partisans of the two great western powers, maritime and continental, and also by the rivalry between the temporal power and the spiritual primacy of the Popes. At the same time the earlier rural culture was once again being superseded by town and city life, thriving commercial centers were developing on and around the seacoasts of the South and West; thus the centers of economic and, as a result, political gravity were being shifted throughout Europe.

The beginning of the 13th century witnessed the general conflagration that had now become inevitable. The Battle of Bouvines in 1214 spelt the end of the Holy Roman Empire and the beginning of French ascendancy. And now that Europe had been liberated from the dual tutelage of Pope and Emperor, the rudiments of our western culture, with its emphasis on man the individual, began to take form under the joint leadership of France and England.

In England the Magna Carta (1215) and the institution of Parliament, and in France the creation (under Louis VIII and Louis IX) of a civil service open to the bourgeoisie, nobility and gentry, brought into being a new social class dependent on the central administration and on whose reciprocal support the latter could rely. In Spain the Christians had definitely stemmed the tide of the Moslem invasion in 1212. As compared with the rulers of other nations who imposed their religion on their subjects, the Spanish kings showed more tolerance—or foresight—and allowed the Jews and Mussulmans within their borders to retain their faith and customs. As against France and England, feudal Germany, self-contained but divided against itself, cut the figure of a reactionary power, archaic and decadent to such a point that Frederick II broke away from it in 1220 and turned towards the South and Sicily in the hope of making good his dream of Mediterranean unity—a venture that was thwarted, inevitably, by the papacy and ended with Frederick's death (1250). In her morose isolation and fiercely divided against

herself, Germany fell to pieces and soon became no more than an aggregate of feudal principalities, with different, often conflicting interests and ambitions.

In 12th-century Germany art had entered on a decline after the noble achievements of the Ottonian period, Byzantine influences having gained the upper hand. Something of an exception is the famous *Hortus Deliciarum* of the Abbess of Odilienberg, Herrade of Landsberg (1200)—unfortunately only facsimiles or copies of it are now available—whose inspiration derives from very different prototypes and in which we see a curious crossing of Western or Byzantine influences with ancient traditions, as well as frankly new procedures. Throughout the 13th century a national style struggled to emerge. In mid-century the work of the Franconian artists, who were now in contact with Dominican friars, showed signs of French influence, which can only have been due to the latter, who had kept in touch with the University of Paris. But, though unmistakable, this "Gothic" penetration was a slow process; indeed it did not make good until the extreme end of the 13th and the opening of the 14th century, in Saxony and Thuringia, when the *Sachsenspiegel* (the ancient Saxon Chronicle of Gotha) and the Minnesingers' manuscripts made their appearance. This stubborn resistance to French influence was probably due to the confused political conditions then prevailing in Germany and the absence of a courtly art. On the other hand Bohemia, under Charles IV, gave a ready welcome to French and Italian influences; this was in fact the starting-point of the brilliant phase of Bohemian art whose manifestations we deal with later.

After the collapse of the feudal system a new social and economic order arose (in the 13th century) and the cities that took form under its auspices became centers of art and culture. France now included all the French-speaking lands formerly within the sphere of Roman influence. The Hanseatic League, a federation of the maritime North German towns, controlled the economic destinies of Northern Europe, while a new urban and mercantile civilization developed on the shores of the Danube and the Rhine. Whereas during the Early Middle Ages the Church had centralized in her Abbeys the only spiritual life that then existed, inspired by scholastic Platonism, the 12th and still more the 13th century witnessed the emancipation of human thought and a return to Aristotelian rationalism, very largely due—and this is noteworthy—to Mohammedan influence. For on the outskirts of the feudal West, the Arab universities in Spain and Persia had safeguarded the heritage of ancient wisdom which was now to triumph in the western world and particularly in the three centers of Christian thought: Paris, Oxford and Bologna. This simultaneous renaissance of philosophy, art and literature was conditioned by the political and social currents of the day. Rome, whose hegemony of Christendom was making itself felt, preconized the authoritarian scholasticism of St Thomas Aquinas. England, where an early form of liberalism and parliamentary government now prevailed, stood for the scientific approach and free enquiry sponsored by Roger Bacon; whereas Germany, still the prey of feudal anarchy, kept to her mediaeval mysticism. France meanwhile, where the monarchical régime was gradually being consolidated, based her constitution on Roman law, which seemed both to justify that form of government and to authorize the diffusion of the Aristotelian concepts of

Vincent of Beauvais and Albertus Magnus. And her position at the junction of the great trade highways between England, Flanders, Italy, the Rhineland and Spain caused France, and Paris in particular, to become the focal point of Catholic thought in Europe.

Until the 13th century education was essentially clerical in outlook and provided only in monastic or ecclesiastical schools. But the foundation of the University of Paris by Philip Augustus in 1200 led to the formation of a new intellectual élite composed of laymen, who, conscious of their independence, had no fear of calling in question the spiritual authority to which, theoretically, they were subordinate. Statutes granted by Robert de Courçon, legate of Pope Innocent III, liberated the University to some extent from the control of the Bishop of Paris. This opened new horizons to the students; they now could savor the charms of secular literature, explore the arcana of civil law, indulge in dialectics and free discussion. The interest shown by Innocent III in the advancement of learning was followed up by other popes; Clement V built the University of Orléans, Benedict XII founded that of Grenoble, and Urban V supported no less than 1400 students. "Gaul," wrote the legate Eudes de Chateauroux, "is the oven in which is baked the intellectual bread of the whole world." And a 13th-century clerk could write: "Paris is a fountainhead of learning, the starting-point of aqueducts running not a mere thirty miles like those of Rome but to the farthest ends of the earth; the devil is forever trying to breach them by interrupting the teaching in the Schools." These students formed an international intelligentsia, grouped by nationalities: the French (from lands speaking the Romance tongues), Anglo-Saxons (from England and Germany), Picards (from the Low Countries) and Normans.

Alongside this deliberately pedantic education, a new culture was developing in the princely courts. The "clerks" wrote only in Latin, a Latin for their own use and incomprehensible to laymen. However, in the 12th century poets took to writing lyrics or epics in the vernacular and imitations or translations of these found their way into all parts of Europe. The tales of adventure written in "Romance" prose which now came into fashion were forerunners of that most popular form of literature, the novel *(le roman)*. Brunetto Latini wrote his *Trésor* in French because, as he said, "the French tongue is familiar to more men and sweeter to the ear than any other." The rules of conduct obtaining in the French châteaux came to be regarded throughout Europe as the "touchstone and model of good behavior." The French style of architecture came into vogue everywhere, women dressed *à la française*, life in courts and country houses was trimmed to the French pattern. That new romantic code so sweetly celebrated in *Le Roman de la Rose* and the ideal "courtly love" sung by the troubadours governed the relations between the sexes. The lover was expected to show delicate attentions and pay respectful homage to the lady of his heart. This new culture, worldly no doubt but full of smiling grace, did much to shape the course of 13th-century life.

As might be expected this new spirit found expression in the books required by teachers and students for their courses, or commissioned by connoisseurs and the nobility for their entertainment. Such was the number of students in Paris and such the prestige of Parisian scholarship and literature that Paris now became the leading

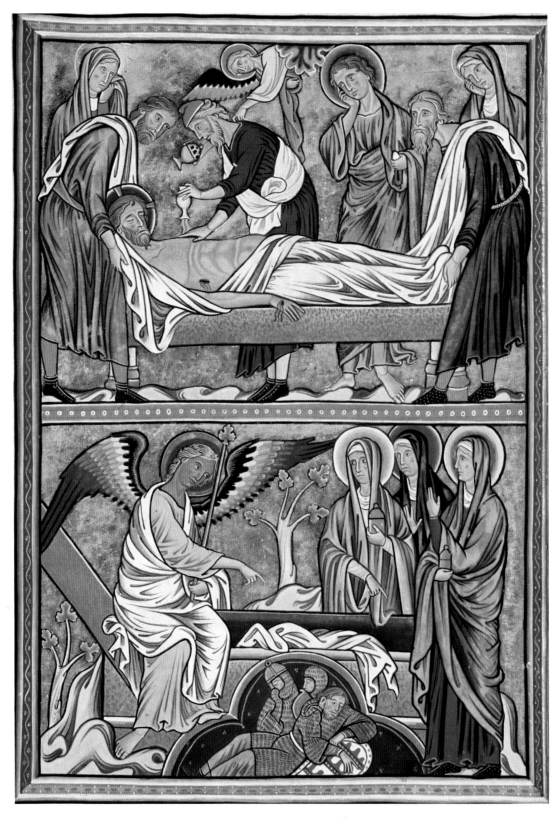

PSALTER OF QUEEN INGEBORG. THE ENTOMBMENT AND THE THREE MARYS AT THE TOMB.
CA. 1200. MINIATURE, FOLIO 28, BACK. MUSÉE CONDÉ, CHANTILLY.

PSALTER OF QUEEN INGEBORG. THE VISIT OF THE MAGI TO HEROD AND THE ADORATION OF THE MAGI.
CA. 1200. MINIATURE, FOLIO 17. MUSÉE CONDÉ, CHANTILLY.

center of book production on the continent. The monastic copyists were replaced by laymen, working in guilds, who naturally had fewer qualms about diffusing pagan or "unorthodox" literature. But, students being notoriously impecunious, it was above all to royal patronage that the makers of illuminated manuscripts owed their success. It was the princesses of the day who showed most interest in these costly productions: Ingeborg, Blanche of Castile, Marguerite de Provence, Margaret of Burgundy, Queen Jeanne of Navarre. True, the books they commissioned were religious, but it was the wonderful illuminations that held the eye and fired the imagination. The princess duly listened to her chaplain's reading of the Prayer Book, but, once the service over, she feasted her eyes at leisure on the pictures. We are struck by the essentially feminine appeal of this edifying literature (the only kind permitted) when we examine the devotional works turned out in such quantities: Books of Hours, Missals, Psalters, "moralized" and abridged Bibles, with more and more space allotted to the illustrations.

If the French illuminated manuscript, hitherto a monopoly of the monks and almost exclusively intended for use in the abbeys, made such striking progress in the 13th century, this was not a wholly spontaneous development, and its origins can be traced. Obviously it is most unlikely that the artist responsible for that magnificent Psalter of Saint Louis could have achieved such technical perfection in, so to speak, a flash of sudden inspiration, without a background of craftsmanly tradition. Now the earlier Parisian works are mediocre and merely carry on the style of the monastic *scriptoria*, a style which owed much to the art of the Romanesque fresco-painters. So drastic is the break between the Parisian art of the 13th century and that of the previous century—between the Psalter of Isabella of France and the Chronicle of the Cloister of Saint-Martin-des-Champs (1188)—that it is quite impossible to regard the former as derivative from the latter. Thus we must cast about for possible antecedents and a clue to these may well be found in the Psalter of Queen Ingeborg, wife of Philip Augustus (ca. 1200). The style shows various influences and this work may be regarded at once as a consummation and as a starting-off point of the new art. Touches of Byzantine formalism and the uncertain treatment of the drapery remind us of 12th-century works, whereas the border decorations, the predominance of blues and browns on a sumptuous gold background and the technical perfection of the calligraphy are in the 13th-century spirit. But the general nature of the linework, notably its austerity, reminds us of the English school of illuminators, whose copious output and wide diffusion had considerable influence.

Little is known about the conditions under which these English illuminated manuscripts were produced. The name of the copyist is sometimes stated, rarely the painter's. But a close study of the illuminations almost always reveals that they are the work of several hands. If the authorship is a mystery, it is almost as difficult to attribute a given manuscript to one or other of the great English abbeys of the 12th century. Probably towards the close of the 13th century the production of these works was no longer confined to monasteries, and laymen took a hand in them. The handsomest books were made for wealthy patrons and were probably the work of professional artists.

EVOLUTION OF THE ENGLISH MINIATURE

To get an idea of the general lines of evolution of the painted manuscript in England, we need to know something of the style before the Norman Conquest of 1066; for certain atavistic trends continued to re-emerge in the work of the best British artists until the 14th century. Among the specific characteristics of this style—they are also to be found in the Bayeux Tapestry—are the following: a free, somewhat elliptical technique; thin, vibrant line; bold distortions that play fast and loose with anatomy but show a remarkable grasp of movement. The Canterbury copies of that famous manuscript the Utrecht Psalter, which bears the impress of the School of Rheims, indicate the tastes of the English school. Forms are lightly washed over with transparent color, almost in the watercolor technique. Made at the beginning of the 12th century, the Evangeliar of St Edmund's Abbey at Bury (Pembroke College, Cambridge, MS 120) likewise illustrates the English national style of drawing which was to be profoundly—if but briefly— modified by continental influences due to the Conquest.

Line grew thicker and lost its distinctive quality, while the color (gouache was now employed) became thick and heavy; in fact there was a sort of retrogression under foreign influence, from which the English school did not recover until about 1125, when it entered on a period of brilliant achievement whose impact was felt on the continent during the early 13th century. Norman monks, copyists and illuminators, took up residence in the English monasteries, bringing new blood to English art. There were now art centers throughout the land: at St Albans, Bury St Edmunds, St Swithun's, the Priory of Winchester Cathedral, the two Houses of Canterbury, Christchurch and St Augustine's, and at Durham in the North. The Winchester Cathedral School made a very large Psalter with thirty-eight full-page miniatures for Henry of Blois, brother of King Stephen and Bishop of Winchester (1129-1171). In this Psalter two miniatures in a quite different style strike a new note; they seem to be copies of Italian originals brought to England by Henry of Blois who visited Rome in 1151-1152. From Winchester too comes a Bible in three large folio volumes justly renowned for the beauty of the drawing and the magnificence of the historiated initial letters. The oldest initials are particularly striking; garments tightly clinging to bodies, curiously restless outlines, figures instinct with life—all are characteristic of a highly mannered style within the Anglo-Saxon tradition.

Quite in the spirit of this tradition are the illustrated Bestiaries—i.e. animal-books —so popular in England at the end of the 12th century. Inspired by the descriptions of animals in the twelfth book of Isidore of Seville's *Origines*, these far-fetched tales of fabulous beasts seem to have had an irresistible appeal for the mediaeval imagination. A Bestiary in the British Museum—Harley MS 4751—contains a large number of such miniatures, most of them painted within medallions or fitted into patterns of circles and rectangles. An excellent example is the picture of hunters pursuing a unicorn with a long, twisted horn, resembling the narwhal's tusk, set in the middle of its brow. So swift of foot that no hunter could hope to capture him by normal means, the unicorn

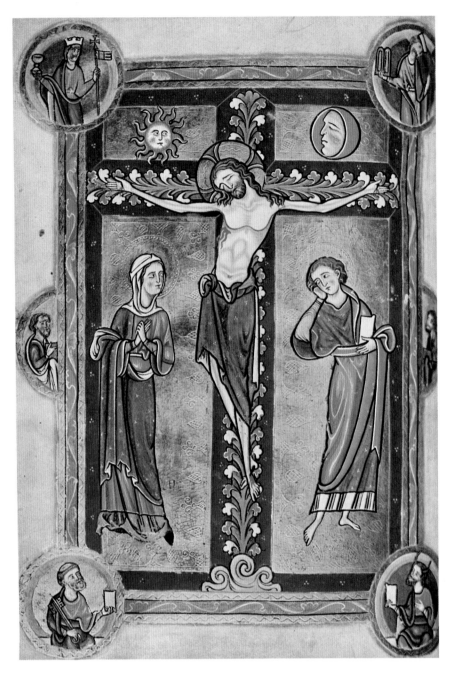

PSALTER OF ROBERT DE LINDESEY. CRUCIFIXION. MINIATURE, PETERBOROUGH, BEFORE 1222.
MS 59, FOLIO 35, BACK. $\left(6\frac{5}{8} \times 4\frac{5}{8}''\right)$ SOCIETY OF ANTIQUARIES, LONDON.

was reputed to be subdued to gentleness at the sight of a virgin. Only then, when he had become all docility and meekly laid his head in the maiden's lap, could hunters approach and seize their prey. Into this legend the mediaeval mind read a symbol of the Virgin Mother whose Son voluntarily delivered himself up to His enemies. Many other fables are illustrated in the Bestiaries, at all of which we smile today—Engoulevent, the bird who builds his nest so high that the only way of bringing down the

APOCALYPSE. CA. 1230. MINIATURE, ROYAL MS 16.2, FOLIO 22. ($9\frac{3}{8} \times 8\frac{5}{8}''$)
TRINITY COLLEGE, CAMBRIDGE.

cinnamon with which he makes it is launching stones at it with a sling; or Caladrius, the bird that flies to the bedside of invalids and either sucks out the humor of their maladies or turns away if they are doomed to die.

The Byzantine or Roman influences which can be seen in the Psalter of Henry of Blois made themselves strongly and persistently felt during the second half of the 12th century and profoundly modified the national style. Henceforth the traditional canon of proportions was departed from; the illuminators turned their improved knowledge of human anatomy to good account and, for their renderings of modeling and garments, took to using living models.

The Psalter (Royal MS 2A XXII) in the British Museum, made at Westminster Abbey at the end of the 12th century, illustrates this change. No Anglo-Saxon traits remain; with its five full-page miniatures on burnished gold grounds, this Psalter is reminiscent throughout of definitely Byzantine prototypes.

Similar developments took place in the abbeys of northern France, which were always in such close contact with those of England that, in the early 13th century, their respective outputs are almost indistinguishable. It was probably by way of these abbeys of the North that the English tradition was transmitted to the Parisian ateliers. In which case may not the Psalter of Queen Ingeborg, chronologically and stylistically the first of the 13th century, have been a production of the north of France?

The vogue of psalters persisted in England throughout the 14th century; booklovers abounded and the illuminators' "workshops" prospered. During this period the chief centers were in Norfolk and Suffolk, from which counties hail a great number of extant manuscripts, some of them of the highest quality. Distinctive of these works are both the richness and vigor of the decorations taken separately and the magnificence of their general effect. Coats-of-arms often figure in their pages, for purely decorative ends. Thus in the settings of the initial letters and in borders we often find armorial bearings that have no connection with the owner of the book, and even purely imaginary bearings. Frequent, too, especially in the marginal decorations, are whimsical or grotesque motifs in which the illuminator has given free rein to his fancy. This practice, peculiar to the English School (in which it made its first appearance in 1250), is not the least of the charms of these 14th-century manuscripts.

Amongst the most striking is the Arundel Psalter (British Museum, Arundel MS 83). It consists of two distinct parts, one with large historiated initials and highly distinctive marginal ornaments; the other, which is previous to 1339, treated in a quite different spirit and containing some magnificent pictures. Particularly impressive is the page illustrating the Life of Christ in six scenes arranged in pairs, one above the other: *The Nativity* and *The Adoration of the Shepherds, The Adoration of the Magi* and *The Circumcision, The Presentation in the Temple* and *The Flight into Egypt.* Each of the six pictures is enclosed in a cusped frame, resembling the partitions of a stained-glass window, the interstices being filled in with a diapered ground. The brilliant originality of this artist is apparent both in the drawing of the figures and in his attempts at rendering perspective. Figures are gracefully proportioned, groups well

arranged and the gestures natural. Indeed he seems on the happiest terms with his medium, in full possession of his painterly means. And in other miniatures in this Psalter, notably in the scene of *The Crucifixion* with the Virgin and St John, the exceptionally monumental, sculpturesque treatment suggests that this artist did not confine himself to miniature painting.

A large painted retable in the Cluny Museum has some stylistic affinities with the Arundel illuminations. It portrays from left to right (the order in which the scenes are placed is rather curious) *The Nativity, The Death of the Virgin, The Adoration of the Magi,* and *St Anne teaching the Virgin to read.* These scenes, too, are enclosed in multifoil frames and the grounds are checkered in squares containing various devices such as birds facing each other, *fleurs de lys* and the heraldic leopard, a detail often found in these miniatures and betokening their British provenance. The style of the faces, and notably the treatment of the drapery seems reminiscent of the Psalter; nevertheless the elongated proportions and the elaborate rendering, verging on preciosity, of gestures makes it clear that the retable should be ascribed to a later period—probably round about 1350. There can be no question, however, that this is a work of the East Anglian School whose headquarters was the cathedral town of Norwich.

In the first half of the 14th century, with Queen Mary's Psalter, the English illuminated manuscript achieved one of its loftiest expressions. Such is the magnificence

UNKNOWN MASTER. SCENES FROM THE LIFE OF THE VIRGIN. RETABLE, RIGHTHAND PANELS. CA. 1350. MUSÉE DE CLUNY, PARIS.

PSALTER OF ROBERT, BARON DE LISLE. SIX SCENES FROM THE LIFE OF CHRIST.
MINIATURE, EAST ANGLIA, BEFORE 1339. ARUNDEL MS 83, FOLIO 124. BRITISH MUSEUM, LONDON.

QUEEN MARY'S PSALTER. JESUS TEACHING IN THE TEMPLE. FIRST HALF OF FOURTEENTH CENTURY.
MINIATURE, ROYAL MS 2 B. VII, FOLIO 151. (7 × 4½″) BRITISH MUSEUM, LONDON.

of this production that it must have been commissioned by some exalted or very wealthy personage, most probably one of the Plantagenets, Edward I or Edward II, since their patron saint, Edward the Confessor, is given a prominent place in the book. But, in the absence of any heraldic bearings or written references, there can be no certainty on this point. This book owes its name to the fact that it was in Queen Mary's reign that it was rescued by a Customs officer from being sent secretly out of England, and presented to the Queen (in October, 1553). The splendor of the illuminations accounts for the conduct of this zealous and patriotic official. For there are no less than two hundred and twenty-three tinted drawings of Old Testament scenes on seventy pages, twenty-four miniatures descriptive of the months of the year, four hundred and sixty-four drawings in pen and wash at the bottoms of pages, and twenty-seven historiated initials. Since the same high standard of excellence is maintained throughout the volume, there is no doubt that all these illustrations are by the same hand. The painter combines lively imagination with high technical ability in the pen drawings heightened by color —green, violet, red or brown—and one feels he is more at his ease in these than in the more elaborate and traditional full-page miniatures in body-color. The marginal drawings reveal the hand of a born draftsman. Whether he is depicting animals or grotesques, cheerful incidents or scenes of martyrdom, his lively, sensitive and precise line imparts the very breath of life to his subjects. Above all he excels in scenes of everyday life and the recreations of the nobility. The scene of hunting with the falcon on the lower margin of a page, under the scene of Jesus in the Temple, preceded the world-renowned miniatures of the Limbourg brothers by over fifty years and ranks with them amongst the finest examples of court art. The two horses ambling side by side, the pleasant-looking couple riding them, the attendant woman (also on horseback), the falconer who has just released his falcon, the birds in flight, a duck seized by the bird of prey—all alike are rendered with amazing visual realism and delightful spontaneity. True, the unknown illuminator of the Psalter is in the direct lineage of the School of Winchester, whose wonderful command of line had made itself felt as early as the 12th century. But this Psalter is in a class by itself and no work comparable with it was produced in the period immediately following. Indeed there was a cessation—owing perhaps to the Black Death (1348-1349)—of the activities of the English Schools and when the end of the century ushered in a revival of this form of art, this was due to incentives stemming from abroad.

STAINED GLASS AND MINIATURES IN FRANCE

For those who are inclined *prima facie* to question our attribution of the Psalter of Ingeborg to a French school of illuminators, a comparison of it with the Psalter of Blanche of Castile which was made at approximately the same time should dispel any doubts they may feel on the subject. For the latter, indubitably French and very probably a Parisian production, has striking similarities with the Ingeborg Psalter, not only as to its general style but in the technique employed for the gold backgrounds. Indeed the only difference lies in its presentation of the miniatures as medallions grouped in pairs within ornamental frames. A change had now come over the world of monumental art with the increasing vogue of the stained-glass window, in which the illuminators found a new and highly fruitful source of inspiration. During the Romanesque period the miniature and mural painting had developed on parallel lines; now it was to the stained-glass window that the illuminator looked for guidance as regards his style, technique and color-schemes. This influence makes itself unequivocally felt for the first time in the Psalter of Blanche of Castile, which indeed is imitative to the point of plagiarism. For, skillful as is the brushwork, we can detect in it a sort of saturation of tones and even a thickening of the impasto, which show how far these virtuosi of the foliated spray let their natural finesse be paralyzed by the massive effects of the stained-glass window.

The Gothic church with its walls of lace and glass and clustering columns left no space for the fresco-painter to work on; deprived of their traditional models, the manuscript painters might well have lapsed into a sterile repetition of the themes and patterns of the past had they not found elsewhere new stimulants to their imagination. And where could they find these better than in the busy workyards of the glass-painters and enamelers, with their abundance of new themes and forms?

French stained glass already had behind it the experience, beginning at Saint-Denis, of three-quarters of a century, during which time it had advanced from strength to strength, achieving its full flowering at the beginning of the 13th century. The windows of Notre-Dame de Paris were then in place and in or about 1210 those of the nave and choir of Chartres were being installed. The vast renown enjoyed by the cathedral workyards is proved by the fact that their productions were exported and they sent out their glass-workers to distant places. Thus a panel in the ambulatory of Rouen Cathedral (ca. 1235-1240) is inscribed by its maker, *"Clemens vitrearius carnotensis m[e fecit],"* and stained glass in the Chartres style (though probably deriving from other workshops not yet clearly localized) is to be found as far away as Canterbury, in the Chapel of the Trinity, at Lincoln, Bourges, Sens and Tours. The many resemblances, which obviously are not due to mere chance, point to a real community of ideas as regards the choice of subjects and their interpretation. Such being the great diffusion of this art, it was natural enough that the illuminators, who (like the copyists) were constrained to keep in line with the tastes of their public, should have ended up by taking as their model the form of art which was enjoying such universal success.

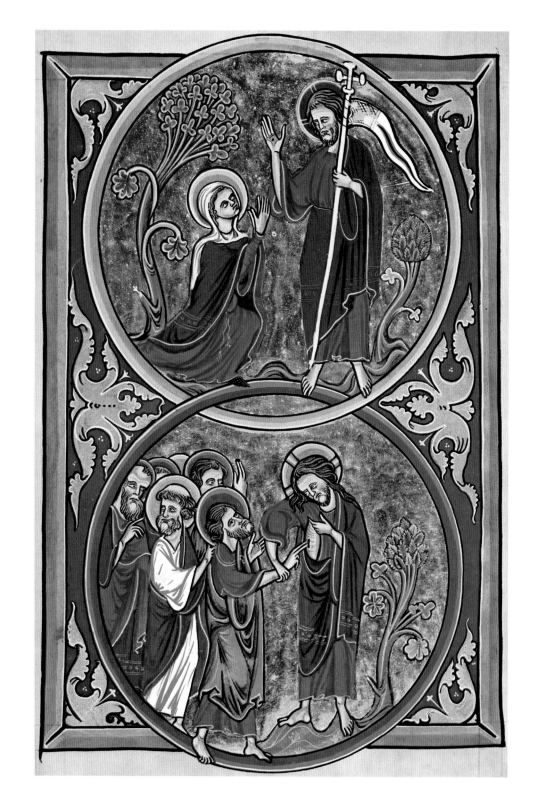

PSALTER OF BLANCHE OF CASTILE.
CHRIST APPEARING TO MARY MAGDALEN AND ST THOMAS TOUCHING THE WOUNDS OF CHRIST. CA. 1230.
MINIATURE, MS FRANÇAIS 1186, FOLIO 26. (7¾ × 5″) BIBLIOTHÈQUE DE L'ARSENAL, PARIS.

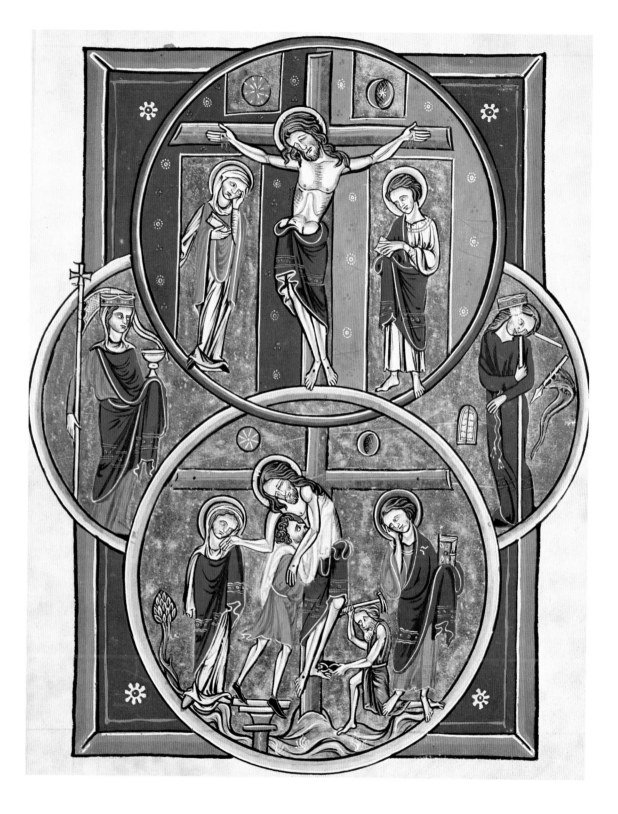

PSALTER OF BLANCHE OF CASTILE.
CRUCIFIXION AND DESCENT FROM THE CROSS, BETWEEN THE CHURCH AND THE SYNAGOGUE. CA. 1230.
MINIATURE, MS FRANÇAIS 1186, FOLIO 24. (7¾ × 6″) BIBLIOTHÈQUE DE L'ARSENAL, PARIS.

The magic or theological significance of the stained-glass windows, which mediaeval liturgists likened to the Apostles and the Prophets, "lights of grace and crystals of the Faith," as well as their extreme costliness—which naturally enough enhanced still further their prestige—explains why the architects of the day kept them constantly in view and even perhaps made innovations in their methods so as to come in line with their requirements. For the relationship between the wall and the window space was never unilateral; that is to say, one was not subordinated to the other. From the 13th century on the structure of the edifice was largely conditioned by the evolution of the glass-painter's technique and his artistic conceptions. In Romanesque churches the openings in the wall had been small and infrequent. In the Gothic period, the triumph of the window was inaugurated by the place assigned to it by Suger in the bays of the Saint-Denis apse. And until 1245 we can trace (as Grodecki has pointed out) a twofold evolution; every time the bays are enlarged to the extreme limit compatible with structural solidity—until indeed the whole wall surface between windows is eliminated—we find a change in the coloring of the windows, which is constantly stepped up as the windows themselves grow larger. In any case the result of this competition or, rather, increasingly active collaboration, between glass-worker and architect, was the substitution of the vibrant, light-saturated expanse of glass for the solid wall, and this necessarily modified the general lay-out of the bay, first rayonnant, then flamboyant. The glorious architectural achievements of the cathedral-builders have tended to draw attention from the primacy of the stained-glass window in Gothic art; but there is now no question that the men, little known as they still are, who made these windows should be regarded as painters in their own right, first among the French Primitives.

The proven fact that some of the chief 14th- and 15th-century painters, such men as Jacquemart de Hesdin, Beauneveu, Nicolas Froment and the "Master of Moulins," were also glass-workers justifies us in surmising that their predecessors at Chartres, Le Mans and Rheims were equally versed in the art of painting. For apart from a few "tricks of the trade" involved in stained-glass technique, there is no basic difference between the latter and painting in the ordinary sense. Both alike involve a knowledge of drawing, of handling paint, of line and modeling, and a nice sense of the correct distribution of values. Misled by our modern notions of the picture, we tend to underestimate or misinterpret the superbly "representative" art of the windows in our cathedrals. Thus we fail to perceive in these works the artist's almost feverish desire to give expression to that special concept of form which is the very essence of this art. Henceforth indeed the stained-glass window must be studied not from the archaeological viewpoint but from that of the art historian, so as to trace in these works the interplay of various currents, to bring out the importance of the coming together of artists from different art centers in the same workyards, and to elucidate the activities of these new "constellations" of artists, as Wilhelm Pinder aptly calls them. At the end of the 12th century and in the first years of the 13th (as has been observed by J. J. Gruber) figures placed on the blue or red grounds of medallions surrounded by vividly colored floral or geometric patterns are rendered in greens of various shades, generally neutral-

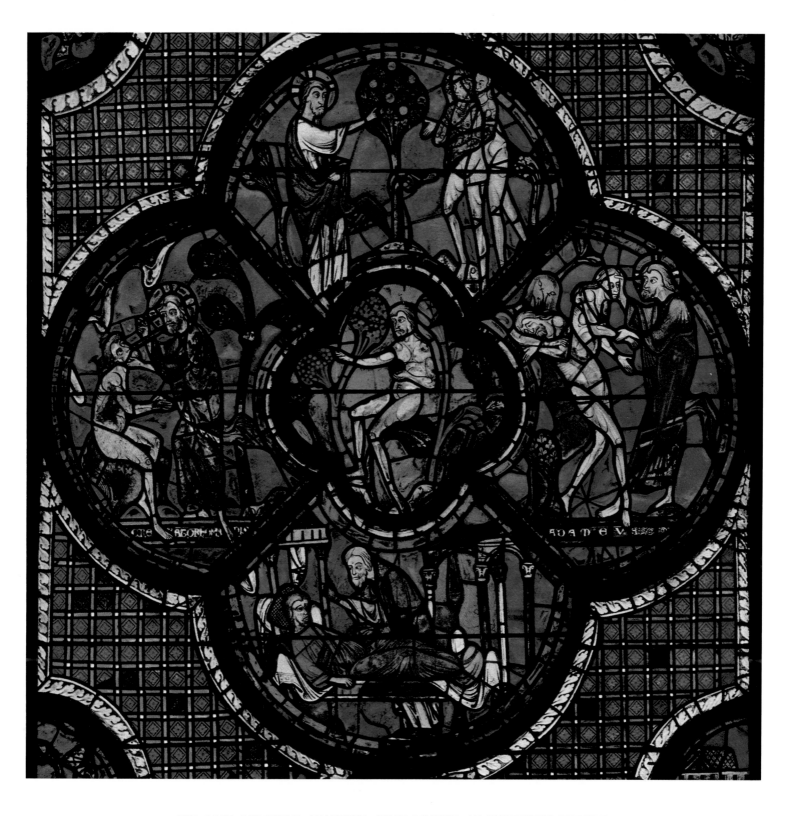

THE GOOD SAMARITAN, FRAGMENT. FIRST QUARTER OF THIRTEENTH CENTURY.
THIRD WINDOW IN THE SOUTH AISLE OF THE NAVE,
CHARTRES CATHEDRAL.

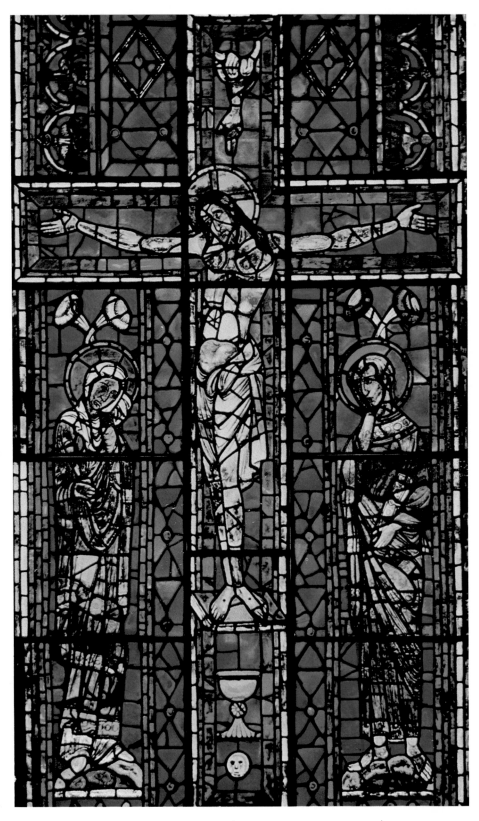

CRUCIFIXION. CA. 1190. (11 FT. 10 INCHES × 7 FT.)
CHURCH OF SAINT-REMI, RHEIMS.

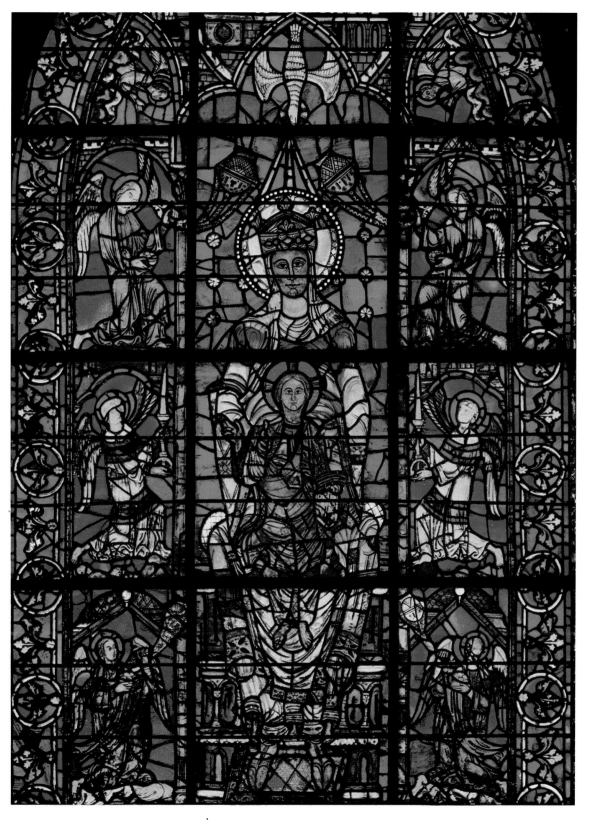

NOTRE-DAME DE LA BELLE-VERRIÈRE. CENTER, TWELFTH CENTURY; SIDES, THIRTEENTH CENTURY.
(16 FT. × 7 FT. 8½ INCHES) FIRST WINDOW IN THE AISLE OF THE CHOIR, SOUTH SIDE, CHARTRES CATHEDRAL.

toned and low in brilliancy; sometimes, too, in purples or pale blues. It is quite clear that this relative density of the figures is due to the artist's sense of plastic values, and also he has exploited all the possibilities of the black enamel employed by the glass-painter for tracing outlines and the folds of garments. Just as the fresco-painter or sculptor starts off from highlights that are simply the natural hue of the stone, left in the rough or polished, so the glass-painter starts out from the natural transparency of glass, and binds his forms with broad streaks of black or close-set hatchings. This was in fact one of the supreme periods of French art, when the flickering shadows of pier statues wove a tracery of curves across the naves and aisles of cathedrals, and the light trapped in pieces of plain white glass set up vibrations in the surrounding colors.

The work of Nicolas de Verdun may be said to sum up the spirit of the art prevailing at the close of the 12th century. In the figures in the round upon his reliquaries, the sheen of whose gold matches that of the stained-glass window, and also in the carved surfaces of the Klosterneuburg altarpiece, whose enamel inlays produce an effect resembling that of the Gothic window, we find this selfsame handling of form.

PSALTER OF SAINT LOUIS. ABRAHAM ENTERTAINING THE ANGELS. 1256. MINIATURE, MS LATIN 10525, FOLIO 7. (5 × 3 ½″) BIBLIOTHÈQUE NATIONALE, PARIS.

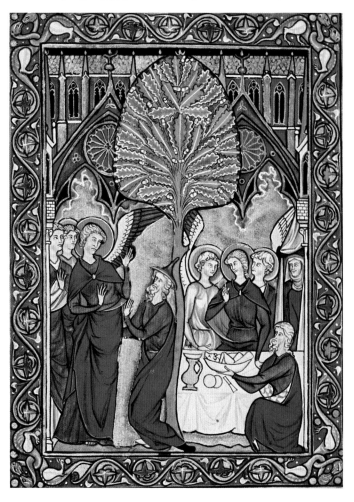

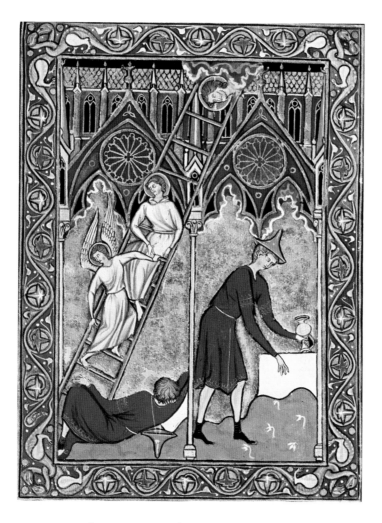

PSALTER OF SAINT LOUIS. JACOB'S LADDER. 1256. MINIATURE, MS LATIN 10525, FOLIO 13. (5 × 3½")
BIBLIOTHÈQUE NATIONALE, PARIS.

Our 13th-century illuminators were far from being mere servile copyists. For while imitating the style and composition of the stained-glass window, they adapted these to their medium, in for example their highly skillful treatment of shimmering gold grounds. Thus the devotional books produced by them were not mere replicas but small-scale evocations of the church window in all its glittering splendor. Soon, however, they carried this process a stage further and drew inspiration not only from the window itself but also from its architectural frame; and, later, from the edifice as a whole. The Psalter of Saint Louis (1256) with its architectural decorations—pinnacles, fretted galleries, rose-windows and the like—illustrates this new development. Moreover, the flowers and leafage adorning the capitals of pillars now began to proliferate on to the margins, hitherto left blank. The artist not only ventured on novel treatments of stock religious themes, but sometimes included scenes from the living world around him. Thus in a picture of the battle waged by Abraham, the warriors look far more like crusaders, knights of Saint Louis, than like biblical characters. In fact the aspect and

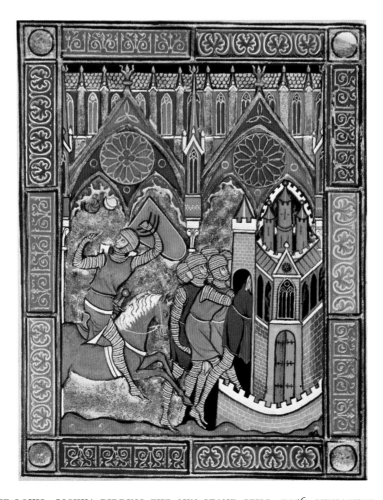

PSALTER OF SAINT LOUIS. JOSHUA BIDDING THE SUN STAND STILL. 1256. MINIATURE, MS LATIN 10525.
FOLIO 46. (4⅝ × 3¹¹/₁₆″) BIBLIOTHÈQUE NATIONALE, PARIS.

deportment of these elegant, gracefully built young warriors exactly corresponded to the new conception of the "very gallant knight" of the age of chivalry. Such anachronisms were due not to obtuseness on the artist's part but to a desire to impart to incidents of ancient history the immediacy of contemporary events.

The king and his court played a very important part in the development and diffusion of the new style. Louis IX (Saint Louis) was a great book-lover; his library, Geoffroy de Beaulieu tells us, "brought to mind that of an Eastern monarch." When Friar William of Rubrouck set out to pay a visit to the Khan of Tartary, Marguerite de Provence gave him a *"psalterium pulcherrimum in quo erant picturae valde pulchrae."* Saint Louis kept on his establishment a group of illuminators all fired by a rare enthusiasm. Moreover the demand for books was intensified by the steady growth of the University. One of the students ruined himself buying manuscripts, so Odofredus of Bologna tells us, and he quaintly adds: *"fecit libros suos babuinare de litteris aureis."*

The illuminated book, hitherto a monopoly of the monastic *scriptoria*, was now produced by laymen, grouped like other artisans in corporations and living in the same

neighborhood. Their status, like that of the sculptors, was a humble one; often indeed they eked out their scanty livelihood by setting up as inn-keepers, doubtless a more remunerative profession. Of the seventeen working in Paris at the end of the 13th century, twelve resided in the vicinity of Saint Séverin's, in the Rue Erembourc-de-Brie (now Rue Boutebrie); others in various localities on the Left Bank, Rue Saint-Victor and the Montagne Sainte-Geneviève; the rest on the Right Bank near the Hôtel de Ville and the Church of Saint Eustache. As they never signed their works, their names are unknown. In a *Livre de Taille* (tax register) for 1292 are listed the first names of two illuminators—surnames were never given: Nicolas and Honoré, both being described as *chefs d'ateliers.*

Honoré seems to have been the more successful of the two as he paid the heavier tax (10 sous). In 1288 he sold an illuminated text of *Gratian's Decretum* for 40 francs, a figure relatively high for the day. In the records of the Treasury of the Louvre we find an entry: *"Honoratus illuminator pro libris regis illuminatis, 20 L"* (*livres* or, in modern parlance, francs). The king referred to in the entry was Philip the Fair, and quite

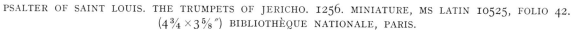

PSALTER OF SAINT LOUIS. THE TRUMPETS OF JERICHO. 1256. MINIATURE, MS LATIN 10525, FOLIO 42. (4¾×3⅝″) BIBLIOTHÈQUE NATIONALE, PARIS.

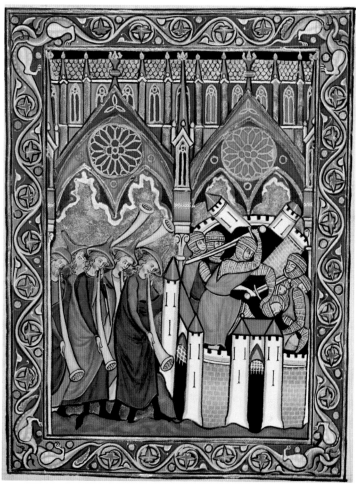

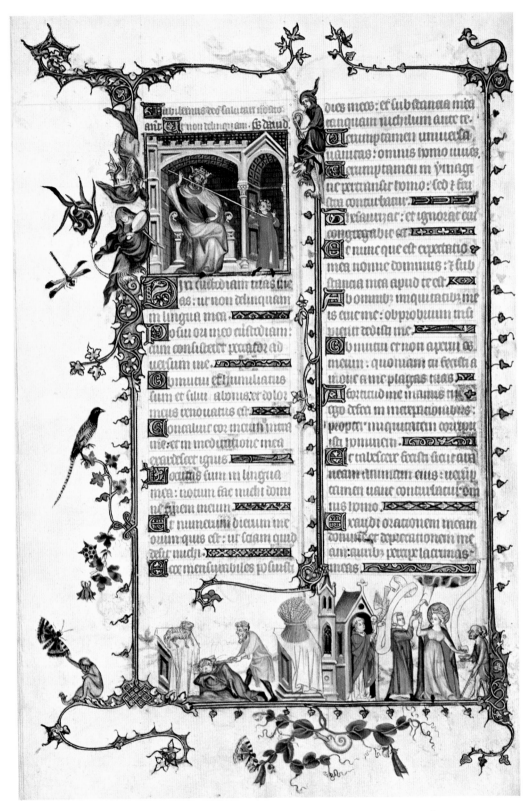

JEAN PUCELLE. THE BELLEVILLE BREVIARY. 1343. MINIATURE, MS LATIN 10483, FOLIO 24, BACK. (9 × 6¼″) BIBLIOTHÈQUE NATIONALE, PARIS.

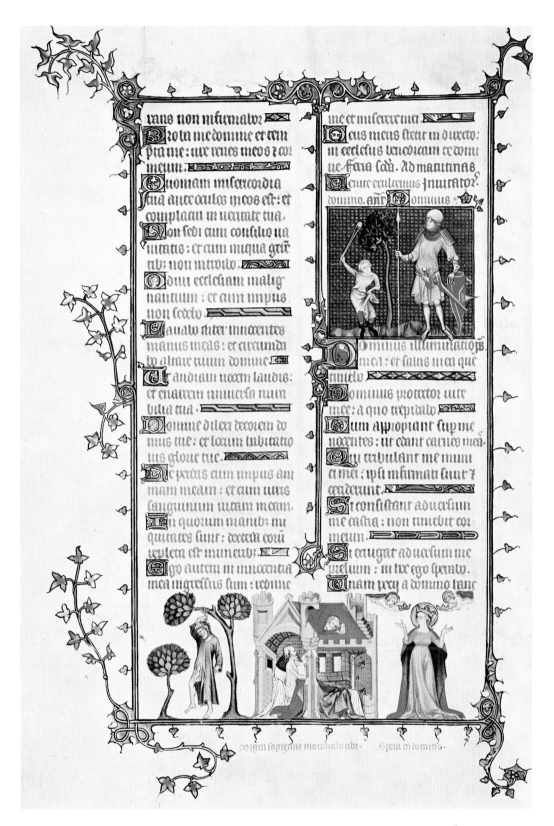

JEAN PUCELLE. THE BELLEVILLE BREVIARY. 1343. MINIATURE, MS LATIN 10484, FOLIO 12.
(9 × 6¼") BIBLIOTHÈQUE NATIONALE, PARIS.

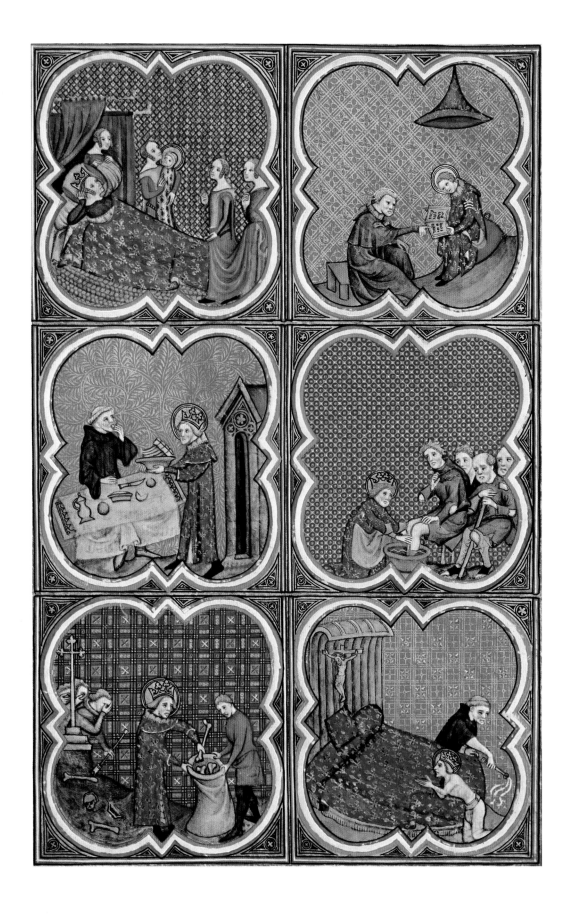

probably the illustrations in that monarch's Breviary, now in the Bibliothèque Nationale, were the work of Honoré. He and his team of assistants, which included his daughter and his son-in-law Richard de Verdun, were more than industrious and skillful artisans; they were artists in the full sense of the term, with a bent towards a more accurate observation of nature. With this in mind they took to using brighter colors, figures were rendered more delicately and less stiffly, the decorative backgrounds being so arranged as to display them to the best advantage. The greatest change is in the ornamentation, less obtrusive than in the past. Honoré's successor in the leadership of this Parisian school of miniature-painters was Jean Pucelle, perhaps his pupil, who set the style of all the work produced in Paris in the 14th century.

Jean Pucelle won great renown as a *chef d'atelier*; his assistants were Jaquet Maci, Anciau de Sens and Jean Chevrier, and their names figure beside Pucelle's in several works. He, too, worked for Philip the Fair and thanks to this royal patronage was inundated with commissions for illustrated books, amongst these being the Bible of Robert de Billyng (1327), the Belleville Breviary (1343) and the famous *Petites Heures* that bear his name. To him is due the credit for a quite new conception of the illuminator's art. The artist now gives free rein to his fancy and virtuosity in the lower portions of the sheets, on the edges of pages and above all in the margins, which now are decorated with gay scenes and quaint devices, including a wealth of charmingly depicted animals and fantastic creatures. Particularly striking is his attempt to solve the problem of rendering space by an ingenious use of light-and-shade effects.

But Pucelle neither discovered nor invented a new style; he merely perfected discoveries and procedures of the past. He was responsible, however, for greatly enlarging the current repertory of ornamental motifs and techniques, notably in the frames enclosing the text; these now consisted of "fillets" throwing off on all sides sprigs and leafage in red, blue and gold, forming a

GRANDES CHRONIQUES DE FRANCE. MINIATURES, BEFORE 1380.
MS FRANÇAIS 2813. BIBLIOTHÈQUE NATIONALE, PARIS
CLOTAIRE RESCUING HIS SON DAGOBERT. FOLIO 66, BACK. $(2\,^9/_{16} \times 2\,^7/_{16}'')$
THE DEATH OF BRUNEHAUT. FOLIO 60, BACK. $(2\,^1/_2 \times 2\,^7/_{16}'')$
THE VISION OF ARCHBISHOP TURPIN. FOLIO 123, BACK. $(2\,^5/_{16} \times 2\,^7/_{16}'')$

◀ SIX EPISODES FROM THE LIFE OF SAINT LOUIS. FOLIO 265. $(8\,^1/_2 \times 5\,^1/_2)''$

41

GRANDES CHRONIQUES DE FRANCE. JOHN THE GOOD FOUNDING THE ORDER OF THE STAR.
BEFORE 1380. MINIATURE, MS FRANÇAIS 2813. FOLIO 394. (6½×5½") BIBLIOTHÈQUE NATIONALE, PARIS.

compact tracery around the body of the writing. From now on the illuminated page
was presented as an organic whole, narrative and decorative at once. But Pucelle does
not seem to have given the miniature its definitive form; though he abolished gold back-
grounds and aimed at effects of modeling, he achieved no real success in expressing
volume or creating the illusion of space. In fact his style, with all its elegance and fragile
grace, was no more than a mannerism—a view borne out by his deliberate use of

monochrome values and highly subtle grisaille effects. All that he did was to prepare the way for the illuminators of the end of the 14th century and the 15th, thanks to whom the French miniature achieved the status of a work of art existing in its own right. Perfectly in keeping as it was with the taste of his time, Pucelle's work was appreciated everywhere and did much to consolidate the renown of this first School of Paris.

Hence the influx of foreign artists into Paris. From 1316 to 1350, out of ninety-two scribes or booksellers recorded as practicing their trade in Paris, fifteen, perhaps nineteen, were English. Begun by Honoré, *Gratian's Decretum* was completed by Thomas de Wymonduswold in 1323 and the text of Pucelle's Bible was the work of another English calligrapher, Robert de Billyng. There was, in fact, a constant intermingling of the art trends of France and England in the 14th century.

Pucelle's influence on the specifically Parisian school of illumination oriented it more and more towards a formal, stereotyped mannerism, and it was only after it had come in contact with the Flemish school that the French miniature assumed its definitive form. Between 1350 and 1380, under the auspices of Charles V, there was a copious flowering of illuminated books, for the most part of a quite commonplace order. From these the work produced by one atelier stands out as showing very real originality. To this artist, who goes by the name of *Le Maître aux Boqueteaux*, are on good grounds attributed the illuminations of the Bible of Jean de Sy, the Poems of Guillaume de Machaut, the *Livy* of Charles V, the Historiated Bible of Charles VI, *The Golden Legend*

GRANDES CHRONIQUES DE FRANCE.
THE MURDER OF THE MARSHALS OF CLERMONT AND CHAMPAGNE, BEFORE 1380.
MINIATURE, MS FRANÇAIS 2813. FOLIO 409, BACK. ($3^9/_{16} \times 2^7/_{16}$") BIBLIOTHÈQUE NATIONALE, PARIS.

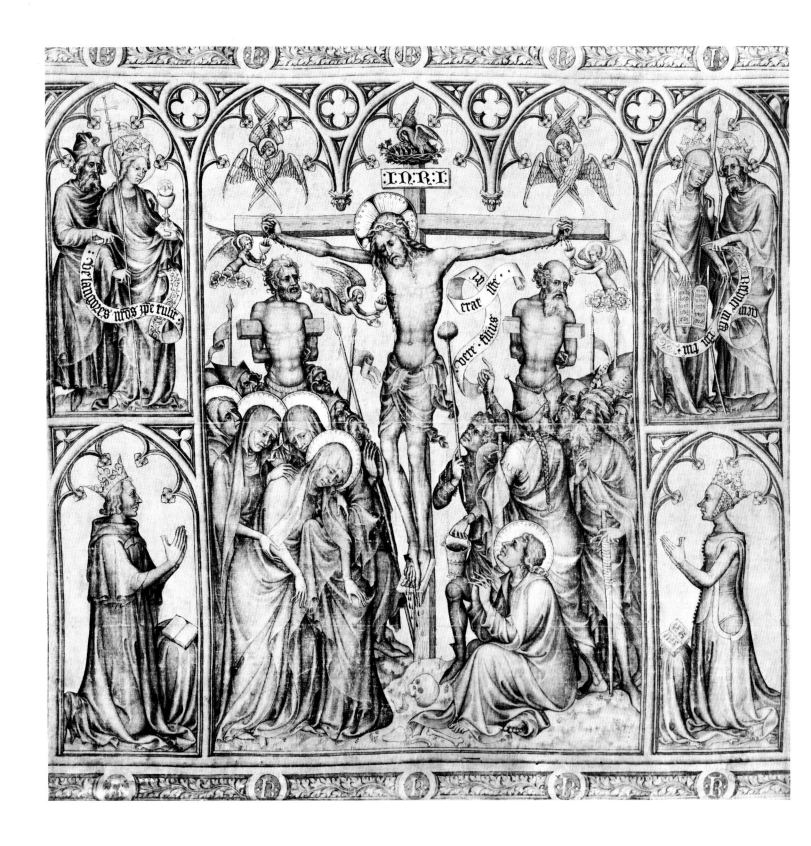

LE PAREMENT DE NARBONNE, FRAGMENT. CA. 1375. THE CRUCIFIXION BETWEEN THE CHURCH AND THE
SYNAGOGUE, WITH KING CHARLES V AND QUEEN JEANNE DE BOURBON. GRISAILLE ON SILK. LOUVRE, PARIS.

by Jacopo Voragine (in Jean de Vignay's translation) and the famous *Grandes Chroniques de France*. Who was the artist or *chef d'atelier* responsible for these works? He may have been the "Jean le Noir" who after serving under Yolanda of Flanders, Countess of Bar, was employed by King John, then by Charles V, together with his daughter Burgot, described as a "female illuminator." Though there is no certainty about his name, his highly personal way of depicting trees, always four or five together in small, serried clumps (*boqueteaux*—hence the name by which he is known) that look rather like overgrown mushrooms, is tantamount to a signature. But this peculiarity is of merely anecdotal interest. More to the point is another idiosyncrasy: his practice, certainly deliberate, of painting without shadows and without, or almost without, color, and with a spareness of line, an avoidance of all but essentials, that ranks him (as has been pointed out by H. Martin) rather as a chronicler than as an illuminator. True, this procedure was not a new one, but from the reign of King John of France onwards painting in grey monochrome steadily gained ground, until under Charles V it became the ruling fashion. Depending wholly on its supple, adroit linework, the picture became a mere pen-and-ink sketch, lightly washed with color. This was the time when grisailles bulked so largely in the stained-glass window and for the first time appeared in a painted panel, the famous Narbonne altar-hanging.

This strip of samite (white silk) painted in grisaille was accidentally discovered in the 19th century in the ancient Cathedral of Saint-Just at Narbonne, and was owned by the painter Boilly before it found its way to the Louvre. Thus, by a series of fortunate chances, this unique specimen of a class of works—the altar-hangings often mentioned in the inventories of kings and princes—none of which was thought to have survived, has come down to us intact. During the Carolingian period it was customary to drape the altar with precious fabrics, and the next step was to vary their decoration according to the season of the liturgical year. This deeply moving evocation of the Passion, commonly known under its French name, *Le Parement de Narbonne*, was displayed in front of the altar during Lent, when the church "went into mourning."

An architectural setting of linked arcades with cusped Gothic heads provides the framework of the scenes, enabling each to make its individual effect without a break in the over-all rhythm. In the central scene, of the Crucifixion, the dramatic tension is heightened by the confrontation of the crowd of Jews and soldiers with the Virgin's drooping form, upheld by the Holy Women. Crouching at the foot of the Cross, his hands clasped in anguish, St John is gazing up at his Master so fixedly that he seems unaware of the bystanders, whose varying emotions the artist depicts so tellingly, yet without ever forcing the note. To the left are scenes of action: Christ's arrest in the Garden of Olives, with St Peter reluctantly sheathing his sword, the Flagellation, and the Carrying of the Cross; on the right, the Entombment, with the Virgin embracing her Son's body for the last time, the Descent into Limbo represented by the yawning jaws of the traditional monster of the mystery plays, from which, along with the Just dazzled by the divine light, a typically mediaeval devil is escaping. The sequence comes to a tranquil close with Christ's apparition to Mary Magdalen. Throughout this composition

the linear arabesque is wonderfully expressive without ever lapsing into the extravagances one sometimes sees in the art of the North; it accords with the tradition of the Paris school of craftsmen working for the royal court. In fact this altar-hanging was certainly commissioned by the king himself, since on either side of the central panel King Charles V and his wife Jeanne de Bourbon are shown in profile, kneeling, with their hands raised in prayer. The artist has been at pains to make the faces lifelike, there is much delicacy in the highly skillful drawing, and the figures have all the naturalness of the statues of the monarchs in the Louvre.

If further proof were needed that the order for this work came from the king, this would be furnished by the royal monogram in the border; its date is probably 1375 or thereabouts, certainly before 1378, the year of the queen's death. We learn from the treasury accounts that similar decorations were made for the royal chapels by Girard d'Orléans, who died in 1361; the artist with whom we are here concerned, doubtless his successor, obviously kept to an ancient tradition in his treatment of the architectural setting, which is in the spirit of the Psalter of Saint Louis; whereas his care for visual truth and the tragic atmosphere he has created for these scenes of the Passion strike a wholly new, dramatic note.

The only extant work which invites comparison with the *Parement de Narbonne* is a silk mitre decorated with grisailles (in the Musée de Cluny); true, there are hosts of contemporary miniatures, but since their colors have long since disappeared, no comparison with them is feasible.

There seemed indeed a danger that the art of illumination was defeating its own ends and might soon become extinct in France. Happily it was now reinvigorated by an infusion of new blood from a foreign source, uncontaminated by the fashions of the day. This was the work of a group of Flemish artists drawn to Paris both by the prestige of the city as an art center and by the prospect of lucrative commissions. Thus the French miniature, which had seemed to be lapsing into sterile mannerism, was given a new lease of life, while line drawing pure and simple took its own path, leading up in due course to the invention of line-engraving.

ITALIAN PAINTERS
OF THE GOTHIC AGE

GIOTTO: A RE-APPRAISAL OF THE VISIBLE WORLD

DUCCIO, REFORMER OF TRADITION — SIMONE MARTINI AND PURE FORM

PIETRO AND AMBROGIO LORENZETTI

NEW TRENDS IN FLORENCE AND NORTH ITALY

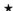

TEXT BY CESARE GNUDI

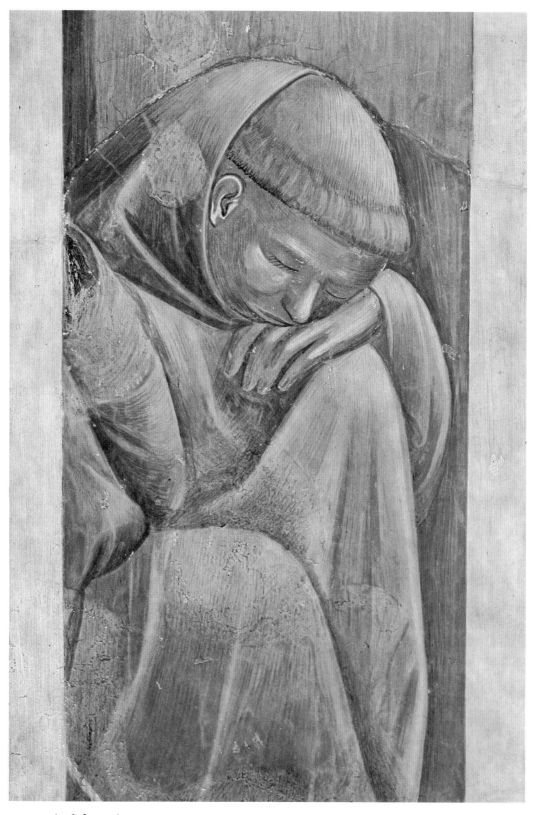

GIOTTO (1267?-1337). THE VISION OF THE BURNING CHARIOT, DETAIL. FRESCO, BEFORE 1300.
UPPER CHURCH OF SAN FRANCESCO, ASSISI.

ITALIAN PAINTERS
OF THE GOTHIC AGE

WHAT precisely were the links between 14th-century Italian painting and the culture of the European continent as a whole at the time when that culture, after growing pains extending over many centuries, had reached the phase of maturity and wide diffusion commonly described as the Gothic Age? The difficulty we find in answering this question is largely due to the fact that the art of 14th-century Italy had such vast historical importance, it was a phenomenon so singular and complex both in its inception and in its evolution that we are tempted to regard it as an independent, local manifestation, uninfluenced by contacts with the outer world. Stress has been laid, and rightly laid, on its absolute originality, on all that differentiated it from the art prevailing in other countries and, at a given moment, enabled it to dominate the European scene. True, it has never been denied that there were affinities between the art of the Trecento and the ideology of mediaeval neo-Latin civilization in general. But most writers on the subject have confined themselves to dealing with special cases in which these interrelations were particularly conspicuous. None the less we are liable to misunderstand their true nature if we neglect the general pattern into which they fall. Indeed a study of the historical background can but heighten our appreciation of the creative genius of the Italian artists.

In the 14th century representative art was in high favor in Italy, and it developed on quite original lines, often noticeably different from the forms of art prevailing in the rest of Europe. Yet even when, at the close of the 13th century, Giotto's new vision won the day so decisively that one is inclined to speak of a clean-cut break with the past, its point of departure was the rich cultural heritage of the neo-Latin western world. The truth is that a sort of osmosis between the various national cultures, then beginning to assume distinctive forms though keeping in close touch with each other, was taking place, and there was a constant tendency to pool their several discoveries. To this was due the development of a common idiom, that *lingua franca* obtaining in widely scattered parts of Europe which is known today as the "International Gothic Style." During this period the great art culture of the Middle Ages was dying out, while the first intimations of a new era were emerging in Italy and Flanders.

Though Giotto's art is often held to be diametrically opposed to all that Gothic culture stood for, it is impossible to appreciate its wonderful originality and the dramatic novelty of its conceptions if we isolate it from the main stream of that culture

or regard Giotto as being in conflict with his age. For this would be tantamount to asserting that the greatest artist of the period deliberately ignored its most vital manifestations and the new forces stirring in the world around him.

While there is no denying the originality of the 13th-century Italian architects and the great Pisan sculptors, we are bound to recognize their debt to French Gothic. During this period a vast spiritual renaissance, a new humanism, was liberating men's minds from the burdensome tradition of the Middle Ages and the cult of Byzantine abstractionism, and gradually pointing the way to direct and friendlier intercourse with the world of reality. Aside from those stylistic particularities—the "pointed" style, the linear style and so forth—which obviously characterize the Gothic phase of this early renaissance, what strikes us most is its urge towards a wider freedom, the achievement of an intenser spiritual life enabling men to view perceptible reality in a fresh light. The makers of the great French cathedrals went about their tasks with a joyous sense of new-won liberty; life was seen steadily and whole, and Space was no longer a prison-house but opened vistas on infinity. Thus at long last men began to feel in tune with the world of nature, to find in it a kindred spirit, and artists gave full expression to this new delight in "all things great and small."

That special attitude to reality which we instinctively associate with the term "Gothic" was basic to Giotto's art as manifested in the Upper Church of San Francesco at Assisi. For the almost exuberant emotion of these frescos, the freedom of their renderings of space and light, and the artist's markedly psychological approach to his various subjects were, in fact, characteristic of Giotto's new way of seeing the world. They were so to speak his raw material, which in the crucible of his genius was given well-defined and meaningful, often wholly novel form.

This will to organize, to harmonize and to canalize within pre-determined limits the spate of artistic inspiration had had precedents in Italy, notably in architecture, in the work of Nicola Pisano and Arnolfo di Cambio. Here we have hints of the course to follow if we wish to trace Giotto's lineage, to avoid regarding his art as rootless, and ignoring the historical soil which nurtured it and enabled it to flower. Like Dante's, Giotto's world is so vast that we can explore it in all directions without ever coming to its end or exhausting all its varied aspects. His indebtedness to the art traditions of Rome and Florence, his links with Cimabue and Pietro Cavallini are common knowledge. To the former artist (whose pupil he may have been) he owed the power of his drawing, the plastic vitality and dramatic tension of his creations; to the latter, the harmonious gravity, the almost statuesque quality of figures composed in terms of a classical rhythm. Yet in Giotto's art there was a new forcefulness, frankly at odds with Cimabue's handling of his subjects, and this it was that enabled him to break through the limitations of Roman classicism, and to persuade even Cavallini to follow in his footsteps. We are, however, apt to overlook the fact that Giotto's "modernism" and his innovations fall into line with the general evolution of Italian Gothic under its more progressive aspects. Thus there is common ground between him and the Assisan architect, Nicola and Giovanni Pisano and Arnolfo di Cambio, though these men belonged to an

earlier generation. They employed the same language and could, so to speak, exchange ideas. Between Cimabue and Giotto, however, there was an unbridgeable gulf, and, paradoxically enough, it was from the conflict between the strong personalities of these two great artists that the new manner of Italian art, indeed its unity, derived.

Nothing short of a miracle was needed for the abrupt transition from Cimabue's mediaeval Latinism—vitalized though it was by the remarkable emotive drive and the new vigor he brought to it—to Giotto's *dolce stil novo*, his serene mastery of an unprecedented realism and the all-embracing humanity of his vision. Epoch-making discoveries of this order, changing as they do the whole course of art, charged with a new, compelling poetry and sponsoring a wholly novel apprehension of reality, tend to strike us as sudden revelations "out of the blue." Nevertheless we do well to assign to them a place in the historical process which has enabled them to fructify. Though the man of genius may seem to make a clean sweep of tradition and even cut the figure of an iconoclast, we always find, on closer scrutiny, that he has pondered over that tradition and reshaped it to his ends. In so doing he rejects all that is mere dead weight, void of contemporary significance, whilst taking over and metabolizing all its promising and vital elements.

Enriched by the lessons of a long historic past, Giotto's age was one of mature enlightenment—and Giotto knew quite well what he was after and what he was discarding. The same is true of Nicola Pisano and Dante, and the latter saw clearly how Giotto stood to Cimabue. While fully alive to the greatness of both artists, he regarded Cimabue as already of the past ("... *si che la fama di colui l'oscura*," Purgatorio, Canto XI), whereas he saw in Giotto a "modern," a helper in the task of building up the new culture both had set their hearts on. But it is certain that the sentiments and aspirations—in a word, the ideal—which led Giotto to his new vision of the world were not, so to speak, born of nothing. For it must not be forgotten that a general revival of culture was in progress throughout the western world; that implicit in the great Romanesque tradition, so persistent in Italy, was an interest in naturalistic detail and classical composition; that the early manifestations of the Gothic in France were prospering in an atmosphere of joyous fervor and enlightened understanding; that in Italy Gothic architecture was already displaying a fine sobriety and feeling for balance in its handling of space, an almost classical serenity. A case in point is the structure of the Upper Church of San Francesco at Assisi, built towards the middle of the 13th century; its lay-out might have been deliberately planned for Giotto's paintings.

Meanwhile that great sculptor Nicola Pisano was opening up a new world of art thanks to the maturity and plenitude of his vision. Even his earliest works at Lucca and Pisa break with mediaeval tradition and are inspired by a new humanism, born in a Gothic climate yet impregnated with the classical spirit. We can trace the evolution of his genius, step by step, from the pulpit in Siena Cathedral to the Fountain at Perugia. Whereas the earlier work is unequivocally Gothic at its freest, most exuberant, the second shows a more refined artistry and the new emotions, naturalistic touches, are integrated into an harmonious, well-balanced whole.

These works, in fact, illustrate the contemporary developments of Italian art. Some of the scenes carved on the Fountain—those which most certainly are by Nicola's hand—foreshadow the rhythmical arrangement of space that we find in Giotto's frescos and in Andrea Pisano's reliefs in the Campanile of Santa Maria del Fiore at Florence.

The relations between Giotto's art and that of Arnolfo di Cambio are easier to trace. Shaped in the atmosphere of Pisan Gothic, Arnolfo was in some respects Giotto's precursor and his master, and both artists followed much the same path. Each worked in Rome and at Florence and between their artistic conceptions a friendly, fruitful interchange of ideas can be observed. The leading characteristics of Arnolfo's art provided the basic elements of Giotto's compositional schemes: notably the notion of a precise organization of space and emphasis on monumental form.

Another point worth noting is that Giotto's earliest works were contemporaneous with those of Giovanni Pisano at Siena and that at this time Giovanni's art was at its splendid best. In the façade of the Cathedral of Siena we have an ensemble of architecture and sculpture in which the influence of French Gothic makes itself more clearly felt than in any other Italian edifice; and its date synchronizes with that of Giotto's great fresco cycle at Assisi. Despite differences of character and means of expression, both works derive from similar artistic conceptions and both alike point the way to the new art culture then coming to birth. We need only call to mind the "Mary" (sister of Moses), the "Habakkuk" and the "Plato" at Siena, statues which hold their own in space with such consummate dignity and ease. When we compare these with any contemporary work by Cimabue, we have no doubt whence came the impulse leading Giotto to break with the traditional pictorial art of the Middle Ages. Nor can we call to mind any artists prior to Giotto other than the Pisans who showed so keen a desire to express human emotions, and bring out to the full their characteristics and contrasts. For Giovanni Pisano imparted a peculiar intensity to the psychological interpretation of human personality and this typically Gothic approach, in a new form, was to be one of the leading features of Giotto's art. Many were the affinities between these two great creators and we are fortunate indeed to be able to see the painter's and the sculptor's work side by side at Padua, in the Scrovegni Chapel. Except for a difference in their poetic accent the similarity between the scenes on the walls and the sculptures of Giovanni Pisano is not to be denied. Pisano's group of the Virgin and Child gazing at each other with a sad surmise has the form of a cylindrical structure, rising in massive power, and this soaring movement is carried on by the alternating rhythm of the angels. Yet when we look up towards the frescos we cannot fail to see the underlying spiritual communion between the carved Virgin and her who, under Giotto's brush, lives out her tragic human destiny. Noteworthy, too, in this context, is the attitude of Giotto's Virgin, instinct with grave emotion, in the *Annunciation* and the *Visitation,* and the fixity with which she gazes at her Son's cradle in the *Nativity* and, again, her faraway look in *The Flight into Egypt.*

Thus it is easier to trace the lineage of Giotto's Assisi frescos if we take into account the part played by the Pisan artists in the contemporary revival of art in

Italy. The St Francis sequence is without doubt the culminating point of Giotto's naturalism and, by the same token, of the Gothic element in his art. In these frescos his unique, one might almost say clairvoyant understanding of the springs of human thought and conduct finds expression in an amazing wealth of themes, an inventiveness that never flags. Taking over Gothic naturalism, Giotto translated it into a balanced, wholly Latin art form. Arnolfo di Cambio and the Pisanos had already done the same for the sister art. This poetic, spiritualizing trend is apparent in several notable works; in the pulpit at Pisa and, still more clearly, in that of Siena, in which Nicola and Giovanni gave full play to their dramatic and inventive powers, and show such insight into the psychological content of their subjects (we have particularly in mind *The Crucifixion*, and *The Elect* and *The Lost*); in the Arca di San Domenico at Bologna; in certain outstanding works by Arnolfo di Cambio, in the disciplined dramatic tension of the episode of *The Story of the Rule* and that of *Saint Reginald of Orléans*; in the statues by Giovanni Pisano for the Fountain of Perugia; and, lastly, in those made by Arnolfo for the tomb of Cardinal de Braye in the church of San Domenico at Orvieto. These works, like Giotto's art, so fully integrated and so crystal-clear, open vistas on Dante's vast horizons and the *dolce stil novo*.

The revival of humanism which took place in this memorable phase of European history, and did so much to shape it, transformed and amplified all the cultural traditions of the Middle Ages. It was indeed nothing short of a Renaissance that made its way with gathering strength in the art and poetry of the time (its influence on the thought of the age came later); and it is no less evident in the finest works of Boccaccio and Petrarch than in those of Simone Martini and the Lorenzetti brothers. But it never lost touch with the Romance cultures, and in particular the French, which indeed had fructified it at its inception. Some have thought that Giotto's art cannot properly be described as "Gothic" since it is *sui generis* and eludes any narrow definition; nevertheless it had links with the Gothic tradition—which indeed played a basic part in the formation of his genius. The common practice of regarding Giotto as an adversary of Gothic art is, to my mind, due to misreading of the data.

French Gothic found its earliest expression in stained glass and illuminations, whose spirit is usually far removed from that of the architecture and sculpture of the period, which reflect but one aspect of its many-sided culture, if an important one. In the form of ivories and miniatures it became rapidly and widely known in Europe; echoes of it are to be found in Italy herself. French Gothic painting was an aristocratic, courtly art, of elegant, sometimes indeed over-sophisticated forms; and its constant quest of poetic or fantastical effects and subtle harmonies of line and color often gives it a curiously unreal quality, the glamour of a dreamworld. (In this respect it fell in line with almost all the poetry and prose of the period.) Architecture and monumental sculpture, on the other hand, gave expression to the religious aspirations and emotions of contemporary man in a far more vigorous and direct manner. Indeed Gothic culture is not to be identified with any one of its many manifestations, nor can the style of any of these be singled out as typical. If Gothic is to be defined solely

by its line, the term is obviously inapplicable to Giotto and the Pisan sculptors—and indeed to many French works of the period. It should therefore be given its widest application, as in fact is done by the majority of modern historians. Thus the word "Gothic" describes a whole phase of civilization in which a great variety of stylistic currents can be traced, each following its own course, though all have certain common trends and likewise, on the spiritual plane, a certain kinship. It is therefore a mistake, or at best a half truth, to set up Giotto's painting against the linear style of the French illuminators and to regard them as basically incompatible. Any such view is found to be untenable when we remember that Giotto's œuvre began at Assisi with a fresco decoration closely linked up with the architecture of the church and ended at the Cathedral of Florence with the decoration of the Campanile, designed by him and executed in close collaboration with Andrea Pisano, an artist whose association with transalpine Gothic art has never been questioned.

The aristocratic side of Gothic art to which reference has been made took effect in Italy from the end of the 13th century on, no doubt as a consequence of the importation of French illuminated manuscripts. Its influence can be seen in Italian miniatures, in the highly refined art of Duccio and still more clearly in the work of Simone Martini. This last-named artist, while taking over the formal elegance of "court" Gothic, transformed it and gave it a more human quality, in the spirit of the art of Giotto and the monumental sculpture of the age. The Lorenzetti brothers carried this tendency still farther, and it indeed set the tone of all Trecento Italian art. There is no basic antagonism between the Giottesque handling of space and form and the line-and-color composition of the French and Sienese painters; on the contrary these procedures interlock to start with—if subsequently they diverge. Indeed we find them present in sharply contrasting forms of art, e.g. that of Giotto and the French illuminated manuscripts, that of the frescos in the Scrovegni Chapel and Simone's *Annunciation*. But Giotto's art is not to be summed up in the Padua frescos any more than that of Simone Martini in his *Annunciation*. The strictly enclosed space of Padua opens out at Santa Croce on wider prospects, while in the Assisi frescos Simone Martini indulges in ampler, more elaborately articulated renderings of space. Similarly, under the influence of the Lorenzettis, the Sienese achieved a complex form of art in which seemingly contradictory trends co-existed side by side. Starting out from Tuscan painting, North Italian art assimilated the discoveries made beyond the Alps and the way was open for the diffusion at the end of the century of what is known as the "International Gothic Style." This took its rise in France, when Simone Martini settled at Avignon and direct contacts were thus established between French and Sienese painting. Yet even when the two conflicting styles seem to coalesce, the distinction between their basic trends remains perceptible. Throughout the century there was a tendency to widen Giotto's classical, formal synthesis by incorporating new elements, adding realistic touches and stressing anecdotal details. But the balanced, classical approach sponsored by Giotto also bore fruit; it prepared the way for that new intellectual and spiritual *Weltanschauung* which we associate with the Renaissance.

GIOTTO: A RE-APPRAISAL OF THE VISIBLE WORLD

Even if new facts regarding Giotto's early works are brought to light we may be sure the Assisi frescos will hold their place as the earliest revelation of the new form of art he brought into the world. For so convincing is the sense of living actuality conveyed by them, so finely classical the serenity with which the emotions they express are ordered and co-ordinated, that their effect on us today is as compelling as it must have been for those who first beheld them. Like Dante's *Divine Comedy* Giotto's painting contained within itself all the modes of expression of the age that was coming to birth. A new world was revealed at Assisi and these frescos are an open book which we can read and re-read with ever fresh delight. That new world owed its emergence not only to the genius of two great artists, Cimabue and Giotto, but also to the fortunate encounter of the latter with the unknown architect who, in the Upper Church of Assisi, achieved a spatial harmony unsurpassed in Italian Gothic architecture. This harmony is not immaterial like that of the Sainte-Chapelle in Paris, with its heaven-aspiring rhythms and shimmering light; it unfolds itself in space, in depth. Its rhythm is measured, set by the wide bays whose orderly recession towards the haze of light at the far end of the church creates an evenly distributed space; an environment in which mediaeval man could feel at peace, at last, with the world around him.

A broad band intersected by clusters of half-pillars runs all along the walls, extending slightly forward so as to bring into prominence the picture sequence based on sacred themes, in particular those relating to the life of St Francis whom the architect had certainly intended to figure in the great nave. The painters started work in or about 1280. All the decorations of the transept and apse were made by Cimabue and his pupils. Though there is no question of the power and the poetic quality of these frescos, which are often of the highest order, one feels that their general conception is out of keeping with the architectural setting. Gigantic forms, almost abstract in their extravagant dimensions, they throng the walls, obliterating the tranquil rhythm of the architecture, crowding and clogging as it were the open spaces. Inset though they are in panels, scenes and figures seem to advance in serried masses on the beholder; indeed the effect of this dramatic onrush of strongly plastic forms is almost overpowering. The figures, particularly, give an impression of monopolizing all the space available with their huge bulk and sweeping gestures. Encompassed by a plethora of ornamentation and a luxuriance that seem the aftermath of some barbarian age, they shatter the calm of the Gothic church and convert it into a place of menacing phantasmagoria, an apocalyptic vision.

If Cimabue, who had premonitions of the new art world that was coming into being but failed to see that it was already taking form, had painted his dramatic scenes not only in the dimly lit choir and transept but on the fully illuminated walls of the nave as well, the whole conception of that man of lofty vision, the unknown architect, would have been frustrated; the measured rhythm of the proportions, the balanced distribution of filled and empty spaces, would have been shattered by the violence and excitement

of Cimabue's paintings. And, worse still, the miracle we owe to Giotto could not have eventuated. For he, Giotto, understood what the architect intended, and, following his lead and supplementing it with his creative vision, conjured up a picture cycle in perfect keeping with the architect's conception of the distribution of the wall space.

Paintings made by Cimabue's pupils and the Roman school figure on the upper register of the nave from the transept to the penultimate bay. It is only when after *Isaac's Sacrifice* and below the gorgeous, multicolored angels (still of Byzantine inspiration) in the upper lunettes, we come to the two final scenes, *The Life of Isaac* and *The Life of Joseph*, that we feel the architect has at last found a painter after his own heart.

Let us begin by studying the composition of the room in which the patriarch is lying, in the concluding scenes of the "Isaac" sequence. It is quite evident that there has been an attempt at rendering perspective. The picture space is clearly divided up into recessive planes, the figures move naturally and are at ease within their setting, everything falls into place. The human and dramatic aspects of the scene are stated with perfect clarity; story-telling elements, plastic and spatial structure are handled in the same spirit. Perhaps no other painting at Assisi comes nearer the art of Giotto's maturity; indeed the poetic vision of reality characteristic of his last phase is present here in its entirety.

In the scenes of the Life of Joseph, like those facing them, the Life of Christ, and those of the Life of St Francis on the lower register, a new ferment of discovery and an urge to innovation make their presence felt. Motifs and themes of a wholly new order seem to well up pell-mell under the artist's brush; forms become more dynamic and less stable, and this mobility sets up a new relation between them with the outer world. Whereas, in Isaac's room, the light was focused so as to give the colors beyond the white margin of the architectural foreground their maximum intensity, in these other scenes we have an ambient light flooding the zones of color, pink rocks and multicolored walls of cities with foreshortened doors and jutting balconies seen in perspective; though occasionally there are passages of vivid light contrasting with the rest as in that stupendous *Deposition*. It is significant that Giotto's *Crucifixion* in Santa Maria Novella at Florence, with its poignant yet restrained emotion and dramatic power, belongs to the same period as these frescos.

Besides the final scenes of the Life of Christ which are by common consent ascribed to Giotto, should we regard *The Life of Joseph* and the last two scenes of *The Life of Isaac* as his work? Such is the quality of these frescos that one is inclined to surmise that Giotto's style was subject to fluctuations—which would explain the special handling of space and landscape that we find here. It must be remembered that, at this phase, Giotto had not yet wholly broken with the art traditions of his formative years. Yet even if we ascribe to some other artist the "Isaac" frescos, it is undeniable that their classicism and their affinities with the work of Cavallini and the Roman School are thoroughly in the Giotto spirit. In short we can feel fairly confident that the so-called "Master of Isaac" was either a painter working in close touch with Giotto or else Giotto himself, during the phase when Roman classicism, one of the ruling influences of his youth and

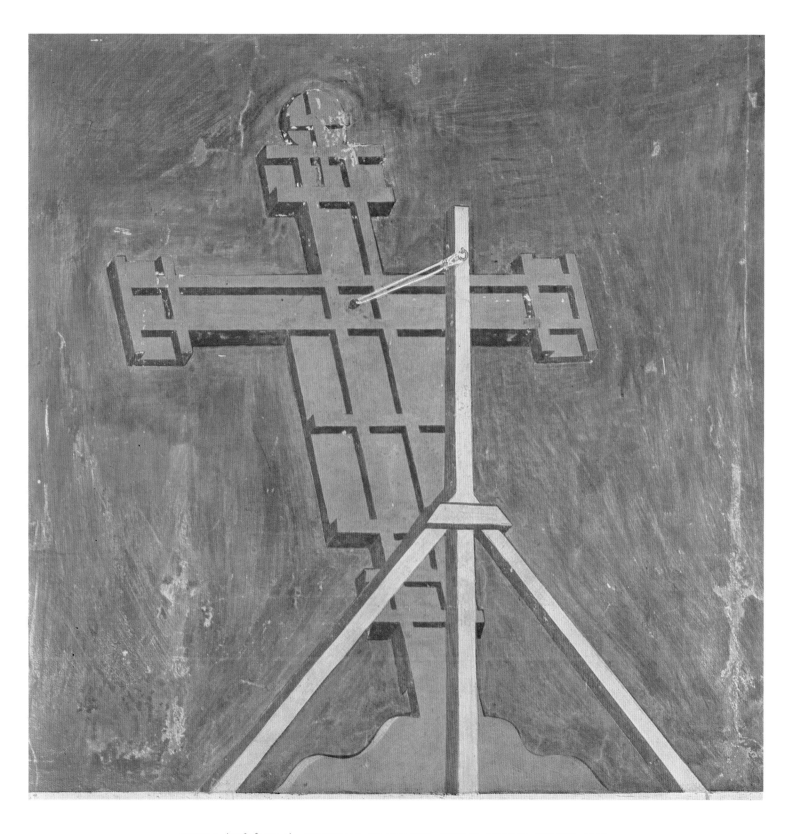

GIOTTO (1267?-1337). CHRISTMAS AT GRECCIO, DETAIL. FRESCO, BEFORE 1300.
UPPER CHURCH OF SAN FRANCESCO, ASSISI.

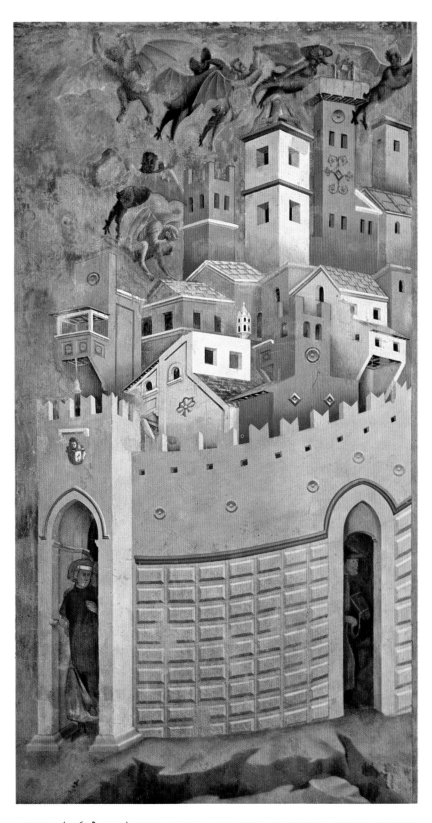

GIOTTO (1267?-1337). THE DEVILS CAST OUT OF AREZZO, DETAIL. FRESCO, BEFORE 1300. UPPER CHURCH OF SAN FRANCESCO, ASSISI.

indeed basic to the world of high imagination he was to build up at the apogee of his career, predominated in his art. In any case there can be no question of isolating these scenes from those on the lower tier of this same wall which celebrate the life of St Francis.

True, there are passages of an inferior order in these frescos: doubtless the work of underlings who in painting the architectural backgrounds (designed, however, by Giotto) failed to achieve those subtle light effects which delight us in the scenes painted by the master himself. Nevertheless these minor defects need not impair our admiration of the rare poetic charm and originality of the entire Franciscan cycle. The creative power of these pictures is particularly noticeable in the painter's skillful handling of space and the plastic values he imparts to his renderings of dramatic action. This theme, the life of St Francis, was very near and dear to his heart. Already the personality of that devout and lovable man was taking on a legendary glamour and Giotto had a wealth of iconographic material to draw on.

These frescos were made in the first flush of Giotto's discovery of a new way of dealing with the facts of visual experience and we can sense his rapturous enthusiasm. First of his innovations was the arrangement of his scenes. The wall space is divided into twenty-eight big panels, separated from each other by a painted motif of spiral columns starting from a plinth and topped by an architrave upheld by bracket consoles shown in perspective. The scenes thus framed open on vistas of buildings, towns or landscapes, varying from panel to panel and balancing the architectural disposition of

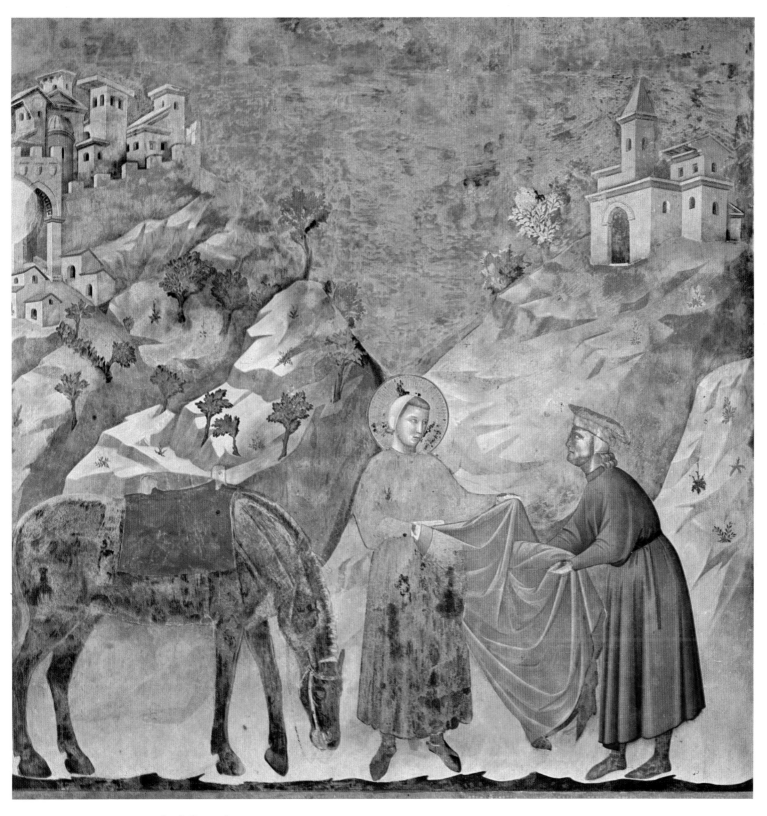

GIOTTO (1267?-1337). ST FRANCIS GIVING HIS MANTLE TO A POOR MAN. FRESCO, BEFORE 1300.
UPPER CHURCH OF SAN FRANCESCO, ASSISI.

the great nave. In *St Francis giving his Mantle to a Poor Man* we see a hillside with a group of houses on its summit, the houses of Assisi. A spirit of vast serenity, of paradisal peace, broods on this landscape, which harmonizes with the two figures in the foreground. In *St Francis renouncing the World* faces are more strongly characterized and emotions conveyed by gestures and expressions more subtly and fully rendered.

This is, in fact, Giotto's most "Gothic" phase; he obviously enjoys meticulous description, sometimes lingering over details, stressing or expanding the setting of a scene. But he is no less interested in revealing character. Clearly he has not yet achieved the classically balanced composition of the Padua frescos, in which one feels that everything is inevitable, it *had* to be thus and not otherwise, and colors, forms and tonal values are integrated into an harmonious unity. At Assisi his quest of a new vision is more apparent; here we can see him experimenting with new methods scene by scene, almost day by day, making unexpected *trouvailles* and incorporating them in his art. And such were Giotto's powers of organization that under his brush these diverse elements fell instantly into place within an all-including, logically ordered pattern. Yet so lively and spontaneous is the effect of these compositions that we feel he invents his own rules in the very act of creation, tests them out as he goes along and applies them to the work in progress.

We see him doing this in his depiction of the room (in which the perspective representation of space recalls that in the scenes of the Life of Isaac) where we see the pope, a heavily built figure almost like a statue by Arnolfo di Cambio, giving his approval to the Rule of the Order; here the impression of spatial depth is conveyed in a highly original manner.

Even the most insignificant details acquire, under Giotto's brush, a poignant human interest; an instance is that group of tiny figures, the sleeping Franciscans, in *The Vision of the Burning Chariot*. Noteworthy, too, is that amazing row of lofty chairs suspended as it were in empty space in *The Vision of Brother Pacifico* or, again, the presentation of the city in *The Devils cast out of Arezzo*, in which the orderly recession of neatly built houses contrasts so effectively with the disordered flight of the panic-stricken demons. In *Christmas at Greccio* people streaming in from all directions fill up the confined space within the precincts of the choir with its decorations in cosmati work, while in the middle distance, bathed in vivid light, the great Cross rises, rooted in a massive substructure and fastened with a white rope to a wooden stanchion set in a pyramidal base. This amazingly naturalistic detail, in which each element of the structure is indicated with geometric precision, might be taken as a symbol, or a résumé of the new conception of space inaugurated by Giotto. A conception which, at its very birth, seems so mature, so fully integrated, that one might well imagine there were centuries of research behind it. In *The Death of the Nobleman of Celano* a big projecting eave, sheltering the communion table, juts forward from the roof towards us and the dramatic tension of this scene is implemented by its striking composition. In the adjoining panel we are shown a room built in the simple, pellucid Gothic style. St Francis is preaching to Pope Honorius III, and on the faces of the group of prelates seated in a

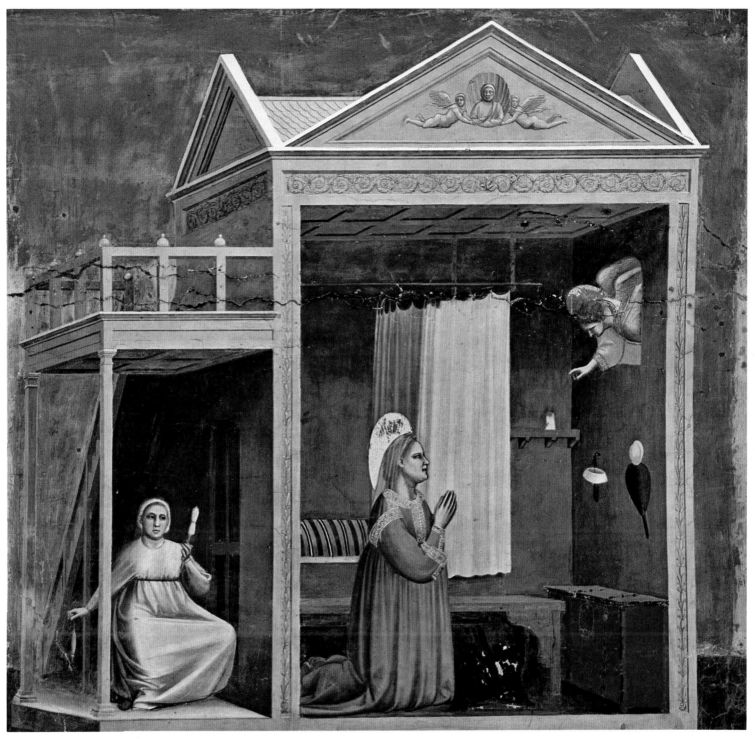

GIOTTO (1267?-1337). THE ANNUNCIATION TO ST ANNE. FRESCO, 1304-1306. SCROVEGNI CHAPEL, PADUA.

half circle we can plainly read their reactions to the sermon, and even their respective temperaments. Some are deeply moved, some humbly acquiescent, others obviously listening with only half an ear. The slender columns of the foreground fall in line with

those which, painted on the walls, demarcate the scenes. The upper part of the room is garnished with gleaming marble, with motifs inset in marquetry work, and the foreground bathed in a gentler light, faintly tinged with blue. The lay-out of this room is governed by a smoothly flowing rhythm and its atmosphere is one of tranquil meditation. In *The Death of St Francis* we find an innovation, the scene being treated as if viewed from above. The Brothers in the extreme foreground kneeling before the dead saint's body are seen from behind and their forms foreshortened; next comes a wide semicircle of monks, fanning out on either side of the body. In all the scenes depicting

GIOTTO (1267?-1337). THE WEDDING PROCESSION OF MARY. FRESCO, 1304-1306.
SCROVEGNI CHAPEL, PADUA.

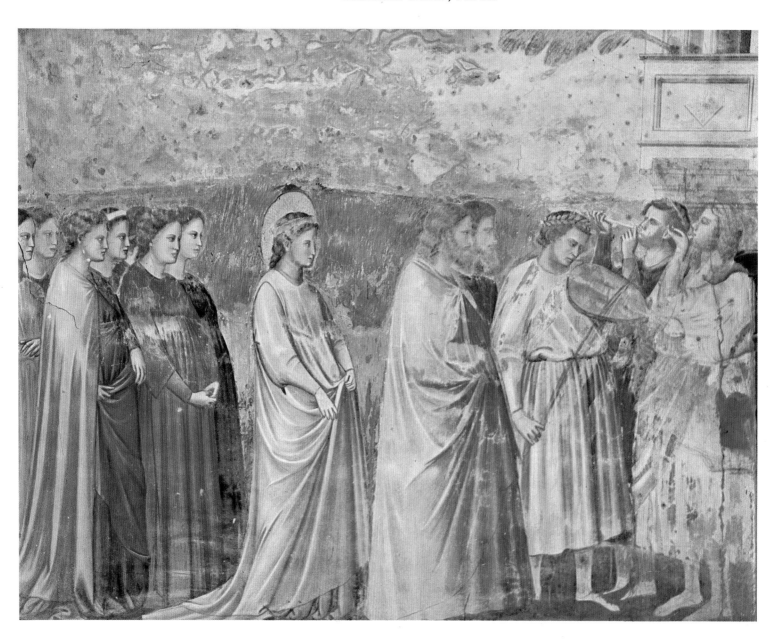

62

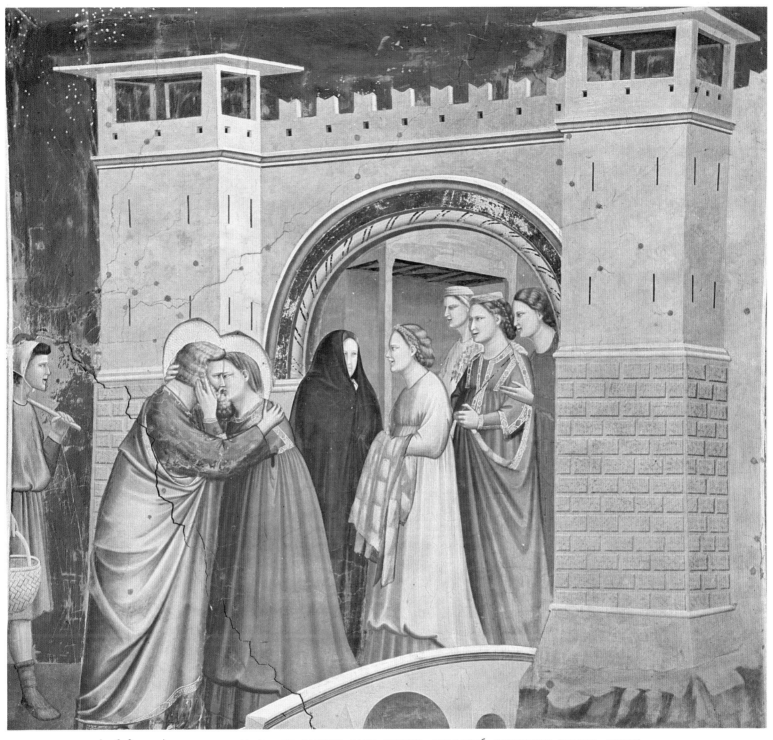

GIOTTO (1267?-1337). THE MEETING AT THE GOLDEN GATE. FRESCO, 1304-1306. SCROVEGNI CHAPEL, PADUA.

the death and translation of St Francis gestures and attitudes are wonderfully natural. In *Ser Geronimo doubting the Miracle of the Stigmata* the painter brings off that justly renowned *tour de force* of representing the pictures of the Cross, the Virgin and an angel

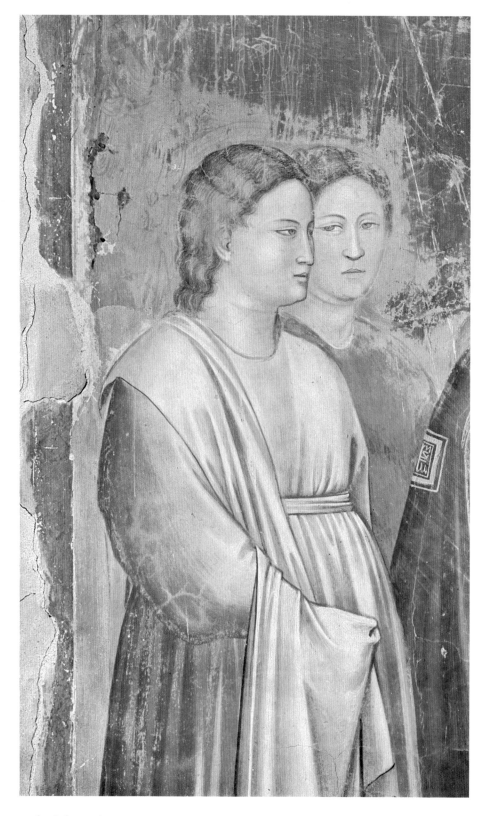

GIOTTO (1267?-1337). THE MEETING OF MARY AND ELIZABETH, DETAIL. FRESCO, 1304-1306.
SCROVEGNI CHAPEL, PADUA.

suspended above the iconostasis, behind the lamps hanging from an unseen ceiling, in true perspective, so that they seem to be actually tilting forward toward the beholder.

The Assisi cycle was completed between 1290 and 1300; some years later (1304-1306) Giotto painted the Arena Chapel at Padua, which once formed part of the Scrovegni Palace. Whereas the Assisi frescos reflect the painter's first fine rapture at the discovery of a new world, the Padua paintings are more tightly knit and the composition almost scientifically balanced. Framed in simulated architectural settings, the scenes of the life of St Francis illustrate Giotto's advance towards a new rendering of space, peculiar to himself. The works at Padua are not functional to the structure of the Chapel, none the less the ensemble is more rigorously ordered within itself. In fact the narrative sequence is more clearly concatenated, progressing without any break of continuity, the result being a quite amazing unity, due solely to the power of tectonic form. Here indeed we have something almost unique in the history of art: a veritable epic poem couched in terms of plastic form and color, vitalized by an inspiration that never flags. And it is the "meter," the rhythmic pattern the artist has imparted to his vision, that defines the structure of this work. It is not until we come to the arch which opens on the characteristically Gothic apse that a direct connection between the painting and the architecture of the chapel makes itself felt, notably in the decoration of the piers from which the arch arises, with two arcaded rooms painted in perspective, balancing the structure of the arch itself. In dealing with the side walls Giotto gave no thought to problems of this order, but confined himself to partitioning off the wall-space for his thirty-four panels by means of decorated bands. Majestically the sacred epic unfolds itself scene by scene and the range of emotional experience covered by it is so vast that we would say that almost every conceivable human sentiment, even the most trivial, is included, yet without any impairment of the over-all rhythm. The effect on the spectator of this unbroken succession of scenes, marching rank on rank, each a complete world in itself, is almost overwhelming.

The fresco sequence starts off with a sort of prelude: the stories of Anna and Joachim, on the upper tier. The leading theme, the one which persistently recurs through the entire sequence, is "stated" here fully and unequivocally. It is, quite simply, the human element; in other words, the representation of Man as he really is, and not, in the manner of Antiquity, under the aspect of some mythological or heroic personage. Man, as Giotto shows him, is a responsible moral being, capable of both the humblest and the loftiest emotions; and this great painter gives us the impression of having explored, as none before him, the secret places of the heart. To the gestures of his figures he imparts much plastic vigor, but without the least trace of over-emphasis or histrionics. The structural lay-outs of these scenes are perhaps somewhat less diversified than those at Assisi, but what they lose in variety they gain in concision and absolute significance. The space-presentation, in fact, is highly simplified and closely co-ordinated with the gestures and actions of the figures.

The scenes of Joachim's "retreat" and his communings with nature are justly famous. Here, however, we would draw attention to *The Annunciation to St Anne* and

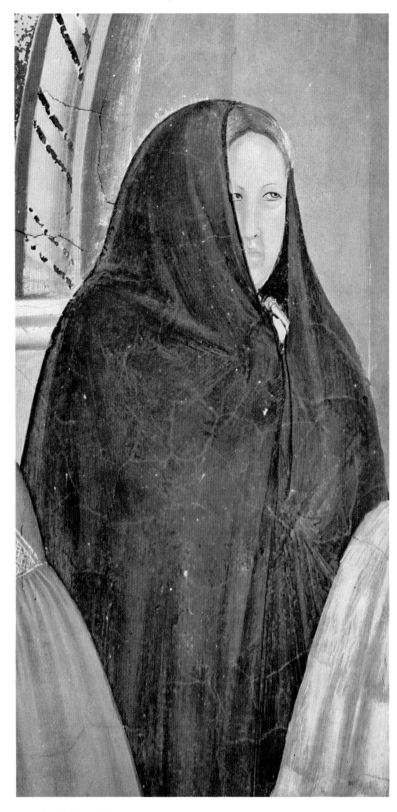

GIOTTO (1267?-1337). THE MEETING AT THE GOLDEN GATE, DETAIL. FRESCO,
1304-1306. SCROVEGNI CHAPEL, PADUA.

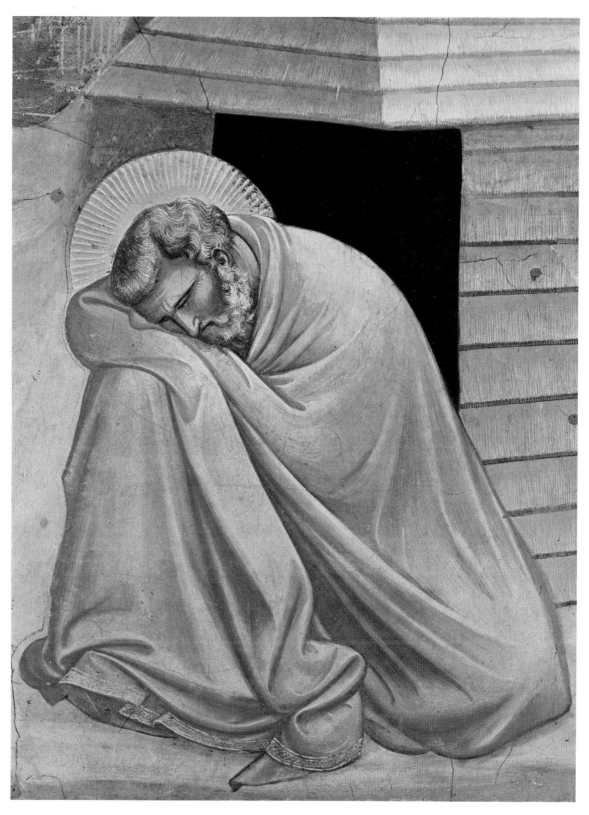

GIOTTO (1267?-1337). JOACHIM'S DREAM, DETAIL. FRESCO, 1304-1306.
SCROVEGNI CHAPEL, PADUA.

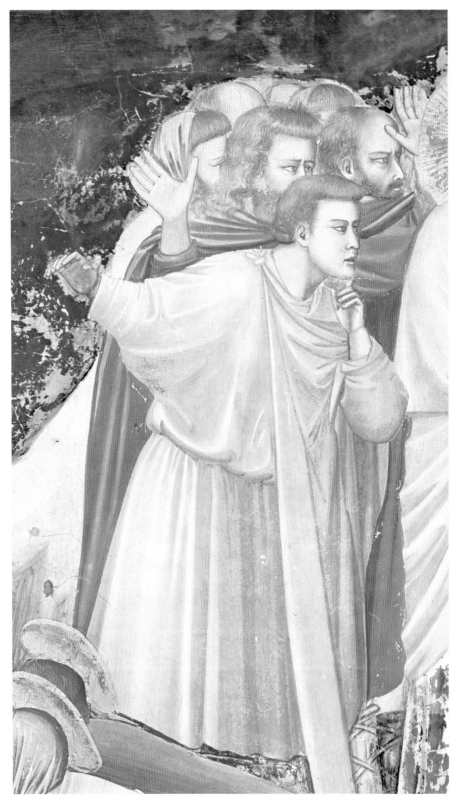

GIOTTO (1267?-1337). THE RESURRECTION OF LAZARUS, DETAIL. FRESCO, 1304-1306.
SCROVEGNI CHAPEL, PADUA.

particularly to the serving-woman going about her humble tasks; notable in this figure is its combination of noble dignity and vital truth, the former due to the plastic vigor of the body, the latter to the homely simplicity of the attitude. Indeed many of the figures in this sequence have that plastic power which we have already compared with Dante's handling of language, his gift of shaping sculptor-like with a few words the creatures of his imagination and bringing them to life by the sheer force of their verisimilitude. We see this sculpturesque quality in the scene of Joachim sleeping, an inert mass —form at its most static; or again in the pyramidal structure of the scene of Joachim and Anna embracing at the Golden Gate, a gesture so momentous in its consequences for mankind; though of this the elegant women following her have naturally no inkling, they have merely paused to gaze vaguely at the somber, heavily veiled form of the woman in the black mantle. Even more cogently than at Assisi these scenes bring home to us the fact that Giotto's spatial composition is determined by his figures and their attitudes; that indeed his whole pictorial architecture centers on the human form, architecture in the literal sense of the term being treated merely as its complement. Subsequently this compositional schema is developed and enriched, yet without in any way impairing the simplicity and vigor of its inner rhythms. But not all these figures are conceived in terms of dignity and a majestic tempo; some strike a gentler note. Thus *The Wedding Procession of Mary* is treated in a lighter vein and though its beauty has the gravity befitting a sacred theme, there is a lyrical quality that makes itself felt in a richer spatial harmony. So intense is the expressive power of certain scenes that we feel Giotto demonstrates in them a psychological insight and dramatic force unexcelled by any other painter, even the most "expressionist." Thus in *The Meeting of Mary and Elizabeth*, where the leading figures form a close-knit, architecturally ordered group, the deep emotion in the looks exchanged between them is somehow transmitted to two women standing outside the magic circle; they, too, seem lost in solemn thought. Similarly the colors, intense yet muted, are in perfect keeping with the hieratic dignity of the forms.

Such was the fervor Giotto brought to his renovation of the traditional motifs of the Gospel story and so intense the human feeling he imparted to them in his painting that we can easily understand why the effect of his art on his contemporaries was that of a spiritual liberation. His handling of scenes whose subject-matter called *per se* for dramatic treatment is of particular interest. Thus in *The Massacre of the Innocents* the poignancy of the scene is actually intensified by the artist's quite unsentimental handling of it. Boldly drawn figures stand out as if carved in stone, violent, brutal or despairing gestures are magnified beyond life-size but simplified as in Greek tragedy, and meanwhile King Herod on his balcony, aloof and elegant, gazes down at the carnage as if it were a game. No less dramatically impressive is *The Resurrection of Lazarus*. The painter has picked on that awe-inspiring moment when Christ bids the dead man, "Lazarus, come forth," and the various emotions of the bystanders are mirrored on their faces, from nervous apprehension to the reverent wonder of the young man who in a flash of revelation has known the speaker for what He truly is. This figure links up

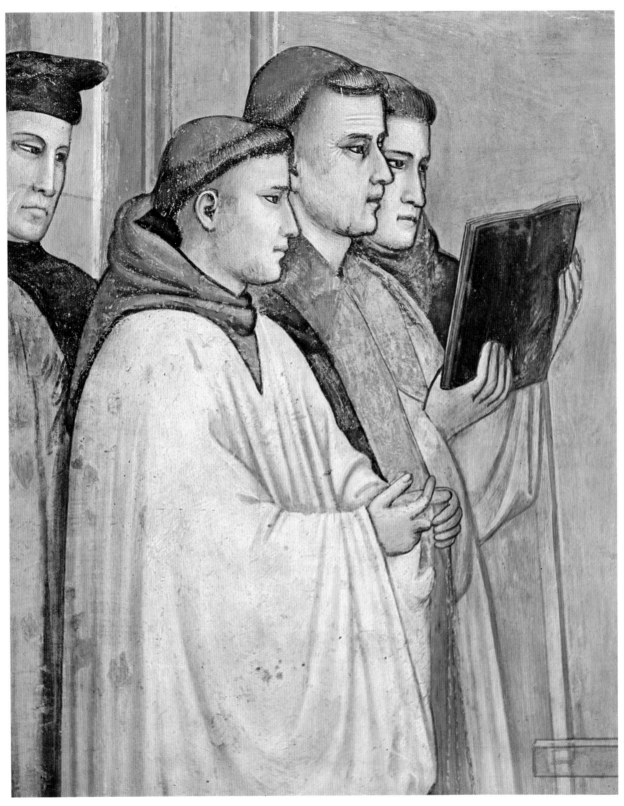

GIOTTO (1267?-1337). THE OBSEQUIES OF ST FRANCIS, DETAIL. FRESCO.
CHURCH OF SANTA CROCE, FLORENCE.

with some of the finest achievements of the following age, not only because of its strongly emotive realism but also in respect of its luminous, translucent colors. However, the prevailing tone of the Padua frescos is very different; colors are frank and usually almost cold; volumes are strongly opposed and stress is laid above all on the clash of emotions. The most high-pitched note is struck in those famous scenes of *The Kiss of Judas* and *The Deposition*. In a later phase, in the Bardi and Peruzzi chapels of the Santa Croce Church at Florence, Giotto takes to a looser form of modeling, calmer expression and a less emphatic rendering of plastic values. His conception of space, too, becomes more flexible, less absolute; in short he tends to relax the rather narrow limits within which he had circumscribed, during his middle years, the exuberantly "Gothic" inspiration of his youth. Within this looser framework the figures seem less sculptural, they move naturally, smoothly; compositions become spacious and the air plays more freely around the forms. Following the Paduan series, the Florentine frescos (unhappily in rather poor condition) suggest that Giotto's art has come full circle; that he is harking back to the "naturalism" of the paintings at Assisi. But, when we compare them, we can see how much ground has been covered in the interim. At Assisi Giotto makes no secret of the fact that he is trying out new methods of rendering space; that, in fact, this is an experimental phase. At Florence he has fully solved the problem; by way of natural, perfectly adjusted relations between objects he creates the sense of space. Flooding, throbbing light softens the modeling, attenuates the incidence of outlines and asperities of features. In the group of reading monks in *The Obsequies of St Francis* we are struck by the lifelikeness of the rendering, the simplicity and forthrightness of the gestures, and though the figures have a solemnity befitting the occasion, they are quite different from the monumental forms at Padua, so natural are the relations between figures, architecture, space and light. And this final discovery of Giotto's was destined to inspire the art of future generations.

Thus in the last analysis Giotto's art is seen to be a long, impassioned meditation on human reality; a reality he discovered thanks to an amazing power of intuition and sublimated by grace of his natural nobility of mind. He does not regard the lofty ideal he sets himself as a terminal point, but as an infinite horizon, with vistas opening on the ultimate significance and purport of man's life. Which is why, like Dante's, Giotto's vision of the world, though keeping within the limits of the Gothic culture of his day, was a starting-off point of the humanistic culture presently to arise.

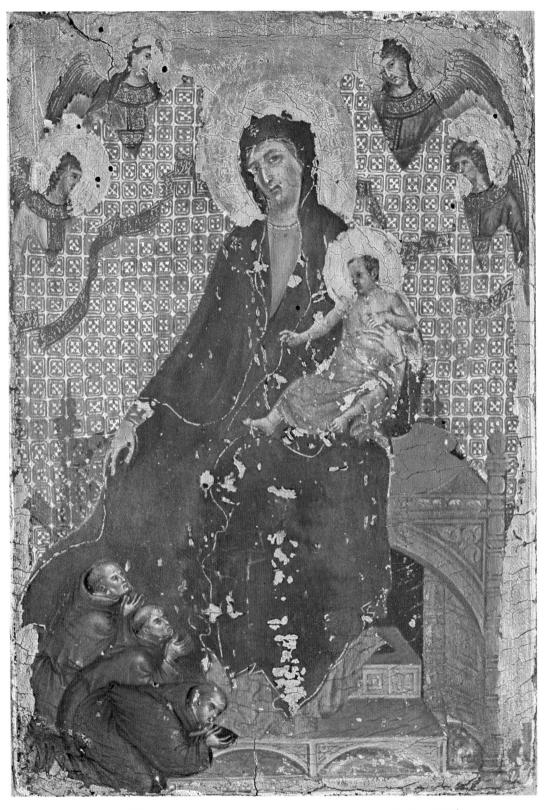

DUCCIO (?-1319). THE MADONNA OF THE FRANCISCANS. (9¼ × 6¼″)
PINACOTECA, SIENA.

DUCCIO, REFORMER OF TRADITION

Almost contemporary with Giotto was that great Sienese artist, Duccio di Buoninsegna. Vast and varied as was the range of his achievement, it is so to speak all of one piece and betrays no sign of any inner conflict or crisis. Nor when it appeared had it that aspect of a "sudden revelation," that well-nigh revolutionary quality which distinguished Giotto's art and made it instantly clear that he had broken with the art tradition of the Middle Ages. On the contrary, at first sight anyhow, Duccio gives the impression of deliberately following tradition and even of being immune from those vague yearnings which we sense in the work of Cimabue, who, though keeping within the traditional framework, glimpsed new possibilities. Nevertheless, even if he had no revolutionary ambitions, Duccio carried the art methods of his day many stages farther, vitalizing and developing them to such an extent as to renew and radically change them. But all this was done so gradually that at first sight his œuvre seems almost static; one may fail to realize that it was Duccio who brought the art traditions of the past into line with the new culture that was taking form. For, though Duccio took conventional themes and procedures as his starting-off point, he transposed, re-orchestrated them. His art is one of subtle nuances, exquisite melodies charged with almost endless overtones. There is nothing in it that jars, no striving for showy effects; all is delicately modulated, "precious" in the best sense of the term. Effortlessly he had mastered all that was best in Byzantine classicism, but he also kept his eyes open to the progressive elements of contemporary art, in particular the recent achievements of French Gothic painting, as revealed in the illuminated manuscripts which were now being imported into Italy and attracting much attention.

Thus in the art of Duccio we find no antagonism towards the past or towards the present. Under his brush the conflicts of taste, which inevitably developed in this momentous phase of the growth of western culture, were reconciled, integrated into an harmonious whole. His expression of the sacrosanct is always dignified and indeed hieratic, yet we find in it a subtle vibrancy, an indication of the new spirit stirring in the hearts of men. What he took from Gothic art was its conception of space, its relish for anecdotal detail, its accurate observation of reality. All these qualities are manifest even in his earliest works, which despite certain resemblances to the art of Cimabue (with whom he may have collaborated at Florence and Assisi), are conceived in a quite different spirit. Let us compare, for instance, Cimabue's *Madonna* (Uffizi, Florence) with the Rucellai *Madonna*, Duccio's first dated work (1285). In the former, such is the tension imparted to the plastic mass formed by the central figure that it seems to be coming forward from the frame, filling the whole of space, absorbing all the atmospheric content of the picture. In Duccio's *Madonna*, on the other hand, volumes are far better balanced and the figures, held together by a free and fluent rhythm, are given, if the expression be permitted, ample elbow room. In short Duccio's work is built to the human measure, it does not overpower us, its atmosphere is intimate, companionable. These luminous

forms, gleaming like old ivory, induce a mood of tranquil contemplation and recapture, across the centuries, the purity of Greek forms. In that glorious stained-glass window in Siena Cathedral (made in 1288) the distribution of space is even more happily conceived; indeed we find some recognition of the principles of perspective in the treatment of the thrones of the Evangelists, the *Coronation* and the central *Assumption*.

The small *Madonna of the Franciscans* in the Siena Pinacoteca, one of Duccio's major works, illustrates, better perhaps than any other, the mingling of quite different stylistic trends which, except in his art, seem always at cross-purposes. While the religious elements are given a majesty that almost seems to enlarge the small dimensions of the picture, a strain of gentler, more lyrical emotion makes itself delightfully felt, and with it something of the aristocratic grace of "courtly" art. The exquisitely chosen colors in this *Madonna* are as warm and glowing as those of the stained-glass window; the elegant line starting from the fluent, graceful arabesque of the cloak grows more expressive in the group of Brothers, and inaugurates the new relationship between space and figures that was to obtain in all subsequent Sienese painting. Its characteristics are recurrent rhythms combined with a highly skillful lay-out which at once situates figures and objects in space and links up the various planes amongst themselves.

The *Maestà* (1308-1311) is Duccio's last dated work. The arrangement of the scenes follows a calm, harmonious rhythm, and there is a well-found concord between religious gravity and aristocratic elegance. It is in the New Testament scenes on the back of the altarpiece and in the predella that we see Duccio at his best. Like Giotto's Paduan cycle, this magnificent tone poem flows smoothly on, without a break. But its spirit is quite different; figures and objects in Duccio's visions of these sacred scenes are bathed in an unreal light, the glamour of a dreamworld. Nevertheless there is no loss of intensity in either the direct human appeal of this "great holy narrative" or the immediacy of its religious message to the beholder; moreover, there is a quite amazing wealth of anecdotal detail. Duccio arranges his figures in a linear counterpoint, coordinated by a slow, mellifluous rhythm; and here we see another of his differences from Giotto, who isolates figures and objects so as to stress their plastic values.

This rhythm does not function merely on the surface, like an arabesque, but in depth, in terms of space. Duccio's sense of space may not have been so precise as Giotto's, but he too was feeling his way towards those perspective values which found expression for the first time, at the end of the 14th century, on the walls of the Upper Church of San Francesco at Assisi. Indeed the scenes of the Passion in the *Maestà* and the interiors (though handled with a greater freedom) reveal an approach to the problems of perspective much like that in the "Isaac" scenes at Assisi. Occasional inconsistencies or seeming-arbitrary touches, far from impairing the coherency and verisimilitude of the composition, seem on the contrary to strengthen the general effect, as in the panel containing two scenes one above the other: *Jesus before Annas* and *St Peter's Denial*. Space is boldly rendered and instinctively the beholder's eye follows up the diagonal formed by the flight of stairs starting from near the porch of the room where the Denial is taking place and terminating at the little balcony or landing of the upper room,

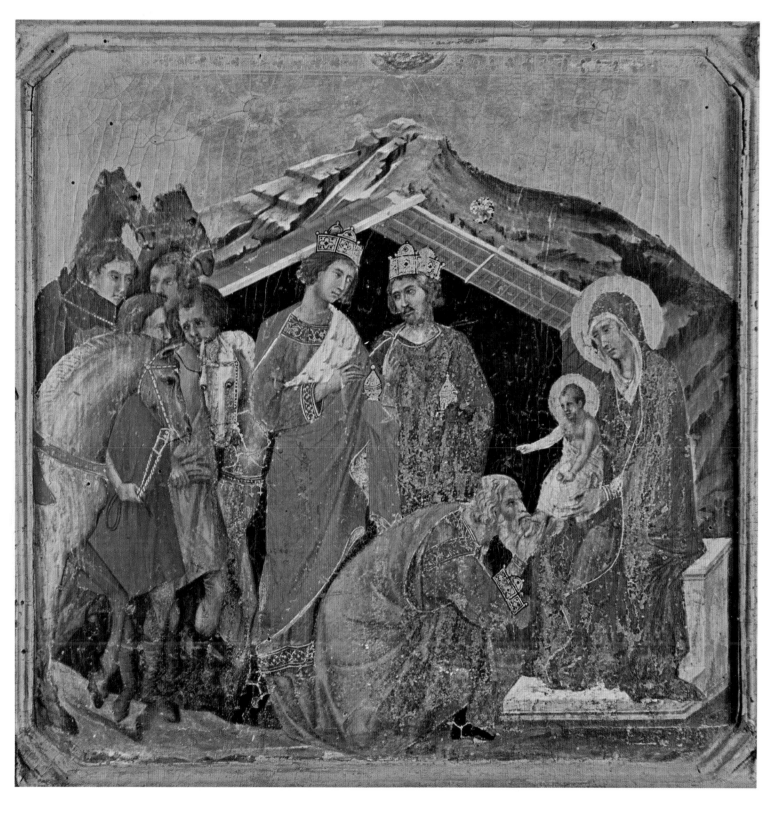

DUCCIO (?-1319). SCENE FROM THE PREDELLA OF THE MAESTÀ: THE ADORATION OF THE MAGI. 1308-1311.
OPERA DEL DUOMO, SIENA.

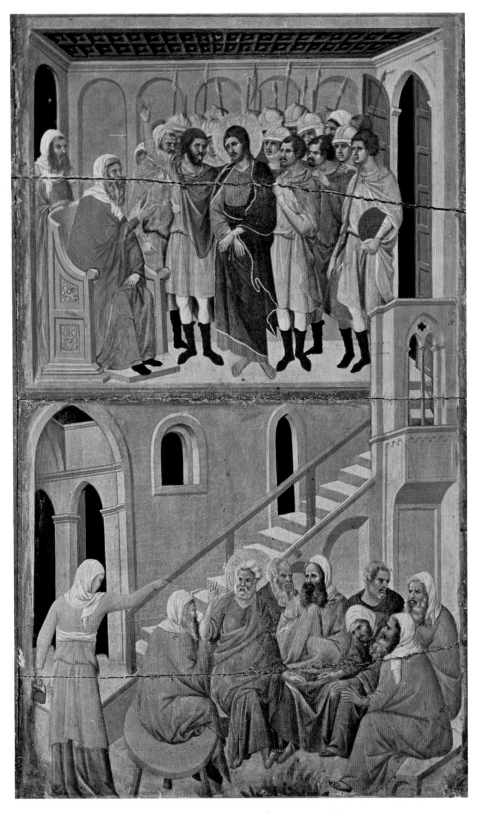

DUCCIO (?-1319). SCENES FROM THE BACK OF THE MAESTÀ: ST PETER'S DENIAL AND JESUS BEFORE ANNAS. 1308-1311. OPERA DEL DUOMO, SIENA.

which is the setting of the second episode. Noteworthy is the different treatment of space in the two scenes. And spatial recession is further suggested by the presence of windows, arcades and doors, whose effect is to remind us in a simple, literal way of the existence of the outside world beyond the walls.

The painter's ingenuity and lively imagination are given full play in several other interior scenes, in which the foreground is strongly illuminated, while the back of the room is plunged in shadow. Relations between colors are happily conceived, and constantly we can see the artist's concern with rendering perspective, one of many examples being the coffered ceiling in *Jesus before Annas*. In the open-air scenes space is rendered with considerable freedom. What a wealth of imagination has gone to the painting of *The Entrance into Jerusalem!* A colorful crowd is streaming up the road, entering the city through gates in battlements and towers, then making its way to the cathedral, whose Gothic cupola looms up in the background. The gold ground is but a symbol of the infinite space behind the landscape crowded with motley figures. This scene comprises *in posse* all the anecdotal motifs that were subsequently to figure *in extenso* in Sienese art. Though very different from Giotto's, Duccio's art gradually adjusted itself to the new art current so dramatically inaugurated by the Florentine, and in which he participated almost without awareness of its influence on him.

Thus in the very early years of the 14th century the Gospel narrative was given a twofold presentation, of unprecedented beauty, in the work of Giotto at Padua and that of Duccio at Siena. Despite their many dissimilarities in style and in poetic content, the works of both artists sprang from the same cultural soil. In their high gravity many of Duccio's scenes recall the work of Giotto; notably *The Temptation, The Prayer on the Mountain, The Crucifixion, The Deposition, The Three Marys at the Tomb, Noli me tangere* and *The Way to Emmaus.* In these panels Duccio is seen at his best. Mountains (a stock theme of traditional Byzantine iconography) are shown in vast recession, rank on rank and blurred by distance, bathed in a light that is no longer abstract, and their elemental rhythm is paralleled by the balanced distribution of the figures. From this pictured world of man and nature, rapt in contemplation of the mystery, there rises as it were a slow, majestic plain-song, vibrant with emotion.

The gradual transition from a classically minded past towards a new, adventurous era is yet more clearly evidenced in the scenes of the *Maestà.* In these we see the time-proved mediaeval tradition confronted by the culture of the coming age, already shaking off the shackles of the past. Every phrase, every word of the familiar text is given a changed significance, resonances hitherto unheard. Yet the discoveries and inventions of the new order do not strike us as rootless, isolated phenomena; rather, they seem to arise quite naturally out of traditional art, and indeed to fall in line with it. And these it is that in the art of Duccio give its compelling accent of reality to the ancient text. The haunting beauty of this art and its mysterious grandeur are found, in the last analysis, to derive from the intermingling of these elements. Duccio was the transmitter of a heritage which, coupled thus with Giotto's innovations, had a preponderant influence on the destinies of Italian art.

SIMONE MARTINI (1284?-1344). GUIDORICCIO DA FOGLIANO. FRESCO, 1328. PALAZZO PUBBLICO, SIENA.

SIMONE MARTINI AND PURE FORM

Duccio was still alive when in 1315 Simone Martini's *Maestà* made its dramatic appearance in the great hall of the Palazzo Pubblico at Siena, and it was evident at once that Italian painting was entering on a new, eventful phase. Both the forms and the emotional tenor of Simone Martini's world were vastly different from those of Duccio's and Giotto's; they were manifestations of the new spirit, the new attitude to life of the early 14th century. For distinctive of the art of Simone Martini is its delicate, aristocratic beauty, combined with a fine economy of means.

True, it may be that Cimabue, Giotto and Duccio made proof of greater powers of expression and deeper, more vital emotions, while beyond a doubt Pietro and Ambrogio Lorenzetti, as we shall see, express themselves more vigorously and deal with a far wider range of feelings. Yet in their works we do not find that soft inner radiance arising from the beauty of pure form, and that awareness of what might be called the aristocracy of art, which pervade the work of Simone Martini. Always in quest of an ideal harmony, he built up his compositions with loving care, seeking that ultimate refinement which alone could satisfy his fastidious taste. Indeed all his work might be described as variations on a single theme, that of harmonious beauty. Hence the sublimation—or, more precisely, rarefaction—of human passions we find in his art; they lose their urgency on the serene heights of his artistic vision. His art, we feel, is thought out through and through, yet though the form of its expression produces an effect of studied calm, that expression is never artificial, monotonous or cold; its limpidity derives from mind-controlled emotion, emotion "remembered in tranquillity." Simone Martini was fully aware of the value of his art, of his ability and intellectual equipment, and also of the importance of the age into which he had been born. There was, indeed, no false modesty about him; he had a somewhat arrogant but typically Petrarchian belief in his

personal enlightenment. For like Petrarch he was at once a great poet and a fervent humanist, all for a new, refined and "courtly" art. To this ideal he subordinated all other values. Again like Petrarch, his friend and one of his admirers, he was intensely sensitive to the beauty of the visible world and it was with this terrestrial beauty that in his paintings he invested even the most hallowed figures. We can well understand why both Simone's contemporaries and the next generation regarded his art as one which, better than any other, satisfied their notion of ideal beauty.

There was another reason why he was a leading figure of his time; on him converged and from him stemmed all the new art trends of the day—notably the Gothic. Indeed he acted as the connecting link between Italian art and that of the rest of the continent, France in particular. For the fashionable, highly cultured art then flourishing in France was making its influence felt in the figurative arts as well as in Italian literature. In this respect Simone's debt to France is evident; we see it even in his quite early works, painted well before the artist went to Naples at the invitation of the King of Anjou and became a member of his court. (A case in point is the Siena *Maestà*, in which all the characteristics of his very personal style are already present.) Was it by way of miniatures, ivories and painted fabrics that Simone became acquainted with French art in those early days? Or was he in touch with a French milieu from the very start? The treatment of the throne in the *Maestà*, vaguely evocative as it is of the Sainte Chapelle, favors the second alternative, for its distinctively Gothic characteristics had no equivalent in any building then to be seen in Italy. True, the handling of line is still very similar to Duccio's, but that special lyrical quality which we only vaguely sense in Duccio makes its presence felt conspicuously in the *Maestà*.

Reference has been made to the contacts between Simone and the French art of the time, but we must not overlook his intimate association with the work produced by purely Italian artists in the first decade of the century; for example, that great baldequin with its billowing folds, that opens curtain-wise on space in the *Maestà*. Like Duccio's, Simone Martini's *Maestà* would have been inconceivable in any period other than that of Giotto. Not that Simone's vision is to be identified with Giotto's. On the contrary, their forms of expression were radically different, though both alike were conditioned, in the last analysis, by the new art culture that was "in the air." And it was Giotto who, at Assisi, launched the conceptions basic to that culture, with his instinctive solution of the problem of spatial representation.

The charm of Simone's work, however, does not derive merely from its exquisite line, as may be justly said of French 13th-century illuminations, which are essentially decorative, abstract arabesques or else lively little pieces of description. Far more ethereal than Giotto's, Simone Martini's forms seem at once exempt from the pull of gravity and open to the play of light (the Sainte-Chapelle produces just this impression when compared with the Upper Church of Assisi). Yet always we can discern in the composition an awareness of perspective, showing Simone's indebtedness to Giotto's intuitive solution of the spatial problem. Even when, on occasion, perspective seems to be ignored or replaced by an abstract, somewhat baffling calligraphic flourish—as in the

Saint Louis (Ludovic) of Toulouse in the Naples Pinacoteca—the fact remains that even so forms are defined in terms of space, which circumscribes them to begin with, then lets them die away into a haze of tenuous light. The various figures, for example, in the big Pisa polyptych are also treated in this manner; they are not merely outlined on a flat surface but, bathed in light, are fully integrated into space.

Some time between 1320 and 1330 Simone decorated the Chapel of St Martin in the Lower Church of San Francesco at Assisi. Obviously in this work, conspicuous for its exquisite handling of line and color, the painter has given much thought to the relationship between light and perspective. Throughout Simone's œuvre space retains its value as a formal element always borne in mind even where it tends to be submerged by linear arabesques and flooding light. Actually this rhythmic, well-nigh immaterial conception of the content of the picture was but one facet of Simone's genius; it did not characterize any given stage in his artistic evolution but was something to which he reverted again and again.

It must not, however, be thought that Simone's art can be briefly summed up in terms of an emphasis on line (evidenced in that world-famous picture *The Annunciation*) and an opening up, so to speak, of the space dimension. On the contrary even in his earliest works we find a tendency to interpret space in terms of *rhythm*. Even after the Uffizi *Annunciation* (1333) a complex, rhythmic interplay of perspective effects is often to be found in his works, an example being his *Episodes from the Life of St Augustine*. This factor is always given more prominence when stress is laid on anecdotal elements, but makes itself less felt in pictures where the theme, stepped up to its maximum intensity, culminates in pure lyrical effusion.

No other work by Simone demonstrates so clearly as the Assisi frescos his skill in handling a work of epic dimensions, a narrative poem couched in terms of form and color. Despite their "literary" tenor these frescos are permeated everywhere by the poetic inspiration distinctive of this artist's work, and we find in them a fine serenity, a preoccupation with harmonious, classically composed forms, which, purged of all impurities, all passion spent, create a world where beauty reigns supreme, the appropriate ideal of a culture conscious of its emergence from a darker age. These frescos, which also testify to Simone's gift of realistic observation, enable us to see that basic to his cult of beauty and classical balance is a very real enthusiasm for the new way of seeing the world and for the vast field of new possibilities open to the exploring mind. The famous *Guidoriccio da Fogliano* fresco (1328) in the Palazzo Pubblico at Siena, almost contemporary with the Assisi sequence, illustrates this to perfection; the rider might be an effigy of the aristocratic spirit and of human dignity. The nightbound landscape, in which the works of man are given a place, is a masterpiece of grandly rhythmical composition. So powerful is the general effect that we may easily fail to notice the loving care with which the painter has depicted, for example, the elaborate costume of the condottiere; his almost Flemish attention to exactitude of detail; his panoramic vision of the slumbering camp in the blue darkness—and how these elements, fused together in an organic whole, acquire more than a scenic, a symbolic value.

SIMONE MARTINI (1284-?1344). THE KNIGHTING OF ST MARTIN, DETAIL. FRESCO, BETWEEN 1320-1330.
LOWER CHURCH OF SAN FRANCESCO, ASSISI.

All the characteristics of Simone's art are present unmistakably in the frescos of the Chapel of Saint Martin at Assisi: his poetic feeling, his special way of handling visual data, his ideal of beauty and perfectly balanced composition. In fact what we have here is a representation on a larger scale and in greater detail of the world which in the *Guidoriccio* fresco has the remote glamour of a poet's dream. Obviously both works may be dated, roughly, to the same period: between 1320 and 1330. In *St Martin abandoning the Profession of Arms*, we find the same method of rendering expressions

SIMONE MARTINI (1284?-1344). ST MARTIN ABANDONING THE PROFESSION OF ARMS, DETAIL. FRESCO, BETWEEN 1320-1330. LOWER CHURCH OF SAN FRANCESCO, ASSISI.

and emotions, the same handling of objects, as if the painter were seeing them for the first time, with a sense of faint surprise. The contrast between the aspect of the soldier in the conical hat, all arrogant brutality, and the almost effeminate gentleness of the saint is particularly striking. Yet the general effect is one of harmony, a harmony created by the looks that are being exchanged within the "magic circle" and by the happy concord of bright, translucent colors, violet, pink, pale blue. In *The Investiture of St Martin* (and, for that matter, in all the scenes of interiors) we can clearly see the painter's concern with problems of perspective. But for all his emphasis on line, Simone always bears in mind the necessity for an harmonious concord of form and color. Delimiting the areas of volumes, his line enables the zones of color to produce their maximum effect—an effect seen to perfection in the many-hued costumes of the players of the double-pipes and the lute standing just in front of the singers, who, as we can see from their faces, are intently listening to the melody, all eagerness to follow it exactly. This little scene is imbued with the spirit of a "courtly" age, the period of the troubadours, but the artist aims at something beyond the presentation of an age; at the creation of a world of beauty. St Martin, in his rich attire (in *St Martin and the Poor Man*), might stand for the symbol of that world; when he turns to give a last glance at the poor man and presents him with his mantle, we see that underneath it he is wearing a still handsomer garment.

What a wealth of imagination Simone displays in the composition of the scene of St Martin with the Emperor Valentinian; in that other scene, like a foretaste of the Renaissance, of *The Death of St Martin*; in the Gothic church with its cusped windows opening on the blue of the sky in *The Obsequies*! Here the artist's refined and subtle taste, elsewhere manifested chiefly in the form of line and rhythm, makes itself yet more strongly felt in the color patterning, the play of light in space. In those shadows faintly tinged with color, delicate nuances alternating with gay tones, we see an anticipation of the rich chromatic fantasies of International Gothic. Likewise occasional frankly naturalistic touches prefigure the painting of the near future; the group of singing friars and onlookers in *The Obsequies of St Martin*, for example, who may well have been painted directly from life. Yet despite these touches of realistic observation, the dominant impression is one of an otherworldly glamour, of strange enchantments, combined on occasion with a devout pensiveness which, in *The Vision of St Martin*, attains a high solemnity. In this world of serene harmony and magical delights we must not look to find Giotto's dramatic tension; its atmosphere is one of purest poetry, rapturous contemplation of an ideal loveliness. So complex is this art, so rich in intimations, that we should be chary of attempting (as some have done) to seek to explain it wholly in the light of a few selected masterpieces such as the Uffizi *Annunciation*, though unquestionably this magnificent work represents the highest point of Simone's lyrical expression and the ultimate refinement of his art. When we remember that emphasis on line on the one hand and, on the other, perspective representation of the space in which an incident is taking place do not stand for successive stages in the evolution of Simone's style but, in practice, synchronized, we see why, for example, the *Life of St Augustine* is not so far removed as one might think from the Uffizi *Annunciation*. We can also see that both

SIMONE MARTINI (1284?-1344). THE OBSEQUIES OF ST MARTIN, DETAIL. FRESCO, BETWEEN 1320-1330.
LOWER CHURCH OF SAN FRANCESCO, ASSISI.

works have a definitely "Gothic" accent and a like preference for clean-cut expression —but also, as a result, a less classical rhythm than that of works produced in the century's first three decades. Thus in *Episodes from the Life of St Augustine* the narrative, being treated more vivaciously, is not so strictly balanced. Faces, too, have that slightly hard, incisive line which we find in the Virgin of the *Annunciation*.

When Simone and his pupils left for France, he was passing through his most Gothic phase. The Virgin of the Antwerp *Annunciation* formed part of a polyptych whose panels are now dispersed and which was certainly painted at Avignon. But there are no

SIMONE MARTINI (1284-?1344). ST MARTIN RAISING A CHILD FROM THE DEAD, DETAIL. FRESCO, BETWEEN 1320-1330. LOWER CHURCH OF SAN FRANCESCO, ASSISI.

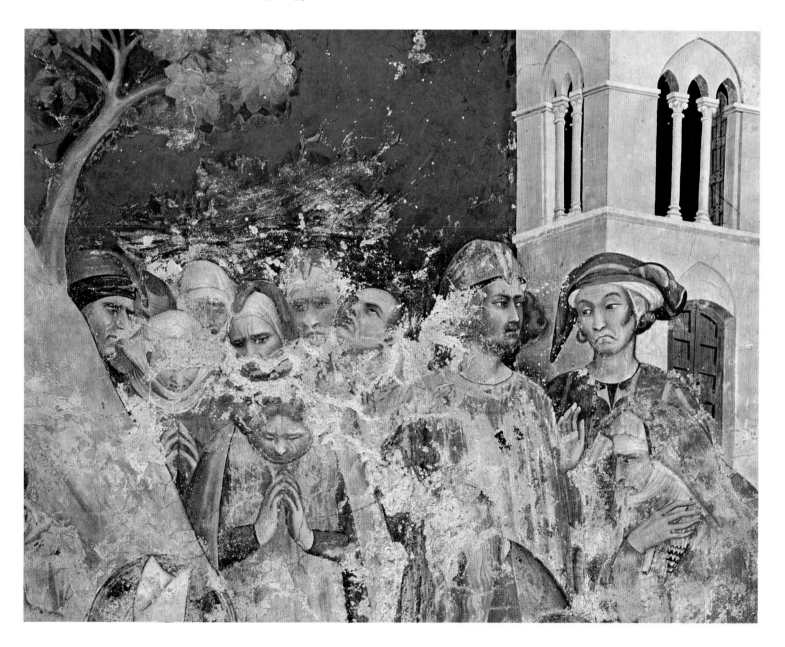

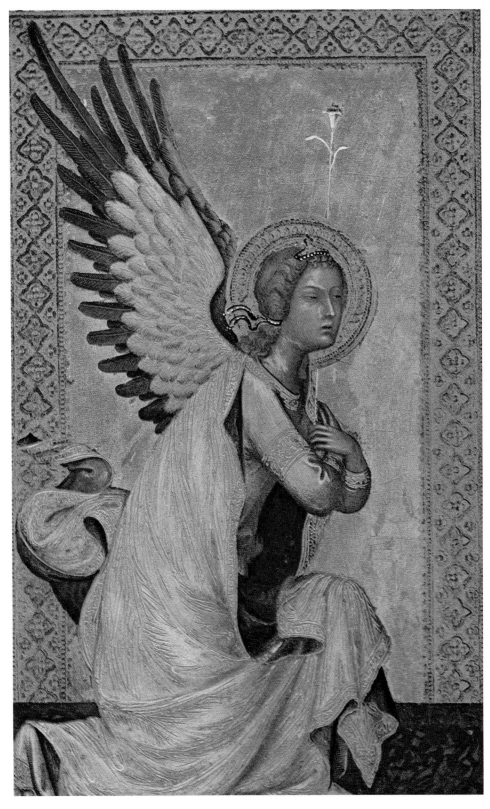

SIMONE MARTINI (1284?-1344). THE ANGEL OF THE ANNUNCIATION. AFTER 1339.
(9 ¼ × 5 ¾″) MUSÉE ROYAL DES BEAUX-ARTS, ANTWERP.

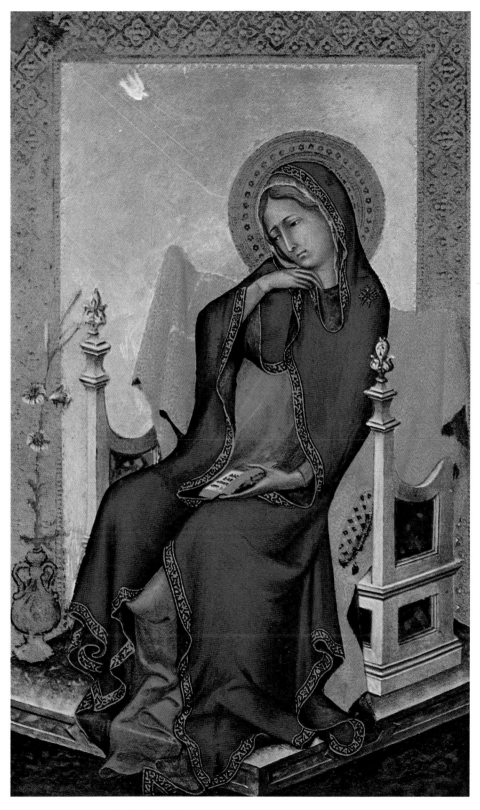

SIMONE MARTINI (1284?-1344). THE VIRGIN OF THE ANNUNCIATION. AFTER 1339.
(9½×6″) MUSÉE ROYAL DES BEAUX-ARTS, ANTWERP.

fundamental differences between this and the *Episodes from the Life of St Augustine*, probably the artist's last major work before he left Italy. Generally speaking the Antwerp Virgin much resembles the Florence Virgin; however, the linear arabesques in the former are more elaborately planned and there is more sensitivity, more vibrancy in the representation of the Virgin, placed diagonally within the panel. And the angel, with the great sweep of his gleaming, buoyant wings, might be an Apollonian effigy of light incarnate. There is both grace and grandeur in this, the last vision of his ideal of beauty Simone gave the world. In the Antwerp *Annunciation* are foretastes of the International Gothic style: a lyrical handling of the various motifs, an adroit, poetically imaginative use of expressive line combined with a tendency towards descriptive realism always of an extreme elegance and evoking natural appearances, the play of light, the flicker of emotion on faces, in soft, translucent color. Despite its deeply moving human quality this work has affinities with much French painting of the time, with its subtle literary allusions and its sublimation of reality to the confines of the abstract.

In the panels of this polyptych (dispersed in Paris, Berlin and Antwerp), in the small work at Liverpool and in the Virgil miniature at the Biblioteca Ambrosiana, Milan, we find the same tendency towards a more dynamic, more expressive style. One has the impression that Simone was gradually moving away from the monumental, strictly balanced architecture of his previous work and aiming at more emotional effects; while at the same time the picture-surface developed faint vibrations like the surface of a lake ruffled by light breaths of air, and the colors took on the delicate nuances of the finest paintings in the International Style prior to Gentile da Fabriano.

However, the few frescos (in very poor condition) that are still to be seen at Avignon show that Simone was then reverting to his broadest, most monumental style, while in the work of his pupils—the frescos in the Robe Room of the Palace of the Popes—we find reminiscences of his innovations and the touches of realistic description he gave to his portrayals of the everyday life at the court. In the miniatures of the famous Codex of St George made by an unknown painter who was certainly in close touch with him, we have reduced-size illustrations of his style; the differences between them and the miniatures and stained glass of the previous period are noteworthy. Forms are more "alive," more sinuous and mobile; the line flows far more smoothly.

Indubitably Simone Martini did much to shape the course of Italian art. He was in touch, perhaps from the start, with the manifestations of early French Gothic painting, and he was one of the great pathfinders of that eventful period of art history, the beginning of the Trecento. Thereafter his intercourse with French culture was more direct and it is not too much to say that he exercised a vast influence on the subsequent course not only of Italian painting but of European painting in general.

His residence at Avignon (from 1339 to 1344, the year of his death), the art movement which he set on foot and the widespread diffusion of his work largely determined the evolution of French art in the second half of the 14th century. Indeed he played a major part in the formation of the "International Style" which spread all over Europe during this century and the opening years of the next.

PIETRO AND AMBROGIO LORENZETTI

There are good grounds for believing that Pietro Lorenzetti, born in or about 1285 and thus almost contemporary with Simone Martini, was slightly older than his brother Ambrogio. Though he is known to have been practicing as an artist during the first ten years of the 14th century, the earliest extant works by him belong to the next decade, 1310-1320, that is to say to the period of Simone Martini's *Maestà*. The Cortona *Madonna* is one of these early works. In it we find the painter already in full possession of his means and revealing an artistic personality no less remarkable than Simone Martini's. And just as the early Siena *Maestà* adumbrates the ideal of beauty, the poetic vision and the serene delight in "all things lovely" to which Simone's art owes its peculiar charm, the Cortona *Madonna* no less clearly bears the imprint of the soul-searchings, the feverish quest of new experience, new discoveries, which were to characterize Pietro's art throughout his career. His approach to the subject of the picture was psychological and, far from seeking to present emotions in a classically modulated, harmonious pattern, he deliberately probed into the secrets of the human heart. Likewise he never tired of research into the resources of his medium, and we find him trying out a host of different "manners" even in works belonging to almost the same period.

Pietro had an insatiable interest in the workings of the human mind and with this he combined a tireless creative energy far surpassing that of any other artist of the day. This may account in part for his versatility, which often takes us by surprise; at one moment he is haunted by the tragic sense of life and, the next, brimming over with *la joie de vivre*. In this emotive drive lies his true originality, and it comes out most, perhaps, when he handles themes already dealt with by his immediate predecessors.

Giotto, Duccio, Simone and Ambrogio Lorenzetti had no doubt a more coherent vision, a clearer conception of the limits of the poetic and intellectual possibilities of their art. None of them struck out in so many directions as Pietro; none explored so vast a field, none took such risks. And no one before him—except perhaps Cimabue some years previously (and how long ago that seemed already!)—had raised emotion and its expression to such a pitch of intensity. Yet, unlike Cimabue who found in constantly dramatic expression the one and only outlet for the emotions surging up within him, Pietro discovered other solutions; though capable of rendering emotion with the most passionate, most harrowing poignancy, he yields now and again to a gentler mood—and then his art is all serenity and sweetness. Thus on the one hand we have the predellas of the Church of the Carmine polyptych, the Uffizi *Madonna*, and the *St Humilitas*; on the other, the great *Crucifixion* at Assisi.

While Pietro's art covered an exceptionally wide range of human feelings, his culture was no less vast and varied. This explains the continual changes in his manner of expression, his readiness to welcome new ideas and to profit by the discoveries of others. None the less he metabolized all that he laid hands on, giving it the imprint of his highly personal genius. Unlike Simone, Pietro was not the pioneer of any specific

cultural trend; he had far too restless, too adventurous a mind to pledge himself whole-heartedly to any given cause. He was always trying out new procedures, and these he brought so quickly to maturity that he soon abandoned them. Hence the great difficulty in tracing Pietro Lorenzetti's artistic evolution, and in fixing the chronology of his works on internal evidence.

Certain elements, notably the angels in the Cortona *Madonna*, undoubtedly stem from Duccio, but not only is the architectural concept of the work as a whole much

PIETRO LORENZETTI (?-1348). SOBAC'S DREAM.
PANEL FROM THE PREDELLA OF THE CARMINE ALTARPIECE, 1328-1329. PINACOTECA, SIENA.

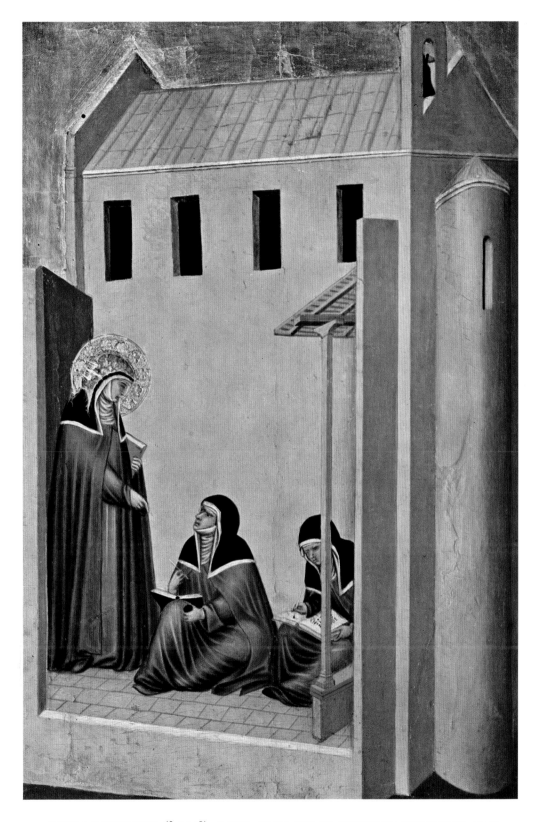

PIETRO LORENZETTI (?-1348). PANEL FROM THE ST HUMILITAS ALTARPIECE, 1341.
UFFIZI, FLORENCE.

bolder, but it has a vitality, a nervous energy all its own. True, there is a high gravity in the faces of the Virgin and Child gazing pensively at each other, yet this Madonna is very different from those of Duccio and Simone Martini, whose impressiveness is largely due to the static, hieratic line. It is not so much of Giovanni Pisano that the *Madonna* reminds us as of Giotto; indeed there is no doubt that in their early work both Pietro and Ambrogio drew freely on their reminiscences of Giotto. But this holds good for all the Italian painters who, between 1310 and 1320, sought to give plastic values to figures and their settings.

His first dated work is the great Arezzo polyptych which was painted in 1320—that is to say at about the same time as Simone's Pisan polyptych—and as a matter of fact it bears traces of Simone's influence, especially in the half-length figures in the front row. There is much similarity in the broadness of the drawing, though Pietro's line is more incisive, and similar, too, is the compositional rhythm, which however in Simone's work was much more delicately formulated. For here the *Madonna* has the swelling resonance of organ music echoing in a Gothic cathedral, and the outlines of the figure are so boldly stated that it stands out from the background, full of plastic vigor, dominating the entire composition. In the *Annunciation*, one of the panels of this polyptych, we find a simple, forthright rendering of the relations between figures, space and light, and moreover a tremulous play of middle tones in the color masses which has no equivalent in other Sienese works of the period. Indeed this picture reminds us more of Giotto's last phase than of the works of his immediate successors.

Transposed as it were into a different key, these compositional elements reappear in the altarpiece, painted in 1328-1329 for the Church of Santa Maria del Carmine at Siena; this work, together with its predella, is now in the Siena Pinacoteca. Angels and saints modeled in full light surround the gracious, yet superbly majestic figure of the Virgin, flooded with a celestial radiance. In the scenes of the predella, space and perspective are indicated by a skillfully contrived interplay of light effects, while the passages of color are arranged in an elaborately variegated geometric pattern. Here we can see the painter's indebtedness both to Duccio's highly imaginative renderings of such scenes and also to the classically harmonious interiors painted by Simone Martini at Assisi. Nevertheless the ease with which the figures are assigned their natural positions in space suggests an acquaintance with the work of Giotto's last period. In any case direct recalls of Giotto's final style were to be seen also in the paintings of his pupils, who worked on the frescos of the righthand transept, on those in the Chapel of San Nicola, and on those (sometimes almost indistinguishable from the master's) in the Chapel of the Magdalen.

In the predella of the altarpiece of the Church of the Carmine, Pietro displays much ingenuity in his handling of the structure of rooms and loggias and in rendering the living, vibrating quality of light. In that delightfully lyrical scene (in the predella), *Sobac's Dream,* light rippling across the various zones of color at once binds them together and brings out such happily conceived details as the checkered bedspread, the towel hung up to dry, the snow-white curtain.

The date of the Assisi frescos, undoubtedly Pietro's supreme achievement, is a moot point; still there are reasons for thinking that anyhow some of them were painted before 1329, the year of the Carmine polyptych, as they have marked resemblances to the early works and to the Arezzo polyptych; whereas the Carmine altarpiece clearly belongs to a transition period, when Pietro was moving towards his final style. We are here on the way to the Uffizi *Madonna* (1340), in which the figures seem to dilate within a great sea of light that gives a gem-like luster to the colors and heightens the translucency of the various tones of blue. Noteworthy in this context are the *Nativity* (1342) in Siena Cathedral and the *St Humilitas* altarpiece, in which a number of scenes, some animated, some reposeful, are grouped around the central figure. Were we unaware of the prodigious versatility of Pietro's modes of expression, it would be hard to believe that this work (dated 1341) comes between the Uffizi *Madonna* and the *Nativity*. Here he treats his subject as if he were illustrating a tale; hence the employment of more spontaneous methods of expression and of a more fluent rhythm.

For convenience' sake we have so far reserved discussion of Pietro's frescos in the left transept of the Lower Church of Assisi. It is above all to the big *Crucifixion* that we would draw attention, for though this is one of the very greatest pictures of the whole Trecento, it does not seem to us to have met with the recognition it undoubtedly deserves. Perhaps this is because not enough stress has been laid on the novelty of its whole conception. Vivid imagination was needed to conjure up that motley group of figures at the foot of the three crosses towering high into the blue, and to give their attitudes and gestures such variety and aptness. Here, boldly discarding the traditional mediaeval iconography, Pietro has visualized the scene afresh and treated it from a new angle. Everything is subordinated to the expression of the very diverse emotional reactions of the onlookers: generous compassion or sadistic cruelty, scorn or love. Soldiers of some barbarian race, handsome but, one feels, completely callous, take up a large part of the scene, and each man is given a distinctive attitude, expressing indifference, contempt, arrogance, or vague bewilderment, as the case may be. Here and there we see one of them looking up at the dying Victim, but there is no pity in his gaze. Aloof, on one side, is the group of weeping women and the three Marys, prostrated with grief.

This great work may be said to strike the most "Gothic" note in all Trecento painting. It is permeated through and through with intensely human feeling, a prodigious emotive realism in the treatment of figures and gestures; while the thematic structure of the composition is elaborate to the point of intricacy, full of interruptions and recalls, contrasts and contrapposti. The underlying pattern is a system of circles, interlocking, juxtaposed, divergent. The first is formed by the three crosses; that of Christ which hugely dominates the foreground and the two others which, rising in the midst of the serried groups around their bases, seem to be swinging round, converging on the central cross. Thus an over-all gyratory movement is imparted to the scene. Space is broadly rendered and in it forms are represented not with the reticence of a Simone Martini, but with an incisiveness of outline prefiguring the strong linearism of certain painters of the next century, Andrea del Castagno for example. Here the wealth of vivid colors, far from

PIETRO LORENZETTI (?-1348). CRUCIFIXION, DETAIL. FRESCO, BEFORE 1329.
LOWER CHURCH OF SAN FRANCESCO, ASSISI.

PIETRO LORENZETTI (?-1348). CRUCIFIXION, DETAIL. FRESCO, BEFORE 1329.
LOWER CHURCH OF SAN FRANCESCO, ASSISI.

producing an effect of over-sumptuous decoration, lends intense vitality to the architecturally ordered scene telling out against the vast backcloth of the sky, across which rise the livid bodies of the crucified.

Until (quite recently) this picture was restored, the dulling of the colors made it difficult if not impossible to gauge the very real grandeur of this, Pietro Lorenzetti's masterpiece. Only brief mention need be made of the other justly famous works figuring in this cycle. In the *Deposition* we see Pietro at his most dramatic. His treatment of the emotive elements of the scene might be described as a classical synthesis, somewhat reminiscent of the frescos in the Scrovegni Chapel; nevertheless it is by the power of his line that he makes the masses of the bodies stand out so effectively against the somber background.

Pietro's versatility, the diversity of modes of expression at his command, can be seen almost at a glance when we compare this picture with *The Madonna with St Francis and St John the Evangelist*, for as it so happens these two works figure side by side in the same transept. Nevertheless, even when a scene is full of gentle, poetic emotion, his line never loses its incisiveness or its vibrancy; this is indeed the hall-mark of his art. In these two practically contemporaneous frescos (and for that matter throughout his œuvre), we find that conjunction of a variety of seemingly incongruous elements which is one of the disconcerting features of his work. An unwearying creator of forms, ever in quest of fresh fields to conquer, Pietro Lorenzetti brought to art a new range of emotions, a new visual poetry which beyond all doubt did much to shape the cultural evolution of the 14th century.

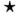

The accepted view that Ambrogio was the younger of the two Lorenzetti brothers is confirmed by an examination of their respective works. Pietro was already producing pictures in the first decade of the century and his art linked up more closely with Duccio's; by 1315, the approximate date of the Cortona *Madonna*, however, he had fully matured his personal style. Ambrogio painted the Vico l'Abate *Madonna* in 1319, and it is not only his first dated work but almost certainly the earliest of those that have come down to us. Though no less pleasing to the eye than his brother's Cortona *Madonna*, it is a much less finished production; indeed there is a certain roughness in the execution suggestive of the work of a young man who has not quite found himself. The composition as a whole is monumental, abstract, neo-Romanesque; the drawing of the faces neo-Byzantine. These archaisms, nostalgic reminiscences of an earlier age, strike an intriguing note, coming at a time when a quite new form of art had gained the day. One feels that the painter, though he did not shut his eyes to the brilliant discoveries of his Sienese and Florentine contemporaries, had his own ideas on art and wished to create a very special ambience, an atmosphere of myth and fantasy congenial to his highly independent temperament. The world he conjures up is curiously remote—it is as though a faintly misted mirror were held up to the facts of life, softening asperities and adjusting their emotive or dramatic values to a mood of pensive contemplation. As compared with

AMBROGIO LORENZETTI (?-1348). VIEW OF A TOWN. (8½ × 12½″) PINACOTECA, SIENA.

Pietro's frankly emotional treatment of his subjects, Ambrogio's art gives an impression of aloofness, some almost metaphysical preoccupation. In the Vico l'Abate *Madonna*, also, we find early intimations of the style that was to be peculiarly his. Though there are reminiscences of Giotto in the plastic fullness of the figures, the work as a whole shows that already Ambrogio was far less influenced than his brother by the art of the

AMBROGIO LORENZETTI (?-1348). THE EFFECTS OF GOOD GOVERNMENT, FRAGMENT.
FRESCO, 1337-1340. PALAZZO PUBBLICO, SIENA.

great Florentine master. That grandiose rendering of the image to which Giotto constantly aspired was not regarded by Ambrogio as essential to the picture; it was something to be borne in mind—a working hypothesis, so to say—but he left his creative imagination free to choose its own direction. Even in this work, where Giotto's influence is so evident, Ambrogio tends to eliminate the light-and-shade effects used by Giotto for rendering plastic values; forms are presented facing the beholder, volumes and space seem to be moving forward on to the picture surface.

But when we compare this early work with the famous *Madonna del Latte* in which, many years later, the artist reverted to the same theme and which illustrates the ultimate fruition of his style, with its amazing clarity of form, we cannot fail to be impressed by

AMBROGIO LORENZETTI (?-1348). THE EFFECTS OF GOOD GOVERNMENT, FRAGMENT.
FRESCO, 1337-1340. PALAZZO PUBBLICO, SIENA.

the technical enrichment of this later phase. Volumes now advance unmistakably *beyond* the foreground; the various color planes are aligned or echeloned in spacious, harmoniously demarcated zones, co-ordinated by a linear network precisely defining their position in space. To such effect that, far from forcing themselves into the field of vision and creating their own space, the elements of the picture seem to work their way into it discreetly, gradually, almost one might say diffidently. This visionary world of tranquil beauty, a poet's dream, is vibrant everywhere with deep, human emotion. But whereas in Pietro's rendering of the same subject the Child's gesture has the naturalness, the spontaneity of a causal impulse, Ambrogio's close-knit line crystallizes and immobilizes the gesture in an eternal moment.

AMBROGIO LORENZETTI (?-1348). THE EFFECTS OF GOOD GOVERNMENT, FRAGMENT.
FRESCO, 1337-1340. PALAZZO PUBBLICO, SIENA.

As in the case of Pietro, we are unable, in the space at our disposal, to trace the development, stage by stage, of Ambrogio's highly complex genius; we must limit ourselves to indicating its most significant aspects and characteristics. His art is at once uniform and infinitely varied, though the feelings it expresses are pitched almost always in the same key. And this diversity derives from the various ways in which he adjusts direct observation of reality to his very special temperament.

Thus Giotto's representation of space, his realistic and dramatic approach to the facts of life, are transmuted by Ambrogio into the elements of a new, poetic conception of the world; they are but taking-off points for imaginative flights. In the frescos of the Church of San Francesco at Siena, he seems to have been influenced by his brother's handling of space in the predella of the Carmine polyptych, painted shortly before.

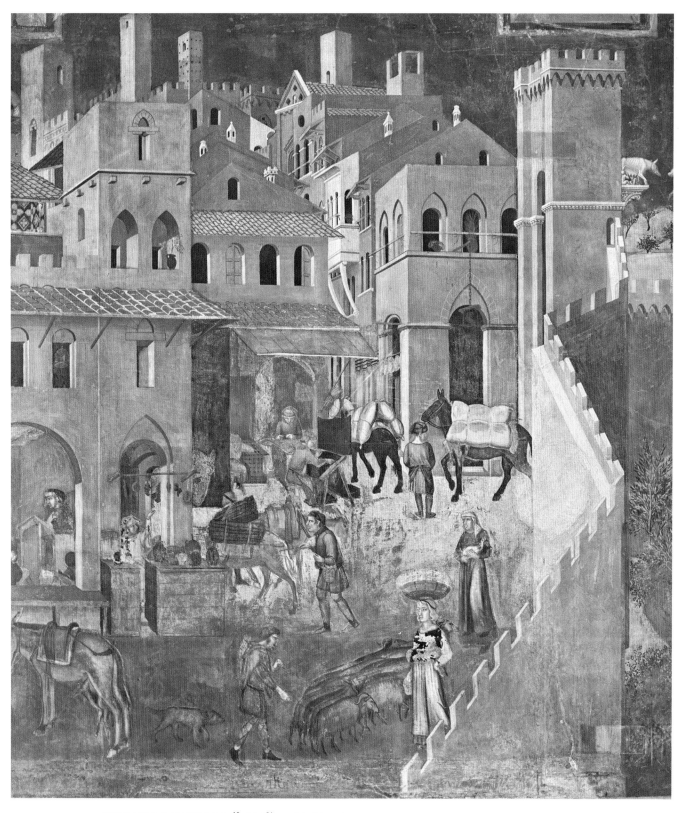

AMBROGIO LORENZETTI (?-1348). THE EFFECTS OF GOOD GOVERNMENT, FRAGMENT.
FRESCO, 1337-1340. PALAZZO PUBBLICO, SIENA.

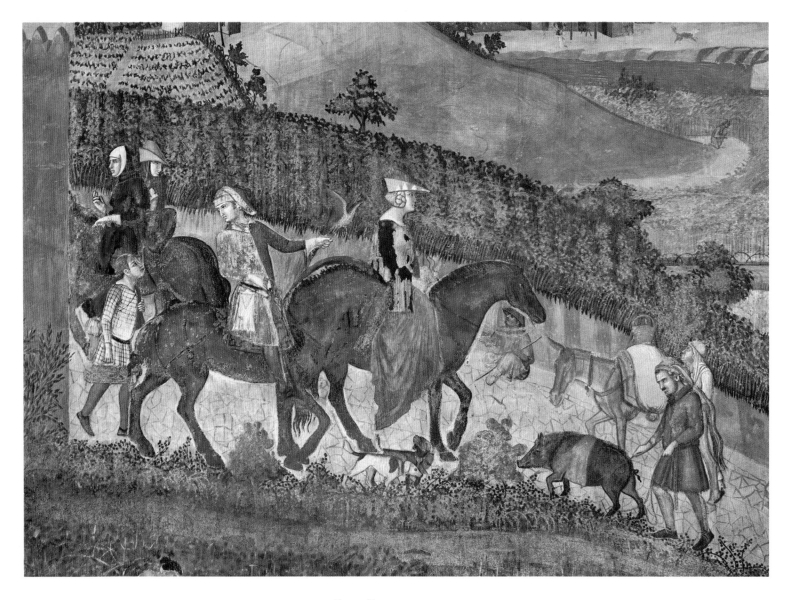

AMBROGIO LORENZETTI (?-1348). THE EFFECTS OF GOOD GOVERNMENT, FRAGMENT.
FRESCO, 1337-1340. PALAZZO PUBBLICO, SIENA.

Indeed it would seem that here, as in some other works of this period, he voluntarily took over certain procedures of his brother, in conjunction with whom he was working at this time. A picture dated 1335, which has now disappeared, bore out this co-operation between the two brothers and, given the echoes in them of Pietro's work at Assisi, the brothers probably collaborated in the painting of the Siena frescos. Nevertheless, by and large, these frescos in the Church of San Francesco, in which Florentine and Sienese art currents intermingle (there is even a touch of Simone Martini in the marvelous group of horsemen figuring in one of the scenes), are quite in Ambrogio's style. The smoothness of the planes of color, in which highlights emphasizing plastic values are sparingly employed and no stress is laid on volumes, and the sense of hieratic calm

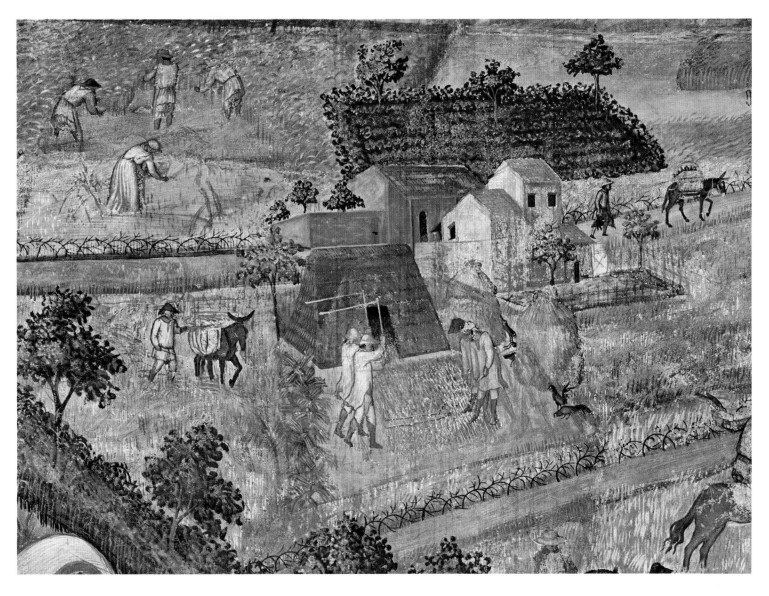

AMBROGIO LORENZETTI (?-1348). THE EFFECTS OF GOOD GOVERNMENT, FRAGMENT.
FRESCO, 1337-1340. PALAZZO PUBBLICO, SIENA.

infusing them are typically Ambrogio's. Here, too, the space dimension and even the descriptive, anecdotal details called for by the narrative seem merged in a tranquil, all-pervading harmony, and dramatic accents are few and far between.

The Frankfort polyptych and the altarpiece depicting *Episodes in the Life of St Nicolas* (Uffizi), painted during the artist's last sojourn in Florence (ca. 1332), are remarkable for their highly skillful handling of perspective. But here, too, Ambrogio is not aiming at effects of illusionist realism; on the contrary, he sets forth all the elements of the composition in such a way as to impart to it the glamour of an old-world folktale, while the loving care he lavishes on the tiniest details reminds us of the elegant lyricism of International Gothic.

Undeniably there are anomalies in Ambrogio's work; he does not always achieve a just balance between abstraction and the concrete representation of emotions—that dilemma which has perplexed so many an artist. The creative imagination, untrammelled by any purely intellectual considerations, which is the motive force of all Ambrogio's art, fails in some cases to weld these conflicting elements together in a concordant whole. Thus in the Massa Marittima *Maestà* the incongruity between the compositional scheme and its Gothic fantasies is only too apparent. And though we have here one of Ambrogio's most majestic and most human Madonnas, her form is not satisfactorily integrated into the somewhat over-laden composition.

Some works, however, achieve a flawless balance: for example, the Sant'Agostino *Maestà*, the small *Madonna with Saints and Angels* at the Siena Pinacoteca (here too perspective is suggested by purely imaginary motifs), and some later works such as *St Dorothy, The Presentation in the Temple* (1342) and *The Annunciation* (1344). Noteworthy in *The Presentation* is the elaborate perspective arrangement of the setting, while skillful variations of the light and colors create a soft and shimmering radiance around the figures. In *The Annunciation* perspective is merely hinted at, it is of an intrinsically mental order; that is to say it owes nothing to realistic observation, being purely a creation of the artist's prolific imagination.

This imaginative power found its fullest expression in the frescos in the Palazzo Pubblico at Siena illustrating *The Effects of Good and Bad Government*. Though these were painted between 1337 and 1340 (i.e. before the works mentioned above), we have reserved discussion of them to this stage because, appearances notwithstanding, their interpretation sets some difficult problems, and perhaps what has already been said about Ambrogio's work may help to elucidate them.

We have already noted that one of the characteristics of Ambrogio's art is the way in which he allows all strong emotions to simmer down before bodying forth his vision of the world. Pietro focuses his attention on emotive fragments of real life and forthwith synthesizes inspiration and expression in the light of his immediate response. Ambrogio, on the other hand, stands back from his subjects, his approach to them is gradual, and he makes a point of filtering emotions through the medium of his poetic vision, though some elements occasionally prove intractable.

Thus in *The Allegory of Good Government* the structure and didactic elements do not always harmonize with the poetic motifs, which however are numerous and of exceptional beauty. Whereas on another wall, where he depicts scenes of town and country life with well-nigh careless spontaneity, he is brilliantly successful. These scenes present a world of smiling peace whose forms seem gradually, effortlessly, to emerge and come to life. Space is broadly rendered as a sequence of successive planes advancing from the background to the picture surface, and the zones of color interlock in an harmonious pattern.

Nowhere else in all 14th-century Italian painting do we find such direct observation of reality, or a theme so contemporary, and the artist makes no secret of his emotional response to a subject that obviously fascinated him. Indeed he seems to trouble little

about the "allegorical" bearing of this work, when he depicts the activities of workers in the countryside and in the town; nevertheless he sublimates these scenes, which seem to well up from the depths of memory, into a grandiose vision, universal, indeed elemental in its scope. Such is the realism of certain details that we seem to see anticipations of the art of the Limbourg brothers, and even of the Van Eycks. Yet, for all its verisimilitude, this is a magic realism, full of strange enchantments. Though no other Italian work of the period shows such minute observation of life and nature, this picture is also the most fantastic, immaterial creation of the age; indeed it is more in the nature of a singularly vivid dream than a record of visual experience. We can feel both the loving care that has gone to its making and the subtle alchemy of genius transmuting every aspect of the scene into something rich and strange. Obviously a picture such as this might have a purely descriptive interest; yet even its most realistic details, with all their freshness and spontaneity, even passages that have the air of being culled straight from life have more, far more, than an anecdotal value. That sense of infinite tranquillity, of serene contemplation, which Ambrogio has infused into this unique work, lifts it from the level of merely illustrative art into a world of high imagination.

We have not here the consummate mastery of Giotto, who selects, simplifies and synthesizes different aspects of reality and human emotion so as to present them in their purest state. Nor have we here the lyrical abstraction, the synthetic line, of a Simone Martini. The greatness of Ambrogio's work does not derive from selectivity, the rejection of all that may not serve his turn. It is the result, rather, of deep meditation, a long pondering over life and nature as a whole, and the artist is as attentive to their most trivial aspects as to the most grandiose. From the passing moment, the changeful eddies on the surface of the visible world, he distills the essential residue and, by grace of his poetic vision, transmutes it into something "solid and abiding."

We realize this when we cast our eyes over this wonderful depiction of the town and country life of Italy six hundred years ago, the daily round of toil in fields and streets, with as a background to these activities the vast serenity of nature. The various planes are so arranged, beginning from the back of the scene, as to create a sequence of delightful vistas. After a general survey, our gaze lingers on each detail, then moves easily through tranquil avenues of color, towards a prospect of fields, valleys, lakes and hills; then the little streets of the town, with its pinnacles and palaces, gables and cathedral tower. All is bathed in the genial light of a spring morning which is calling people out of their houses for the day's duties or amusements: work in the fields, buying and selling, festas, dances, a hunting party or a cavalcade.

There is nothing here of the spirit of Giotto; rather, something of the purely imaginary space that Duccio conjures up in the episodes of his *Maestà*. This poetic yearning for the infinite and fathomless horizons, characteristic of all Sienese art, is quite other than the concept of space in Florentine art, and Giotto's in particular.

Pietro and Ambrogio Lorenzetti are said to have died of the plague in the same year, 1348, as Andrea Pisano, and not until the advent of Masaccio did any Italian artist create a body of work so varied and so vast as theirs.

NEW TRENDS IN FLORENCE AND NORTH ITALY

In the works of the Lorenzetti brothers we see the intermingling of two main streams of art, Florentine and Sienese, represented by Giotto on the one hand and Duccio and Simone Martini on the other. It was the fusion of these tendencies, so brilliantly achieved by Pietro and Ambrogio Lorenzetti (and by Giotto's immediate successors), that shaped the course of the new Tuscan art, and before long that of Italian art in general. Meanwhile, however, a number of elements stemming from other traditions and various sources were incorporated.

By and large—apart from a few elements taken from foreign sources—it may be said that all subsequent developments of Tuscan and Italian art in the 14th century derive from the men of genius named above, who unified the Italian art culture and set its future course. Not that a number of highly original artists did not emerge in Italy and make new, often brilliant discoveries, but none of them attained the stature of the great pathfinders. We shall not attempt to deal with all the painters of the period, but confine ourselves to mentioning a few outstanding personalities and the most significant developments, and also to outlining the main trends and directives perceptible in the vast and varied output of this prolific age.

Beginning in Giotto's lifetime and continuing in the years immediately following his death, there was a great flowering of art in Florence, in which several front-rank artists played a part. They contributed in no small measure to the unification of Italian pictorial art. The leading figure of this period and milieu is unquestionably the painter of the frescos depicting *Episodes in the Life of St Sylvester*, in the Santa Croce Church at Florence. If we are to believe Ghiberti, they were painted by Maso, rightly regarded by him as Giotto's ablest pupil. Particularly striking is the originality with which he develops and transforms Giotto's formal and spatial conceptions, notably those exemplified in the frescos of the Bardi and Peruzzi Chapels, and in particular the architectural features in *St Francis renouncing the World* and *St John the Evangelist raising Drusiana from the Dead.*

In Giotto's frescos this vision stemmed from intuition pure and simple and was expressed with equal purity and simplicity. Maso seems to enlarge on it, almost one would say deliberately to draw attention to it, were it not for the poetic inspiration pervading all his work. Still it is evident that, despite its poetic tenor, the artist pondered deeply over the structure of his compositions and that intellect guided imagination in their making; hence a certain tendency towards stylization and that combination of disciplined artistry with noble spirituality which gives his work its singular charm.

A pillar and a broken arch placed on the left define the foreground of *The Miracle of St Sylvester*, while ruined walls mark the limit of the middle distance in which the successive stages of the miracle are illustrated. The background consists of an architectural complex handled by Maso with a geometric precision that almost brings to mind the "metaphysical" art of a much later age. This is perhaps the most accomplished

solution of the spatial problem ín all 14th-century art: a vast recession of colored, fully illuminated planes, whose rhythm is complemented by the stately gestures and the careful spacing of the figures. When we compare this architectural setting, these pure, unmodulated colors and somewhat harsh light effects with Giotto's last works, we realize how far Maso has advanced in the direction of abstraction.

The other scenes in the Chapel of St Sylvester, though some are no less pleasing to the eye, lack this poetic charm; they have too many "literary" touches and these later men had not Giotto's gift of fully integrating such material into the texture of the picture. On the other hand, their aristocratic elegance and sumptuousness might almost lead us to regard them as Florentine equivalents of Simone Martini's (perhaps contemporaneous) frescos at Assisi. As so often happens in the case of works of this description it was not so much owing to their intrinsic beauty as to their intellectual content that Maso's frescos had so powerful an influence on the subsequent development of Italian painting.

Formerly a group of frescos at Assisi, in the basilica of San Francesco and in other churches, was ascribed to Maso. As a result of recent research, however, it has been decided—rightly in my opinion—that they were made by some other artist, very likely

MASO (FIRST HALF OF FOURTEENTH CENTURY). THE MIRACLE OF ST SYLVESTER. FRESCO. PANEL FROM THE RIGHT WALL OF THE CHAPEL OF ST SYLVESTER. CHURCH OF SANTA CROCE, FLORENCE.

"the painter Stefano" of whom Vasari speaks. After Maso, this artist can justly be regarded as the greatest of the Giotteschi. In this group of works at Assisi we find poetic sensibility of the highest order, and though here too Giotto's influence is manifest, the motifs and formal qualities of these works display exceptional refinement. The San Remigio *Pietà* (in the Uffizi), a masterpiece that probably should be ascribed to a later generation, is in the direct line of descent from the works we have been discussing. Perhaps, following Vasari, we may ascribe it to Tomaso di Maestro Stefano, also known as "Giottino."

To the same art stream belong the frescos in the Strozzi Chapel of Santa Maria Novella in Florence. They are the work of Nardo di Cione (whose art was very different from his brother Andrea Orcagna's) and were probably made soon after the middle of the century. With the San Remigio *Pietà* they illustrate one of the most poetic phases of 14th-century Florentine painting, after that of the generation of the first great Giotteschi.

Henceforth the course of Tuscan art was shaped by various factors, stemming from Giotto and his disciples no less than from the Sienese masters. But all these ingredients are so well blended that it is hard to assign them to their sources. Undoubtedly in Nardo's frescos there are reminiscences of Sienese art; but they make their presence felt discreetly, indirectly. Indeed as early as the beginning of the century, a tendency developed in Florentine painting towards a softening of the outlines of forms by enveloping them in a gentle light smoothing out all asperities. This is well illustrated in the finest scenes of Nardo's fresco sequence in the Strozzi Chapel, especially in the figures of the Virgin, Christ and the two angel musicians, rendered in three colors, blue, pink and white. Here the characteristic Gothic elongation of the bodies reminds us of the statues in French cathedrals. This vast composition, to which the painter has obviously aimed at giving an archaic aspect, is held together by a smoothly flowing rhythm interspersed with motifs of an ethereal delicacy reminiscent of the charming inventions of Simone Martini. The most famous and most striking feature of these frescos is the long procession of female saints in the foreground: comely young women in highly elegant attire. It has the solemn languor of a long, slow melody weaving through the silence of the ancient chapel; a plain-song hymning the grace of youth and sainthood at their loveliest. The soft hues seem illuminated from within, glowing with a subdued radiance, and the effect is that of a dreamworld, ineffably serene.

If we have treated these aspects of 14th-century Florentine art at some length (similar trends can be detected in the work of Giovanni da Milano and in that of Giusto, who introduced them subsequently into Venetia), this is because, to our thinking, they strike a new note, quite other than that of the traditional, relatively familiar art of the Sienese and Giotto's followers. It must not, however, be inferred that we underestimate the importance of certain aspects of the art of such men as Taddeo Gaddi, Bernardo Daddi and Andrea Orcagna. Particularly noteworthy is the hieratic gravity, the sense of restrained drama present in Taddeo Gaddi's later work, for instance the Uffizi *Madonna* of 1355; or, again, the delicate minuteness (midway between the manners of Giotto and the Sienese), combined with lofty inspiration, of the predellas and small altarpieces

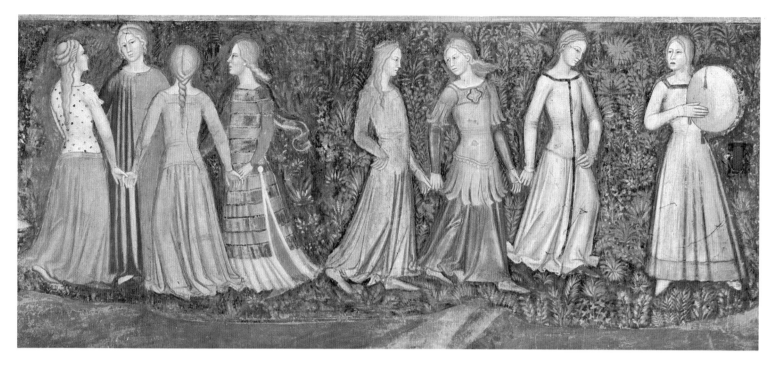

ANDREA BUONAIUTI DA FIRENZE (?-1377). FRESCO FRAGMENT FROM THE SPANISH CHAPEL, 1365.
CHURCH OF SANTA MARIA NOVELLA, FLORENCE.

painted by Bernardo Daddi. Nor must we overlook the part played by Nardo di Cione's brother, Andrea Orcagna, towards the middle of the century, chiefly by reason of the academic sharpness of definition he imparted to his renderings of forms. In his last works there are touches of Gothic feeling and idiom; we find them also in the work of such men as Agnolo Gaddi and Spinello Aretino, who however belong to the Late Gothic phase, one of whose most notable exponents at Florence was Lorenzo Monaco.

The frescos made in 1365 by Andrea Buonaiuti da Firenze in the Spanish Chapel are of considerable interest. Though their trend is allegorical and their aim didactic, and though they rarely have much poetic feeling, there is no question of their brilliant originality. They also show that Florentine art, while starting out from purely intellectual data, was quite capable of handling vivaciously big narrative sequences. Here, too, we see traces of Sienese influence, notably in some of the more animated scenes, such as that of girls dancing in an orchard. This scene reminds us of Ambrogio Lorenzetti and Simone Martini; indeed it has much of the elegant, courtly realism of the Avignon School. The fresco sequence in the Spanish Chapel might well have been made to the order of some dignitary of the Papal Court, a worldly-wise ecclesiastic or a cultured layman, whose attitude to the scriptures and theology was coolly critical and who set more store on the amenities of his earthly life than on the welfare of his soul.

There is no denying that, as compared with the achievement of the great artists mentioned above, those of the Sienese seem more provincial, narrower in scope. One of the best painters of this second period was Barna, who is mentioned by Ghiberti and

known to have been a close friend of Simone Martini. However, the warm, vibrant colors of his fresco sequence of New Testament scenes, in the collegiate church at San Giminiano, are very different from Simone's. A few other pictures, notably the Asciano *Madonna*, have been ascribed to him, all executed with a delicate grace of touch.

The frescos (ca. 1360) depicting *The Triumph of Death*, *The Last Judgment* and *Lives of the Hermits* in the Pisan Camposanto rank amongst the finest and most famous decorative compositions produced during the entire 14th century. Their authorship is a moot question; were they painted by a Tuscan or a Bolognese master? Perhaps discussion of this problem should have been deferred until we come to deal with the art of Emilia. Yet though in some respects they have obvious affinities with the School of Bologna, we are definitely conscious of other influences. Never, for example, do works produced in Bologna reveal influences so definitely stemming from Sienese art and from that of Orcagna. Indeed it is not going too far to say that the fine sense of balance

UNKNOWN MASTER. THE TRIUMPH OF DEATH, FRAGMENT. FRESCO, CA. 1360.
CAMPOSANTO, PISA.

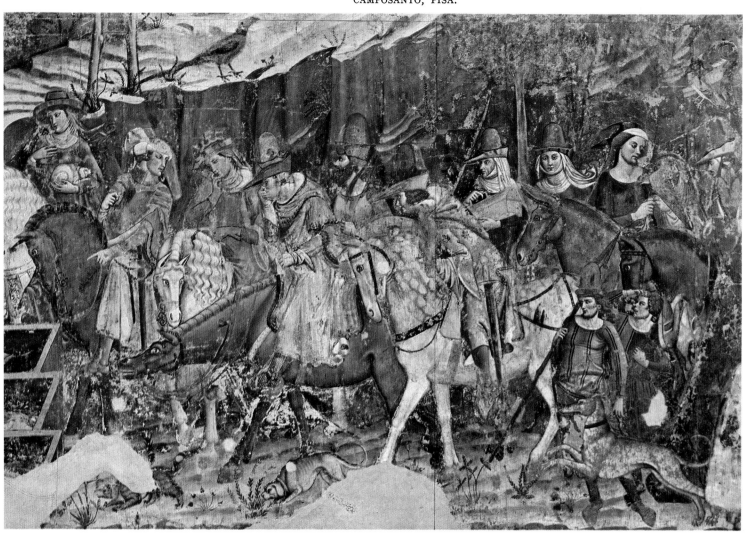

we find in these frescos affiliates them, rather, to the Tuscan tradition. This painter may have been a Tuscan who traveled or studied art in Emilia; or else a Bolognese who left his native city and settled in Tuscany. However this may be, one thing is certain: his work transcends the scope of Emilian art and its inspiration is mainly Tuscan.

The most famous scenes in *The Triumph of Death* are those of the riders, the poor folk confronting Death, and the gay company making music while above the house-tops a horde of devils is unleashed. Truly amazing in these scenes, and indeed in the whole sequence, is the power with which the painter conjures up his personages before us; they fill space with their gestures, each face is eloquently characterized. No doubt similar traits can be found in the work of many Bolognese painters; but whereas in their case the cultural tendencies behind their work make themselves felt in a haphazard, or imprecise manner, in the Camposanto frescos we are conscious that the artist had a humanistic background and stemmed from an homogenous, stable cultural milieu. Even though in certain details he seems to step up his expression to the pitch of frenzy and, especially when rendering gestures, to play fast and loose with plausibility, there are on the other hand moments when his work achieves a spacious calm, a plastic fullness affiliating it to the best Tuscan art. As a rule, however, we find the two currents intermingling in a rich poetic harmony, and indeed, with their complex yet fully integrated composition, these frescos are one of the peak-points of 14th-century Italian art.

It was by way of the Rimini painters that Tuscan culture and Giotto's art became known in northern Italy. Not all of these Rimini painters were artists of the first rank, but all sprang from the same cultural soil, had breathed the same artistic atmosphere, and they created what was in effect a new school of unquestionable originality.

Chief among them was the painter of the frescos in the Campanile Chapel of the Church of St Augustine at Rimini. Probably a Tuscan, he may be regarded as one of Giotto's ablest pupils, for we must not forget that the Master himself worked for a time at Rimini. However it would seem that this artist drew his inspiration from Giotto's earlier work, in particular his first Assisi cycle.

In the same church another very fine painter decorated the back of the apse with two big scenes: *Christ enthroned between the two Saints John* and a *Virgin in Glory*, while on the triumphal arch he depicted *The Last Judgment*, fragments of which can now be seen in the Sala dell'Arengo.

Both were very great artists, the one profoundly moving, the other more exuberant and grandiloquent, and both alike made Roman tradition and the art of Cavallini their starting-off point at the time when a give-and-take between the art of Giotto and the latter was developing.

It is not known if these two painters were natives of Rimini. In any case there is no trace of provincialism in their work, nor, generally speaking, does it owe anything to the local traditions of north Italian art. There is no doubt that they gave the initial impetus to the School of Rimini and the Romagna which was to flourish for some fifty years. Fascinated as they were by the Byzantine art whose splendors could be seen in nearby Ravenna, its members never swerved from that path or paid heed to the new

art developing in Tuscany. Thus these Rimini painters have a somewhat archaistic flavor, something of the hieratic gravity of an earlier age. Yet we should be wrong to regard them as retrograde or archaeologically minded; their work included new elements, which however were fully integrated into the style they had deliberately forged out for themselves. Indeed one might go so far as to say that the more new elements their work contains, the more we feel its majestic power and its nostalgic evocation of a world of bygone beauty.

In the Church of St Augustine we have a veritable treasury of the masterpieces of the Rimini School. Besides those described above there is another fresco cycle illustrating *Scenes from the Life of St John the Evangelist,* a large-scale work which in some respects strikes a new note. For this painter had a very real gift for naturalistic observation and the "human touch." True, his work has not Giotto's grandly measured composition or the Sienese sense of rhythm and space; nevertheless both in its lay-out and in the treatment of details are touches of lively imagination differentiating it from Tuscan art. Perhaps we have here the work of an Emilian painter acquainted with the vivacious, witty innovations of the Bolognese. Not that he deliberately broke with the classical conceptions of the Giotteschi who some years before had worked on decorations in the same church. Incorporating these, he composed a sequence of scenes which for all their animation, seem like reflections in a tranquil lake. There is nothing here of the incisiveness, the textural excitement of similar Bolognese productions; the smoothly flowing colors have the bright simplicity of spring flowers. This painter, in fact, has a very fine feeling for color, which he handles quite otherwise than his contemporaries. Nothing could be more delightful to the eye than this gay color orchestration of delicate pinks and greens, violet and pale blue. Even when depicting incidents calling for spectacular effects, such as *The Earthquake at Ephesus,* he imparts to them something of the atmosphere of an old-world fairy-tale.

This School was nothing if not prolific, and we shall not attempt to deal in detail with its enormous output. This much may be said: that, viewed as a whole, it produces the effect of an immense chorale scored for many voices, so consonant are the various "parts." In this connection mention may be made of Neri da Rimini, the illuminator, and Pietro da Rimini, painter of the Urbania *Crucifixion,* some fine frescos in the Santa Chiara Church of Ravenna and the *Deposition* now in the Louvre. Giovanni da Rimini whose signature can be read on the Mercatello *Crucifixion* (1345) was a great painter who carried on the Giotto tradition; he must not be confused with Giovanni Baronzio, who in the same year painted the *paliotto* in the Urbino Gallery. Francesco da Rimini, who worked at Bologna, links up more closely with Giotto.

As a whole this art current ran counter to a new form of art which was only just coming to the fore at the time when that of Rimini was at its zenith, and whose place of origin was another great Emilian city, Bologna.

There is no question of the absolute originality and novelty of these Bolognese artists' contribution to Italian art. It is not in any sense, like that of Rimini, an outcrop of Tuscan art; the cultural and intellectual roots from which its idiom derived were

UNKNOWN MASTER OF THE RIMINI SCHOOL. THE EARTHQUAKE AT EPHESUS, FRAGMENT. FRESCO, CA. 1330-1340.
CHURCH OF SANT'AGOSTINO, RIMINI.

VITALE DA BOLOGNA (FL. 1330-1360). THE NATIVITY. FRAGMENT OF THE MEZZARATTA FRESCOS, CA. 1345.
PINACOTECA, BOLOGNA.

totally different. Its aspirations took, in fact, an opposite direction, involving a new relationship between imagination and the cultural background, between emotion and the counsels of the thinking mind. Strongly imbued with classical tradition, Tuscan artists kept their flights of fancy under vigilant control and took careful thought before embarking on creative action. Thus all the elements of the composition were plotted out, co-ordinated, and a new form of expression was arrived at, all the richer, the more meaningful, for being rooted in an historic past. The Bolognese artists, on the other hand, frankly broke with classical tradition—indeed with any established tradition whatsoever. They worked as a corporate body which, thanks to the famous "Studio," was in touch with all the countries of Europe, and they were accessible to very diverse influences, unlike the Tuscan painters whose art, stemming as it did from an homogeneous culture, attained a higher qualitative level. Hence the relative laxity of the Bolognese style, incorporating as it did so many and such diverse tendencies.

The fact is that the Bolognese painters failed to understand or, if they did, rejected the intellectual self-discipline practiced by the Tuscans and preferred to trust to the inspiration of the moment. And thus their art lacked a solid basis. Some minor painters developed a picturesque idiom of their own, with occasional touches of real inspiration, but its range was limited. The really great artists, however, men like Vitale or Jacopino (in his best works), thought out for themselves new laws and a new pictorial architecture within which they could freely exercise their imagination. True, it was an unstable structure at best, liable to change at any moment; yet it served its end. As often happens in such cases, the elements of Tuscan tradition they took over and embodied in their compositional schemes were frequently changed out of recognition or even given values diametrically opposed to those they had in Tuscan art. To these changes or transvaluations (which have often a rather puzzling effect) is due the poetic appeal, unique in its way, of the work of the Bolognese artists and the marked originality of their expression. In short, new possibilities, new pictorial horizons were opened up by this escape from, or break with, the past.

Widely diffused in northern Italy, the art of Vitale and the Bolognese in general sponsored a new, quite distinctive way of seeing the world, and this new vision sometimes accompanied, sometimes ran counter to the main stream of Tuscan art. In studying north Italian art during the 14th century we have to take account of these cross-currents involving very different forms of expression: those of Bologna and Emilia, which intermingled with each other in Lombardy, owing largely to the persistent infiltration of Gothic art into that region; those of the Tuscans and, lastly, the forms of Byzantine art whose imprint makes itself strongly felt until the middle of the century and which also did so much to shape Venetian art throughout this period.

Though Bolognese art included elements stemming from so many different sources, it did not show any preferences, but took them all, impartially, in its stride. From the start of his career Vitale showed his readiness to adopt procedures invented by artists north of the Alps; these were, in fact, far more congenial to his wayward temperament than the formal austerities of the Rimini group.

This was the heyday of the famous University of Bologna, and French Gothic illuminated manuscripts found their way in large numbers to that city. The illuminated books then produced at Bologna—to begin with they may not all have been the work of Bolognese artists—were crowded with typically Gothic motifs. One of the handsomest is unquestionably the Latin Bible now in the Bibliothèque Nationale, Paris; the pages are sprinkled with Gothic fantasies and grotesques, and the lay-out of each page follows the "aulic" style of classical-Byzantine tradition. The "Franco Bolognese" whose praises Dante hymned was certainly one of those great illuminators, touched by the grace of the new culture, who came to the fore at the beginning of the century. And meanwhile another masterpiece in the purest North Gothic style, that superb English cope in the Church of San Domenico had found its way to Bologna.

The delicate patterning of line which in the 13th and early 14th centuries had given their distinctive charm to so many French illuminated manuscripts had been taken over by Sienese painting. But in Sienese art it was transformed, its irrelevancies and incoherencies were eliminated, and the Gothic elements completely merged into the balanced, monumental structure of Tuscan art. In Vitale's art, on the other hand, and this is also true of the contemporary Bolognese illuminators, these elements are incorporated in approximately their original state and we find in the work of these artists an exquisite nicety of line, verging on preciosity, while at the same time they show leanings towards what nowadays we would call "Expressionism." That is to say they exaggerate gestures, movements and facial expressions almost out of recognition and vigorously accentuate each detail of the narrative. All the elements of the composition are treated in terms of the linear rhythm, an essentially anti-classical, centrifugal rhythm, implemented by a line sometimes harsh and vividly emotive, sometimes languorous, reposeful.

Vitale, it is true, never discarded certain aspects of Tuscan art, on which indeed all the diverse currents of 14th-century Italian art converged almost as a matter of course. Nevertheless in several highly significant respects we can see that he departed from the Tuscan tradition and this, as we have shown, was due to contacts with the North, that is to say with Gothic art. Thus here we see again, if under other forms, that intermingling of French Gothic with Italian culture which had characterized the work of the Sienese painters in general and Simone Martini in particular. It is an interesting point that Vitale's finest paintings, those in which he gives freest play to his poetic fancy, are precisely those in which the Gothic strain is most pronounced and which prefigure the art trend which was to come to fruition at the end of this century and at the beginning of the 15th.

The Mezzaratta frescos now preserved in the Pinacoteca of Bologna, which fall within the class described above, can be dated, tentatively, to 1345 or thereabouts; that is to say to Vitale's middle period, since his active career spanned the thirty years from 1330 to 1360. That charming scene *The Nativity* is full of poetically imaginative touches, for example the angels dancing for joy like merry children around the Christ-child's manger, the Virgin and the animals. Noteworthy is the boldness with which the

figures are distributed in space and the freedom of the composition, whose turbulent rhythms are tranquillized as it were by the innocent gaiety of the colors. We find much the same poetic charm and many stylistic similarities in *Episodes from the Life of St Anthony*, also in the Pinacoteca of Bologna. Here a wholly irrational, imaginary space, existing only in the artist's mind but appropriate to each scene, and a uniform intensification of the expressive values of gestures impart an over-all unity to this dreamworld of creative fancy.

But Vitale's art has another side; there are times when it is more sedate, we might almost say more guarded, and we feel that the artist is aiming at a subtler composition, intricate, carefully wrought out. This tendency makes itself felt in his last period,

UNKNOWN MASTER OF THE BOLOGNA SCHOOL. THE TRIUMPH OF DEATH, FRAGMENT. FRESCO. CHURCH OF SAN DOMENICO, BOLZANO.

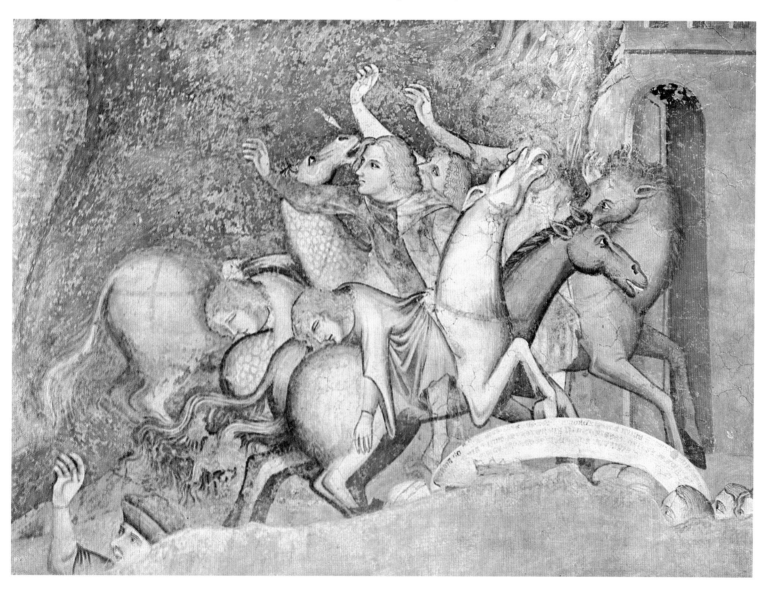

TOMASO DA MODENA (FL. 1345-1375). SCENES OF THE LIFE OF ST URSULA, FRAGMENT.
FRESCO FROM THE DOMINICAN CHAPTER-HOUSE, 1352. MUSEO CIVICO, TREVISO.

for example in the decorations of the chapel in Santa Maria dei Servi at Bologna, some parts of which have recently been brought to light. They illustrate Vitale's conception of the treatment of decoration on the grand scale. There is here a richness of ornamentation unique in Tuscan painting, rendered with the delicate grace of touch of the miniature painter; a gemlike brilliance of color in the decorative motifs, and tucked away in the friezes are tiny "drolleries" like the grotesques in illuminated manuscripts.

In the space at our disposal we must confine ourselves to brief references to some other Bolognese painters whose work displays a similar vivacity and expressive power. First we would mention one of Vitale's ablest pupils, Jacopino da Bologna, who struck a judicious balance between his master's methods and those of the Rimini group. Then we have Andrea who painted the *Scenes of the Life of St Catherine* in 1368 in the

GIOVANNI DA MILANO (FL. 1345-1370). THE BIRTH OF THE VIRGIN. FRAGMENT OF SCENES OF THE LIFE OF THE VIRGIN. FRESCO, 1365. RINUCCINI CHAPEL, CHURCH OF SANTA CROCE, FLORENCE.

Lower Church of San Francesco at Assisi; then another Andrea (Vitale's collaborator at Pomposa), Simone dei Crocefissi, Cristoforo and Lippo Dalmasio, and Jacopo di Paolo. Tomaso da Modena, however, a very fine artist belonging to the group which included Vitale and the illuminators, calls for special mention. After a short period of activity in Emilia he moved to Venetia, and in 1352 painted the frescos in the Dominican Chapter-house at Treviso. In very few 14th-century works do we find the naturalistic expression of personal traits—characterization, in other words—carried to such lengths as in that famous picture of *The Holy Doctors*. Noteworthy, too, is the vivacity of his *Scenes of the Life of St Ursula*. Though we must not look to him for the soaring lyricism of Vitale, he shows a more exact, more intimate observation of nature and a feeling for the significant detail. In fact much of this work reminds us of a narrative couched in the robust, efficient prose of the mediaeval chroniclers; the picture of life it gives is healthy, forthright, racy of the soil. A somewhat heavy-handed rendering of form is remedied by wonderfully vibrant, light-saturated color. This painter opened up a new world to art, human through and through, "of the earth, earthy," a world of simple joys and sometimes savage violence, in depicting which he often displays poetic gifts of the highest order. Tomaso was also an illuminator; indeed there are grounds for thinking it was among the miniature-painters of Bologna that he had his early training.

The School of Bologna was much influenced by the work of the local illuminators whose famous "codices" were sought after in all parts of Europe. But it was further North, and towards the middle of the century, that there arose that meticulously naturalistic yet lyrically emotive narrative art which came to be known as "Lombardy work"—that is to say the art of Giovannino de' Grassi and the earliest Italian manifestations of International Gothic.

The effects of these new trends were evident in painting in the large as well; even in the work of Giovanni da Milano, though, being a Lombard who had made his home at Florence, he was strongly influenced by the art of Tuscany. In his early works such as the *Pietà* in the Martin le Roy Collection, we find a highly ingenious handling of linear rhythms; in the Prato polyptych a tendency to dematerialize forms; and in the Uffizi polyptych an extreme delicacy in the choice of colors. The aristocratic elegance, shrewd observation faintly touched with irony, which we find in these early works are also present, if only incidentally, in his largest and last work, the frescos (1365) in the Rinuccini Chapel of the Santa Croce Church at Florence. In some parts of these frescos it would seem that the painter was handicapped by the necessity of treating his subject with a gravity that did not come naturally to him, but whenever the themes lend themselves to more intimate, more naturalistic treatment and he can assimilate them to everyday reality he is at his vivacious best.

Emilian art was sponsored in Venetia not only by the work of Tomaso da Modena, but also by that of Vitale, Jacopino and other painters whose names are unknown. Of particular interest in this connection are the San Domenico frescos at Bolzano containing that wonderful *Triumph of Death* whose rhythmic vitality and fantasy, especially in the scene of the cavalcade, remind us of Vitale.

PAOLO VENEZIANO (?-CA. 1360). EPISODES FROM THE LIFE OF ST MARK, FRAGMENT. 1345.
BACK OF THE PALA D'ORO. CHURCH OF SAN MARCO, VENICE.

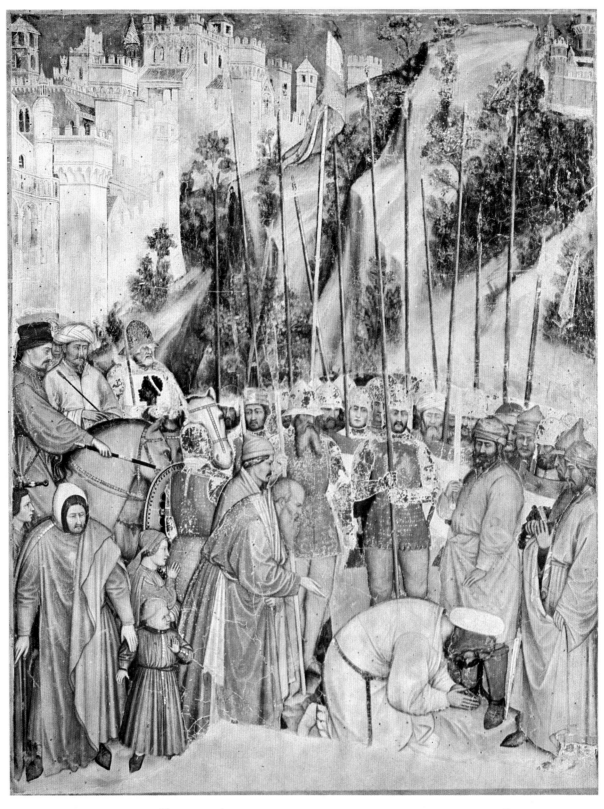

ALTICHIERO (?-CA. 1390). THE BEHEADING OF ST GEORGE. FRESCO, CA. 1385.
ORATORY OF SAN GIORGIO, PADUA.

Venetia was the meeting place *par excellence* of many art currents—Tuscan, Emilian, Lombard and Byzantine—and three cities vied for pre-eminence: Venice herself to start with, home of Byzantine tradition; then Padua, famed for her humanistic culture, scene of the activities of Guariento and Giusto di Menabuoi; and lastly Verona, point of confluence of several art trends and hometown of a very great painter, Altichiero.

A Venetian artist who flourished in the first half of the century, Paolo Veneziano, took over certain elements of Byzantine tradition but brought them into line with his very personal outlook on the world. It was he who achieved the feat of integrating ancient tradition, Gothic elements and even some of the new procedures for rendering space into an homogeneous whole. We see this in *Episodes from the Life of St Mark* (1345) painted on the back of the Pala d'Oro at Venice, perhaps his best work. Warm golden light brings out the gemlike luster of the colors, while the composition is governed by a classical rhythm that, by way of Byzantine tradition, recaptures something of the pure serenity of Greek art. And despite their "antique" aspect, due in part to the finely balanced construction, these scenes embody a new conception of space.

Verona on the other hand kept open house to the most varied and vital art forms of the century, and Verona was Altichiero's birthplace. His style included all that was most advanced in contemporary art, combining naturalistic trends with the new approach to reality we find in the work of the Bolognese, of Tomaso da Modena, Giovanni da Milano, and also in Lombard and Bolognese illuminations. With these elements assimilated and transformed, Altichiero built up a personal style, basic to which was the structural solidity of Tuscan composition. Thus his art was not merely intuitive, governed by the emotive drive of his poetic vision; it owed no less to his quest of formal integrity. Not that his poetic inspiration ever flagged; on the contrary it breathed life into the skillfully co-ordinated fabric of his art. True, a vein of rather provincial ostentation can sometimes be detected in Altichiero's work; he obviously likes to parade his astounding manual virtuosity, to prove that nothing comes amiss to him and that he can record the facts of optical experience with absolute precision. Thereby he proves himself a true Northerner; he applies his technical skill to the depiction of reality, of mundane things, of the world of ordinary men. And this he does with prodigious facility; indeed he is sometimes over-lavish of his means. Much of the poetic charm of his art resides in his power of entering into the inmost life of his subject, for beneath his seeming objectivity lies very real emotion.

The only picture Altichiero painted in his birthplace can be seen in the Church of Sant'Anastasia at Verona. In this votive fresco commemorating the Cavalli family we see knights in shining armor kneeling before the Virgin surrounded by the angelic host. Alongside the knights are patron saints clad in the rich costumes of the period. The atmosphere is that of a friendly gathering; one feels that all the persons represented, divine and human, are on easy terms with each other. Softly radiant in the flesh-tints, the color is modulated with an elegance anticipating that of Gentile da Fabriano and Pisanello.

These qualities are strikingly present in the two great Paduan cycles in the Chapel of San Felice del Santo (1379) and the Oratory of St George (ca. 1385). Amongst those

who collaborated in the latter work was a certain "Avanzo," perhaps to be identified with Jacopo·Avanzi of Bologna. Avanzi's use of jagged outlines and his preference for sharp fragments as against a coherent whole differentiates his work from Altichiero's, in which there is no break in the even flow of the narrative and everything falls naturally, smoothly, into place. Thus in *The Beheading of St George* (in which the figure of the man holding a child's arm on the extreme left may be by Avanzo's hand) there is perfect cohesion between the figures and the landscape setting. With their tall lances silhouetted against a background of precipitous cliffs, a group of soldiers encircles the kneeling saint and the headsman with his sword poised ready to strike. All movement seems arrested in this solemn moment, this brief but tragic pause in the narration.

If now we cast our minds back to the Scrovegni Chapel, we realize at once how far removed is Altichiero's art from Giotto's, from its transcendent vision of reality, and its quest of absolute values behind the world of appearances. It was somewhat on these lines that the masters of the Renaissance proceeded, but in the 14th century the tendency was, rather, to abandon Giotto's rigorous synthesism in favor of a greater latitude. New interests, new forms preoccupied the artists, culminating in Altichiero's full-fledged naturalism. And we cannot doubt that these new departures had a salutary effect on the subsequent course of Italian and indeed of all European art.

COURT ART

THE AVIGNON INTERREGNUM

MURAL DECORATION AND TAPESTRIES — FRENCH ART UNDER THE VALOIS

THE COURT PAINTERS OF THE DUKES OF BURGUNDY

THE DUKE OF BERRY AND HIS ILLUMINATORS

THE ROYAL DOMAIN — COURT ART IN ENGLAND

RISE OF THE SCHOOLS OF VALENCIA AND BARCELONA

THE COURT OF CHARLES IV AT PRAGUE

THE GERMAN AND AUSTRIAN SCHOOLS

TEXT BY JACQUES DUPONT

★

ITALIAN MANIFESTATIONS OF INTERNATIONAL GOTHIC ART

TEXT BY CESARE GNUDI

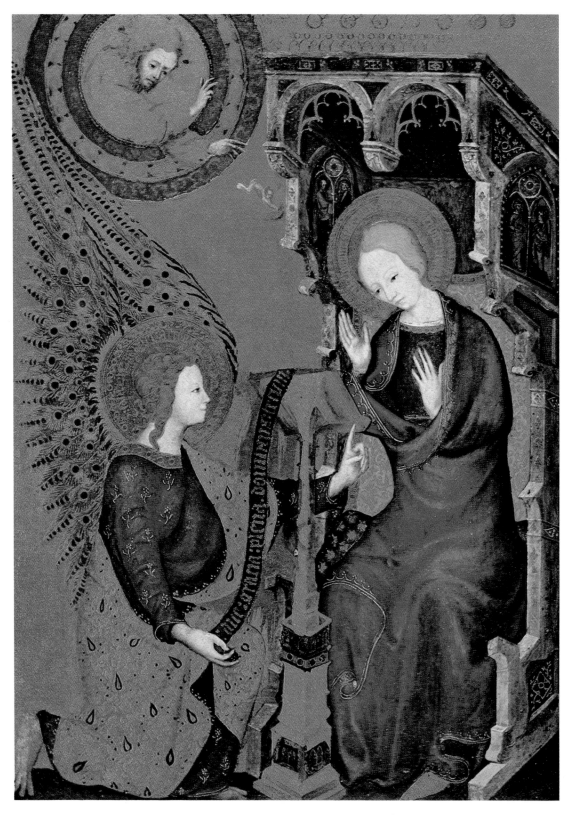

UNKNOWN MASTER. THE ANNUNCIATION, CA. 1390. (13¼ × 9¾")
ARTHUR SACHS COLLECTION, CLEVELAND.

COURT ART

THE 13th century had witnessed the rise of an urban culture, and a monarchical system which, bypassing the feudal principalities, now relied for its support on towns and cities had arisen in France and England, and, slightly later, in Spain. During the 14th century both processes were speeded up. There was a rapid expansion of economic activity, and the monarchies, confident in their new power, put an end to the ambiguous situation which had so long prevailed in western Europe owing to the predominance of the spiritual authority of the Holy See over the temporal authority throughout Christendom. Likewise the political system based on the prestige of the Holy Roman Empire and the joint authority of Pope and Emperor, which had already been showing signs of instability, now fell to pieces. It was France who took over, *de facto* if not *de jure*, the heritage of the Empire. When Philip the Bold proposed himself for the German crown, he made no secret of his desire to re-establish for his own benefit Charlemagne's continental empire, and similarly Charles of Anjou, King of Sicily, had visions of a new Latin Empire comprising all the Mediterranean area. The plans of both fell through for, like the Hohenstaufens, they came up against the mediaeval concept of the inviolable unity of Christendom under the aegis of the popes.

More realistically minded, Philip the Fair pursued a short-term but judicious policy, by means of which he considerably strengthened the power of the French monarchy. When he died the only regions of the West that had kept any effective independence were Brittany and Flanders, the province of Guienne remaining in English hands, The king governed through a central administration staffed by members of the middle class, and with the aid of Italian bankers who supplied the necessary funds. The collaboration of the most vital forces in the country was indispensable if his project of consolidation was to be put through successfully; hence the king's reliance on the middle class, the only class in which the spirit of enterprise and the habit of thrift still persisted. For a complete change had come over the social order at the beginning of the 14th century, and the traditional hierarchy of classes had been profoundly modified. True, the Church was still extremely powerful, but its too obvious connection with Rome made it politically suspect. The notorious wealth of the clergy and their lack of apostolic zeal had led to the appearance of new heresies. The nobility, which had financed and borne the brunt of the crusades, was ruined, had lost heart in its vocation and degenerated into a parasitic, almost a playboy class. To live like a gentleman now

meant spending one's time on sports, hunting or making war. But though ready enough to sacrifice their lives on the battlefield in deeds of gallantry, the French nobility had a profound contempt for efficiency and were incapable of adapting themselves to the new developments in military tactics and technique. The series of defeats—Courtrai, Crécy, Agincourt—should have been a lesson to them, but they missed its point.

Thus we need not be surprised by the rapid rise to power of the new middle class, which now became the backbone of the social order. And, by the same token, the whole structure of that social order was modified in accordance with the great changes taking place in the economic life of western Europe.

As was to be foreseen, the development of international trade led to the reappearance of capitalism and therewith of social unrest. Most commodities were sea-borne, shipped from Venice, Genoa, Barcelona, Bruges, London, Hamburg, Danzig and Lübeck. But there was also a great continental highway running from Venice to the Danube, then branching off in one direction to Riga, by way of Prague, Budapest, Breslau and Cracow, and in the other along the Rhine to the Low Countries. The development of this trade route spelt the ruin of the international market-fairs in the Champagne district, which had so greatly prospered in the 12th and 13th centuries, and their place was taken by the marts of Bruges, Frankfort, Lyons and Geneva. Necessarily this widespread international trade called for corresponding currency facilities and the use of the bill of exchange, first employed in the Champagne fairs, now became generalized.

It was in Italy, in the 14th century, that the system of "bills" and protests in the case of non-payment originated. Florence minted her own florins, Venice her gold ducats. Rich families and monasteries took to investing their money at fixed interest rates. The banks of Siena and Florence were wealthy enough to finance the political activities of Philip the Fair. Meanwhile, however, artisans and workmen were banding themselves in guilds and corporations so as to counter the domination of the moneyed classes, and a conflict became inevitable.

The system of obligatory membership in what we now call trade unions led to the formation throughout Europe of a lower middle class, and the object of the guilds was to champion the cause of the craftsman or artisan, whether working on his own account or as member of a group, against the capitalist employer. During the periods of economic depression following on the all-too-frequent wars, there was widespread social discontent which sometimes flared up into rebellion. Flanders, "cross-roads of the highways of the North," was the scene of the first organized conflict between capital and labor. Flemish "trade-unionists" played a part in all the movements for reform in England, Bohemia and Paris. *"Vive Gand"* ("Up with Ghent!") was the workers' war-cry in the streets of Paris and Rome. But vigorous capitalist reprisals at Roosebeke and Florence in the same year, 1382, quelled effectively these stirrings of revolt. The result was that the best artisans and artists, realizing the impossibility of earning a decent livelihood in their own country, migrated from the great manufacturing centers of Flanders to the princely courts of Europe. Indeed the only generous patrons of the artists were the kings and princes of the day and their entourage, whose cultured or would-be

cultured tastes indicated them for this role. For it was in palaces and the homes of the aristocracy that, whether sincerely or affectedly, the work of art was held in honor, and elegance admired. True, the universities and colleges had lost nothing of their renown; indeed some new universities were founded, the University of Prague, for example, in 1348. But their educational methods, still restricted to a sterile exposition of the ancient texts, allowed no scope for the free exercise of the intelligence. There were endless disputations between the Neo-Platonists and the Nominalists, whose god was Aristotle. But, happily immune from this pedantic, clerical, soul-deadening erudition, another way of living and thinking, aristocratic in outlook, was gaining ground in the courts and châteaux. There everyone, young and old, was reading translations of works by pagan authors, romantic tales of love and derring-do, and the taste for this literature was shared by the well-to-do middle class. With its emphasis on courtesy and knightly honor, the courtly-social moral code which these books extolled as against the sterner morality preached from the pulpit was doubtless of a rather superficial order. Still this code of honor certainly existed. We must beware, however, of accepting the picture of the social life of the day given by Dante, Petrarch, Boccaccio or Chaucer at its face value; indeed the historical interest of their works lies chiefly in the fact that in them for the first time great authors expressed themselves not in a dead or artificial language but in their mother tongues.

Though at first sight this brief summary of economic and social conditions may seem to have no bearing on art, it must be remembered that the art of any given age is often a mirror held up to the social order of the day and the expression of a certain way of living. Thus we need to know something of the background against which the 14th-century artists produced such brilliant work. We have not dwelt on such spectacular historical events as the Hundred Years' War; actually it only affected certain limited areas and had no direct effect on the art of the time. The Hundred Years' War strikes us today as being no more than a long and lamentable series of futile conflicts between princes of the same blood, of the same culture, and speaking the same tongue. But perhaps at this stage of European history we lack the objectivity which would enable us to view such events in true perspective. France and Great Britain then constituted a vast Franco-British empire; all western France was in English hands, but the King of England recognized the French king as his suzerain. Indeed England was regarded as no more than a fragment of the continent, separated by a narrow arm of sea; it was only in the 15th century, with the wakening of a new sense of nationality in France, that England grew aware, politically speaking, of her insularity.

The similarity of the social structure everywhere in the west, the uniformity of European culture, active commercial intercourse and the absence of defined frontiers facilitated the diffusion of a type of art which, while not absolutely international (really this epithet is inapt, for "nationality" as we understand it did not yet exist), manifested itself throughout Europe under forms more or less conditioned by the racial backgrounds of the artists, by their individual temperaments or by the personal taste of their aristocratic patrons.

THE AVIGNON INTERREGNUM

The prevalent social and economic unrest was aggravated by the crisis which had arisen within the heart of the papacy. The nationalistic ideas behind the new monarchies of western Europe ran counter to the mediaeval conception of Christendom as an indivisible whole owing allegiance to God alone, and a clash between the spiritual and temporal powers seemed inevitable. However, on the death of Benedict XI in 1305, Philip the Fair, having taken care to "pack" the conclave with his supporters, secured the election of a French pope, Bertrand de Gouth, who took the name of Clement V.

For some time the popes had been absenting themselves from Rome so as to escape the atmosphere of party conflict and dissensions prevailing in the Eternal City. After his coronation at Lyons Clement V took up residence at Avignon, where he soon became a docile tool of the French king. Hoping to fortify their status by a display of pomp and power, the French pontiffs were at pains to make their court at Avignon as magnificent as possible. This was a costly undertaking and to meet the expenses it involved, they now levied taxes on the emoluments accruing to the clergy in the exercise of their functions, and as was to be expected, this irritated both the clergy and their congregations; it was only a step to accusing the pope of simony.

Meanwhile Clement's favoritism towards France was making him unpopular in England, where a movement was set on foot by Wycliffe, who protested against the temporal power of the Holy See, asserted that the head of the church in England was the king and not the pope, and demanded the secularization of the property of the clergy.

The situation was becoming dangerous and Gregory XI, taking advantage of a brief setback of French ascendancy, left Avignon, ended "the Babylonian captivity of the Church," and went back to Rome (in 1376). There St Bridget implored him to set his house in order and to purify the Church which had, as she put it, become no better than a brothel. But the trouble was too deep-seated; when, on Gregory's death in 1378, Urban VI succeeded him, the French cardinals declared the election void and elected Clement VII in his stead. New factions gathered round the popes and antipopes, with the European kingdoms taking sides for one or the other, and the Great Schism went far to justify the heresy of the Bohemian reformer John Huss. Now that the Church had failed them, many devout Christians, not knowing where to look for spiritual guidance, took refuge in mysticism. The ancient city of Avignon was completely transformed by the arrival of the antipope and became a great cosmopolitan center. The local artists were quite unable to cope with the demands of a host of wealthy patrons, the result being that painters and decorators were called in from outside.

The first we hear of is an artist from Toulouse, a Minorite brother named Pierre Dupuy, whom Pope John XXII put in charge of the decorations in the Papal Palace. A team of decorators, for the most part French, worked for ten years in the Chapel of St Stephen (in the Palace) and also in the Chapels of Notre-Dame-des-Doms; none of their work there has survived, but we are tempted to ascribe to them the Sorgues

frescos, discovered in the ruins of the Palace of John XXII. These are scenes of country life, in some ways resembling those in the Robe Room, but of a simpler, almost artless order; indeed they have almost the look of enlarged miniatures.

Under Benedict XII there was an influx of Italians; Sienese bankers, money-lenders, businessmen and clerics made their way to Avignon in ever-increasing numbers, and with them came painters better qualified than their predecessors for carrying out the Pope's great decorative schemes. When Paolo of Siena arrived in 1322, he had already been preceded by Lombart and Docho of Siena. Next came Simone Martini with his wife and his brother Donato, and his stay at Avignon was brightened by the company of Petrarch, his poet friend. He did not work in the Palace itself but on the porch of Notre-Dame-des-Doms. Unfortunately his *Virgin and Child with Angels* is now in a ruined state, and his *St George slaying the Dragon* on the right wall of the porch, a work imbued with all the glamour of the Golden Legend, disappeared long ago. Indeed we would know nothing about his work at Avignon were it not that the charming polyptych he painted for Cardinal Napoleone Orsini (whose armorial bearings figure on it) has survived, though not *in situ*, being dispersed in Paris, Antwerp and Berlin. The exquisite drawing, vibrant color and dazzling sheen of the gold grounds in these small panels must have been a revelation to those who saw them at Avignon. The French miniature had never yet achieved such density, such powerful composition —for these scenes are, in fact, miniatures, but miniatures on which the artist has brought to bear the skill acquired in large-scale painting. Some panels attributed to this period can be seen in the Aix-en-Provence Museum. The *St Louis of Toulouse*, presented to the nuns of St Clare in 1340 by Robert le Sage, King of Sicily, an *Annunciation* and a *Nativity*, both of an exquisite elegance, and a set of works grouped under the name of "The Master of the Codex of St George"—all testify to the diffusion of the Sienese style in France.

In or about 1343 Clement VI nominated Matteo Giovanetti superintendent of the decorations of the Palace, and his choice of an Italian for the post is of special interest. For this Pope, who had been successively Abbot of Fécamp, Bishop of Arras, Archbishop of Sens, then of Rouen, had spent most of his life in the north of France, in touch with the royal court, and in virtue of his functions must have had dealings with many French painters and illuminators of the day. The fact that, nevertheless, his choice fell on a foreigner proves that, in the Pope's opinion, no French artist of the day was capable of coping with the vast decorative projects he had in mind.

The first task set the painter—the decoration of the Pope's private study—showed that, notwithstanding his choice of an Italian master-painter, the ex-Bishop of Arras retained the tastes he had acquired in northern France. For the theme he chose was an ideal garden, a sort of Earthly Paradise, with huge trees laden with flowers and fruit and so tall that only a thin strip of sky showed above their summits; and in this garden elegant members of the nobility happily indulging in the various recreations appropriate to their rank of which we hear so much in the old romances: fishing in fish-ponds, stag-hunting, rabbiting, falconry and even children's games—perhaps

somewhat incongruous in their setting but quite in keeping with the tradition of the northern tapestry-makers. On the technical side, however, both the rendering of landscape and the treatment of the figures are typically Italian, and have nothing in common with the French style characterizing the Sorgues frescos.

Giovanetti's other works (in the Chapel of St Martial and that of the two Sts John) are so completely in the Italian tradition, compositionally and iconographically, that one almost wonders what they are doing in Avignon. He had, of course, a whole team of his fellow countrymen working under him: Riccone and Giovanni d'Arezzo, Pietro da Viterbo, Francesco and Nicolo from Florence, Giovanni di Lucca from Siena. True, the long list of workers includes persons coming from every corner of France, from nearby Catalonia, even from England. But we may assume that they were merely subordinates, the figure painting being done exclusively by the Italians and the others doing the spade work so to speak—preparing surfaces and pigments and so forth, no light task in those days—and painting in backgrounds and ornaments. Otherwise the over-all uniformity of style would be inexplicable.

We have to cross the Rhone and Villeneuve-lès-Avignon before coming to the small Chapel of St John the Baptist near the church consecrated by the Pope in 1358. Though there has been a good deal of deterioration, some parts of these frescos have kept their original colors. A typical work of the Avignon School, they depict the Life of St John, apostles and angels in the vault. In this confined space the effect of one of the frescos placed in a prominent position—the subject is Christ on the Cross between the Virgin and St John—is all the more striking because nearly all the color has disappeared; only the essential linework, the bare bones as it were, remains. Hence its extraordinary suggestive power; we do not miss the wanished color, so compelling is the emotion conveyed by the tall figure of St John wringing his hands in agonized despair and the frail form of Mary swaying beneath the burden of her grief.

Did there exist, one wonders, another form of expression independent of and differing from the official art of the Papal Court: a sort of compromise between Sienese technique and the lively sensibility of the South of France? There is very little evidence to go on; yet that singularly charming work, the Thouzon altarpiece, whose Provençal provenance has never been questioned, seems to warrant this view. For all his Sienese air, *St Sebastian* in his red cloak is racy of the soil of southern France, and the man who made this picture, though definitely affiliated to the Avignon School, had a highly original and independent personality. On the other hand, *The Bearing of the Cross* in the Louvre—painted on parchment, it has greatly suffered from the ravages of time— was unmistakably inspired by Simone Martini's small panel, also in the Louvre, though its more "Nordic" style of execution (in gouache) gives it a certain resemblance to the work of the Paris School. Mention must also be made of a group of small panels traditionally ascribed to Avignon, though since the 1904 Exhibition of French Primitives their number has been much diminished. *The Adoration of the Magi* and the *Death of the Virgin* in the Morgan Library are now thought to have been painted in Prague, while the *Annunciation* in the A. Sachs Collection may well be the work of a Parisian

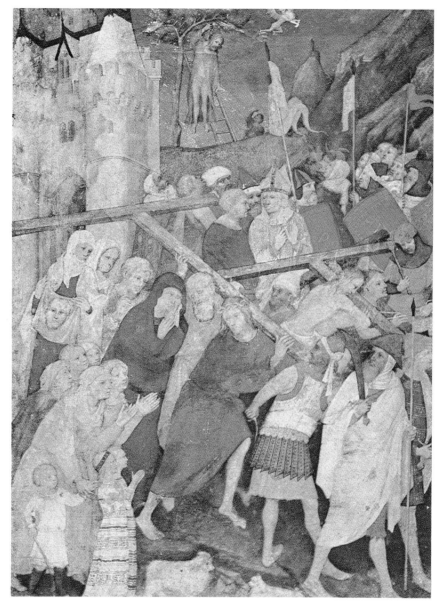

UNKNOWN MASTER. THE BEARING OF THE CROSS, WITH TWO DONORS. CA. 1390.
PAINTING ON PARCHMENT. (15 × 11″) LOUVRE, PARIS.

artist. In any case none of these works shows any intimate connection with the Sienese art milieu; they pertain, rather, to a specifically French style shaped by tendencies deriving from the North of France.

Though records of the time make it clear that Avignon kept in constant touch with Paris, there is nothing to show that the papal School of Avignon played any part in the development of the School of Paris and the French style. Such Italian influences as make their presence felt in these were due to imported manuscripts and visits of Italian artists. The Golden Age of Avignon ended long before the close of the century; when the Great Schism split the Church into two camps and pope and antipope joined issue.

MURAL DECORATION AND TAPESTRIES

The prosperity of art in those days was always very much a matter of royal favor, but since practically all the great decorative works commissioned by the first Valois kings have disappeared, there are few means of judging how far their patronage extended and what its influence was. This much, however, is known: that many large-scale frescos were made during this period, in the châteaux of Poitiers, Conflans, Léry and Vaudreuil, in the Hôtel Saint-Pol, in the old Louvre of Charles V, at Bicêtre and elsewhere. Paris was always the leading art center thanks to the many commissions given the artists by their royal patrons; indeed there is some justification for speaking of a "School of Paris"—though, as applied to the 13th and 14th centuries, this term is almost as hard to define as it seems to be today.

We shall now attempt to answer three questions that here suggest themselves: who were these artists, whence did they come, and on what were they employed? In Etienne Boileau's *Book of Crafts* a distinction is drawn (he is speaking of the 13th century) between "the painters and saddlers" who decorated "shields, saddles, litters, chariots and banners," and "painters and *imagiers*" who painted statues, "chapels on the wall" and altarpieces. The Tax Register for 1292 assigns the artists, according to the materials with which they worked, to four classes: "saddlers, *imagiers*, illuminators and painters." The first Parisian Corporation of Painters (i.e. men who specialized in painting panels or on cloth) had twenty-five master-painters in 1391, all with thoroughly French-sounding names, such as Jean d'Orléans, Etienne Langlier, Colard de Laon, Jean de Thory, Jean de Normandie, Guillaume Loyseau, Jean Parisot and Robert Bourion.

While he was Duke of Normandy, John II maintained a staff of illuminators, but his name is chiefly associated with that of the painter Girard d'Orléans who, when the king was taken prisoner, accompanied him into exile. Though this intimacy with his royal master might suggest he was an artist of some merit, the records of his activities from 1344 to 1362 mention only: chessmen, litters, tailors' dummies, close-stools! It would seem indeed that King John II had no very exalted idea of the functions of a court-painter, if he employed him on such trivial tasks. In 1350, at the beginning of his reign, he had Jean Coste decorate the walls of one of his residences, the Château de Vaudreuil, near Pont-de-l'Arche. Of the quality of this work we have no means of judging, but its program is known: episodes of the life of Caesar, hunting-scenes, and in the chapel an Annunciation and a Coronation of the Virgin. Of these we read in a contemporary record that "all these things were done in fine oil colors, with a field of patterned gold and the vestments of Our Lady in fine azure, and all was well and truly varnished and exceeding smooth, without any blemish." (Incidentally, this shows that painting in oils was practiced well before the Van Eycks.) To Sauval we owe a description of the murals in the Hôtel Saint-Pol: "a great forest full of trees and bushes laden with flowers and with fruit that children were picking and eating."

In 1380 Jean de Troyes made for the king "a litter painted with oak-trees and deer done from the life, fields of bracken and a hunting-scene." Brunetto Latini, Dante's friend and mentor, noticed that in the domain of art France was ahead of Italy and he was impressed by the number of mural paintings on the walls of private residences. "The luxuriousness of the painted houses," as he put it, "much amazes Italy." Since so few works produced at this time have survived, any estimate of their style can be little more than guesswork. Perhaps a clue is furnished by the portrait of John II, ascribed to Girard d'Orléans, painted some time between 1360 and 1364. This is doubtless a fair sample of the work of the time, but its antiquity and iconographic interest should not blind us to the poverty of its inspiration. What a difference from the superb *Parement de Narbonne* (1373-1378) in which the influence of the illuminated manuscript is seen to such advantage in the monochrome, strictly linear, almost abstract handling of the motifs! But while this delicate line is in the Parisian tradition, the new expressive portraiture, with its stress on visual reality and character-revealing traits, is clearly derivative, and reflects the discoveries of the Flemings.

Thus on a general survey (so far as this is possible) of the artistic activities of the 14th century, it seems that the time has not yet come to speak of a school of painting existing in its own right, independent of the miniature. And it follows that we must not lose sight of the developments taking place in the art of illumination, if we wish to trace the evolution of the full-size picture.

That the reign of Charles V, a book-lover and generous patron of the arts, brought about a change in the style of illustration is evidenced by the books in his library: the Grand Chronicles, a Breviary, an Historiated Bible and Mandeville's *Travels*. There are many portraits of the King, which usually figure within frames with tricolor borders and upon highly finished gold grounds, diapered with geometrical patterns. A remarkable thing is the unflattering objectivity of these artists who, though owing everything to their royal patron, had no qualms about recording in these portraits physical blemishes, natural or due to age: the king's long, lugubrious nose and haggard features. This holds good no less for the *Parement de Narbonne* than for the statue in the Louvre. It is interesting to compare with these the contemporary portrait of Petrarch in the Cabinet des Manuscrits at the Bibliothèque Nationale in which the characteristic Italian idealization of the model is so manifest. If French miniatures not only retained their high reputation but achieved a unique perfection, they certainly owed this to the Flemish painters who had now made their appearance in Paris and, championed by that fine connoisseur, the Duke of Berry, won universal admiration.

For a hundred years the Netherlands had played a leading part in the great artistic revival taking place in Northern Europe. Ghent, capital of Flanders, was the first city to possess a flourishing guild of painters. (The painters' guilds at Bruges, Tournai, Antwerp and even Paris were later creations.) In Ghent the art of painting had been cultivated for over a hundred years before the appearance of the Van Eycks. Though unfortunately most of the large-scale paintings of the period have disappeared, a few vestiges remain and some reduced copies made while they were still *in situ* enable us

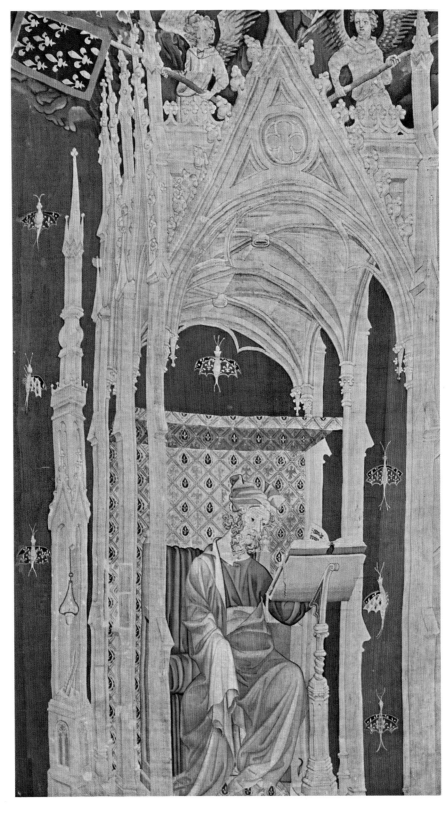

JEAN DE BANDOL AND NICOLAS BATAILLE. THE APOCALYPSE. FRAGMENT: ONE OF THE SEVEN BISHOPS
OF THE CHURCH OF ASIA. TAPESTRY, 1375-1381. MUSÉE DES TAPISSERIES, ANGERS.

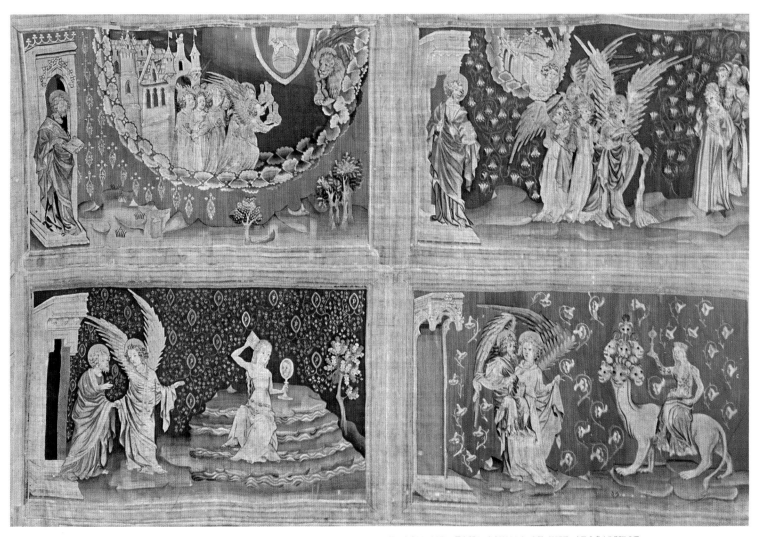

JEAN DE BANDOL AND NICOLAS BATAILLE. THE APOCALYPSE. FRAGMENT: FOUR SCENES OF THE APOCALYPSE.
TAPESTRY, 1375-1381. MUSÉE DES TAPISSERIES, ANGERS.

to get an idea of their chief characteristics. The murals in the Chapel of Leugemeete (1328) are reminiscent of the drawings of Villard de Honnecourt and of those in the manuscript of Guillaume Durant at the Bibliothèque de l'Arsenal, Paris. This French influence makes itself felt not only in the painting of the period but in other forms of art. Thus the carvings in the ancient Beguine convent at Ghent and the Saint-Aubert convent are, aesthetically speaking, Parisian through and through. The same applies to Tournai where in 1423 there were fifteen painters' ateliers; evidently this city had long been an active art center, since as early as 1190 the Bishop of Tournai despatched an artist, "Maître G." (who probably hailed from France), to the Abbot of Saint-Bavon. These Flemish artists from the region of the Scheldt, who had already imbibed French tastes when, owing to social and political upheavals in Flanders, they had found their source of livelihood cut off and left their country, now resumed contact with indigenous French artists. Called in by Countess Mahaut d'Artois, an artist

known as Pierre de Bruxelles had already (in 1330) decorated, in collaboration with Evrard d'Orléans, the Château de Conflans-lès-Paris with large scenes illustrating Count Robert's naval expedition to the coasts of Sicily. The vogue of "painted rooms" is vouched for by a passage in *Le Songe du Vergier*: "The knights of our time have scenes of imaginary battles painted in their rooms." The big reception room at the Château de Bicêtre was adorned with portraits of popes and cardinals, kings and noblemen. "It was"—according to the Chronicles of Saint Denis—"the richest, most splendid assemblage of pictures on the face of the earth." Unfortunately both these works of art and the château itself were destroyed in 1411 by the "Cabochiens" (a band of rebels headed by one Caboche, a butcher by profession). Nothing survives, save here and there a time-worn vestige, a note in the works of Gaignières, the 17th-century antiquarian, or a brief mention in some ancient record, to tell us of the murals at Condé in the Allier Department, at the Château d'Etampes, at Vivier, Villers-Cotterêts and Le Gué de Mauny near Le Mans. These mural decorations were often of a perishable nature, being paintings on common cloth. Obviously their inexpensiveness told in their favor, but the growing desire for comfort won the day, and warm, thick-textured, movable hangings gradually superseded mural painting. Tapestry, most highly esteemed of all, was, owing to its extreme costliness, reserved for royal or princely residences. John II had no less than 239 pieces of tapestry adorned with *fleurs-de-lys* or armorial bearings made for his own use. In his suite at the Louvre Charles V had a very handsome room "all done in green picked out with red, and works of tapestry with leafage of divers kinds wrought on a green ground." Thus we are not surprised to find in this king's inventory two hundred tapestries as against only some twenty pictures.

Strangely enough, little is known about the origins of tapestry. *Arrazzi*, the generic name used in Italy, signifies as little as the term *Gobelins*, the name applied indiscriminately in 18th-century Germany to an Aubusson *verdure* and a Beauvais door-curtain. True, the products of the Arras factory, which owed its rapid rise to fame to Countess Mahaut, were in great demand, but they were often confused with those of Paris—until the English occupation. Unfortunately no record exists of the respective outputs of the two cities during the period before the second half of the 14th century, though we know that the corporation of Parisian *tapissiers* came into existence in 1290. The earliest and curiously enough the largest tapestry that has come down to us is the Angers *Apocalypse*, made in the years 1375-1381. Ordered by Louis, Duke of Anjou, brother of the King, for his castle at Angers, this high-warp tapestry was the work of Nicolas Bataille, the Duke's *valet de chambre*. The cartoons for it were made by an artist from the north, attached to the royal court: Hennequin de Bruges, also known as Jean de Bruges and Jean de Bandol. He had begun by collating a number of illustrated manuscripts, both with a view to finding solutions of the exceptionally delicate iconographical problems set by the theme, and also with the idea of drawing inspiration from the illuminators. In point of fact he seems to have gone so far in this direction as to copy almost line for line the illuminations in MS 30 of the Fonds Salin (Library of Metz), a North French early 14th-century manuscript presented to the Seminary

ATELIER OF NICOLAS BATAILLE. THE NINE HEROES. FRAGMENT: TWO OF THE THIRTEEN FIGURES
IN A BALCONY. TAPESTRY, CA. 1385. METROPOLITAN MUSEUM OF ART, THE CLOISTERS, NEW YORK.

of Namur and, especially, those in MS 482 (late 13th century) at the Cambrai Library. But Jean de Bandol was no mere plagiarist; a completely original miniature by him heads the illustrated Bible presented to Charles V by Jean de Vaudétar. Here the line is masterly, modeling ample and expressive, and the composition as a whole remarkably lifelike. The Angers *Apocalypse*, which is no less than 432 feet in length from end to end, consists of seven pieces of tapestry comprising ninety pictures, of which seventy still exist. Each panel is divided horizontally into two zones, alternately red and blue; on the left is a prophet standing under a sumptuous Gothic canopy; alongside, grouped in fours, are scenes inspired by the Book of Revelations. The monumental effect of the ensemble is largely due to the small range of colors, well-balanced contrasts, extreme simplicity of line, the total absence of perspective. Contemporary with the Angers *Apocalypse*, the *Presentation in the Temple* (Musée du Cinquantenaire, Brussels) was made by one of the Parisian ateliers, perhaps indeed (though, if so, the style is less vigorous than one would expect) Nicolas Bataille's. It has obvious analogies with illuminations—especially with one by André Beauneveu in the *Très Belles Heures du Duc de Berry*.

The three works cited above depict religious themes; actually, however, most of the tapestries produced at this time were secular, intended for adornment not for edification, and dealt with contemporary themes. Such are the *Battle of Roosebeke*, woven by Michel Bernard d'Arras for Philip the Bold in 1378, the *Scenes from the Life of Du Guesclin* (in several versions) by Jacques Dourdin, Pierre Beaumetz and Nicolas Bataille. Other sources were the mediaeval verse-chronicles and the Romances of Chivalry. Examples are the tapestry of *The Nine Heroes and Heroines*, *The Holy Grail*, *The Story of Jason, Ywain and the Queen of Ireland*. There is a romantic old-world glamour about the scenes depicted by the "Arras-makers" as they were called in England; with their glimpses of courtly love and amorous dalliance, hunting scenes, pastoral incidents and, on occasion, moralities or allegories.

Like stained glass in the previous century, tapestry was the medium most congenial to the creative genius of the 14th century. The practice of regarding these as "minor arts" is quite unjustified. As for the stained-glass window, however, we are bound to confess that in the 14th century the workers in this medium seem to have lost sight of its true vocation; the fine enthusiasm, the creative urge, that had inspired their predecessors, had spent itself. No longer was the stained-glass window treated as an end in itself; it was subordinated to its setting, took its orders from the architect and sculptor. Thus it grew brighter and at the same time lost much of its color, and, covered with tracery in grisailles, merged into the architecture of the edifice in which it figured. But what it lost in monumental value it gained in refinement, in its charmingly sophisticated line, in its dazzling silvery yellows, its subtle cameo-like effects. It was still from Paris that the French stained-glass artists took their lead. Though there were groups of glass-painters turning out original work in Normandy, and indeed in most parts of France, their aesthetic and technique were basically Parisian, as indeed were all the new developments then in progress all over Europe, from Prague to London.

FRENCH ART UNDER THE VALOIS

When in 1391 (as already mentioned) twenty-five Parisian painters got together to found an association of master-craftsmen—first of the many "Academies of St Luke"—all, as their names clearly show, were Frenchmen, and we may well suspect that one of the aims of this association was to defend native artists against the invasion of foreigners from the North, with whom they now had to compete. It usually, not to say invariably, happens that when a group within the social order imposes Draconian statutes on its adherents, the purpose of these is to conserve existing privileges, and to pool rather than to promote the interests of individual members. But the artists from Flanders had established themselves too securely to be ousted by "legislation" of this kind. All the princely courts were vying for their services. Though that remarkable man, the Duke of Berry, uncle of Charles VI, was the art patron of the day *par excellence*, there were others keenly interested in art: the king's brother Louis, Duke of Orléans, the Dukes of Burgundy, Philip the Bold and John the Fearless, not to mention many prelates and rich laymen such as the accountant Jean de la Croix who in 1412 presented an illuminated missal to the Church of St Magloire in Paris.

Meanwhile the taste for collecting works of art gained ground abroad; notably in the duchies of Brabant and Limbourg (governed by Philip the Bold's son, Antoine de Bourgogne) and in the counties of Hainaut and Holland (dependencies of William IV of Bavaria). Queen Isabella of Bavaria did much to make Parisian art known east of the Rhine, while the House of Valois in Sicily and the French popes at Avignon played no small part in propagating French art in foreign countries. Meanwhile Italian merchants and such men as Raponde and Pietro Sacco of Verona promoted the traffic in works of art between France and Italy. Jean d'Arbois, court painter to the Duke of Burgundy, traveled widely in the Peninsula, and Coene of Bruges was bidden to Milan to draw up the plans of the cathedral. By the same token some Italian artists settled in Paris; amongst them were Giovanni Alcherio (from Milan) and Pietro da Verona who became art-adviser to the Duke of Berry. Nor did they feel out of their element in the French capital, where at the beginning of the century their compatriots, Filippo Rizzutti, Giovanni and Nicolo di Marsi had worked as *pictores regis* to Charles the Fair.

The Italianate figures in so many of the illuminations produced in Paris at this time seem often to owe more to the influence of the Lorenzetti than (as might have been expected) to Pucelle. For this Pietro, the Veronese artist mentioned above, may have been in part responsible; his official position as art-adviser to the famous Duke gave his opinions weight and he may well have persuaded the local artists, if not to change their style, to break new ground as regards their subject-matter. In their work we often find the strongly emotive accents of Sienese art, and the composition is of a kind never essayed by the miniature-painters; more broadly conceived and better balanced. In inventories of the time we sometimes find the entry "Lombardy work," suggesting that the item in question was made by an Italian. Indeed, starting from

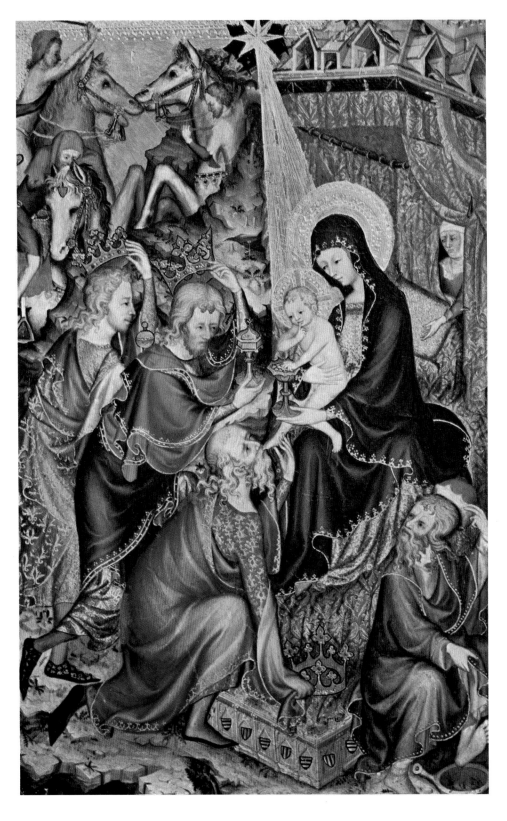

UNKNOWN MASTER. THE ADORATION OF THE MAGI. SO-CALLED BARGELLO ALTARPIECE, LEFT SHUTTER,
CA. 1390. (19½ × 12″) PALAZZO DEL BARGELLO, FLORENCE.

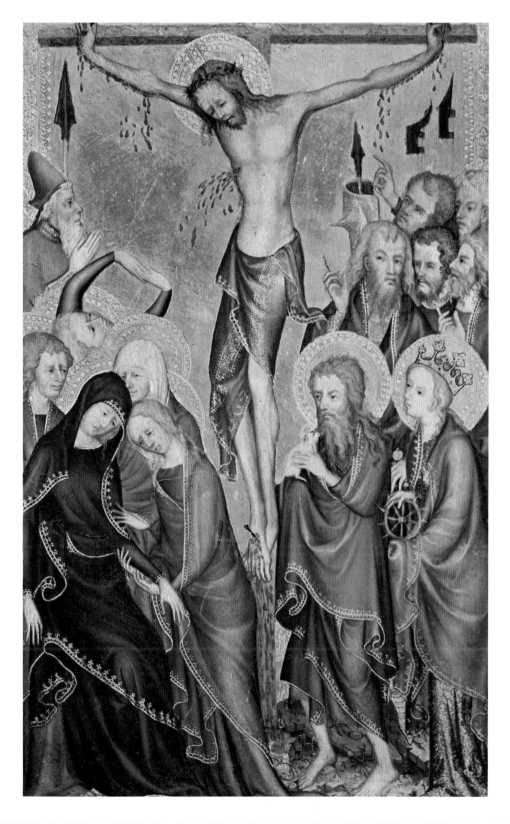

UNKNOWN MASTER. CRUCIFIXION. SO-CALLED BARGELLO ALTARPIECE, RIGHT SHUTTER, CA. 1390.
(19½ × 12″) PALAZZO DEL BARGELLO, FLORENCE.

this hypothesis, some have gone so far as to ascribe the *Très Riches Heures* to Gentile da Fabriano. Actually, however, the term "Lombardy work" merely refers to the new style affected by some Parisian artists under Italian influence; a style which, never taken over-seriously, was no more than a concession to the fashion of the day.

One can see why Courajod was led to classify the output of this milieu, permeated as it was by so many different art currents, as "International Art," but he might better have described it as an internationally diffused French art. For its complexity defies analysis, and interesting though it might be to seek to differentiate its Flemish, Parisian, and Burgundian elements, this would get us nowhere. Who indeed would venture, when speaking of the 18th century, to describe Watteau as a French but predominantly Flemish artist, or Fragonard as a French but essentially Provençal artist? We come up against the same problem in connection with André Beauneveu of Valenciennes and Jean Malouel; should the latter be placed among the Parisian artists or amongst the Burgundians, according as he works for Isabella of Bavaria or for Philip the Bold? Such classifications are arbitrary, to say the least of it. It would be truer to say that there existed one art only, the art of the princely courts, but practiced by artists with different temperaments, more or less influenced by their environment and by the tastes of their respective patrons.

All the members of the House of Valois were enthusiastic collectors, and the atmosphere of luxury with which they surrounded themselves was at once an expression of their predilections and a demonstration of their power. For they realized that a generous patron of the arts is looked up to, and that prestige is a standby of autocracy. Charles V was a book-lover, but in the manner of those bibliophiles who prefer a rare and "curious" work to a well illustrated one; there were not so many handsome illuminated books in his collection as one might have expected. Philip the Bold preferred pictures. The Duke of Berry had no particular preference; nothing that was good to look at came amiss, and he collected tapestries, paintings, illuminated books and precious stones indiscriminately, insatiably. His example was followed by his brothers and his nephews. Louis of Orléans and Louis II of Anjou, however, showed less self-assurance and did not impose their personal taste on the works they commissioned.

Few paintings in the strict sense of the term figure in the contemporary inventories of Charles VI, and fewer still are those which have come down to us. Works of small dimensions, portable diptychs for use in private oratories, they do not seem to have been regarded either by their makers or their owners as having any great value *qua* pictures. They were, rather, *objets de vertu*. We find in them the lavish ornamentation of the reliquaries and goldsmiths' work of the day; what painting there is, inset within a pattern of finials and pinnacles, has the metallic luster of enamel-work. The backs of the panels, sometimes elaborately worked, bear out this impression of the "objet of art," or collector's item. Thus when Simone Martini made for Cardinal Orsini the polyptych now dispersed in Paris, Antwerp and Berlin, he overlaid the back of the panel representing *The Way to Calvary* with a ground of patterned gold, so as to meet the requirements of Parisian taste. Often bordered with gems, the scenes are no more

than miniatures transposed on to dazzling gold grounds incised, diapered and goffered in a technique akin to that of goldsmiths' work. For painting pure and simple, the "picture," had not yet come into being.

The small and the large altarpiece in the Bargello, Florence, more or less contemporary with the Narbonne altar-hanging, clearly belong to this Parisian school; their style, which has all the mannerisms of French court art, is in the tradition of the miniature-painters following Pucelle. The small panel in the Sachs Collection, an *Annunciation*, dated to approximately 1390-1400, has much in common with the two above-mentioned works. It was once ascribed to Duccio but this ascription is all the more improbable since the iconographical treatment of the theme of the Incarnation is not at all in the Sienese spirit, whereas we find it in the Hours of Marguerite d'Orléans and again, some years later, in the works of the Master of Flémalle. Moreover, though the armorial bearings on the back are, so far, unidentified, they must be those of some French family, since the presence of *fleurs-de-lys*, the royal emblem, in the borders shows that this panel was painted for a member of the French court.

THE COURT PAINTERS OF THE DUKES OF BURGUNDY

Like those of Anjou the dukes of Burgundy were members of the House of Valois, so it was not to be expected that Philip the Bold, when he became Duke of Burgundy (1363), would change his tastes overnight, repudiate the court art of his brother Charles V and enlist the services of local artists. Nor did he in the event. In quest of artists qualified to add luster to his new estate, he looked not to provincial art centers such as Bourges, Tournai, or even Dijon, but summoned Jean d'Orléans directly from Paris. When in 1383 he built the Carthusian monastery of Champmol, "the Saint-Denis of Burgundy," he put an architect borrowed from his uncle the Duke of Berry in charge of the work. A native Burgundian school cannot be said to have existed before 1419, when John the Fearless was assassinated and the political life of the duchy henceforth took a more independent turn, with Flanders as its vital core. The Duke of Berry died in 1416, and his most famous painter, Pol de Limbourg, a year later. And after his death the prestige of the international art of the School of Paris was rapidly eclipsed by the Europe-wide fame of the Van Eycks.

On the strength of the fact that travelers between Italy, Avignon and the Low Countries usually went through Burgundy, bypassing Paris, some have attributed the works of art showing Sienese influence to groups of artists working at Dijon. But though this influence can certainly be traced in the work of the Champmol artists, it is far from being peculiar to that group, being equally apparent in specifically Parisian works. In any case the painters employed by the Dukes had so many contacts with Paris, direct or indirect, that there was no reason why, the moment they took up their residence in Dijon, they should promote a style peculiar to the court of Burgundy. Indeed

Philip the Bold had so much admiration for his brother the Duke of Berry's taste, that he often sought his advice, exchanged works of art with him and borrowed his artists. When commissioning Claus Sluter for the sculptures at Champmol, he told him to begin by studying under Beauneveu at Bourges. Of the paintings in the famous Carthusian Monastery nothing remains save some forlorn vestiges of its ancient glory, associated with a host of artists' names, many ascriptions and few certainties. Disdaining the local painters, Philip called in artists either resident in Paris or imbued with the Parisian aesthetic; for example, Jean d'Orléans and Jean Petit of Troyes. He sent for Jean d'Arbois, then traveling in Lombardy, and commissioned him to do some work for him in Paris before accompanying him to Bruges. In 1375 he signed on Jean de Beaumetz, then in the service of the Duke of Orléans. Though of Nordic extraction (he was born at Cambrai) Beaumetz, too, had studied for many years in Paris. He was the leading figure of a new generation of artists hailing from Flanders who retained traces of provincialism, due to their Flemish origin, but their style was not "Burgundian" in any exact sense. Evidently a man of abounding energy, Beaumetz not only decorated the châteaux of Argilly and Germolle but painted twenty-four pictures for the Champmol monastery, as well as several altarpieces. None of his works has survived. On his death in 1396 Jean Malouel succeeded him. Although a Netherlander, Malouel was thoroughly Parisian in spirit and had worked at Conflans and Paris for Isabella of Bavaria. All ascriptions in his case are purely speculative. The most we know is that in 1398 he was commissioned to paint five altarpieces for Champmol and colored Claus Sluter's statuary in "The Well of Moses." The same uncertainty prevails regarding the work of his successor Henri Bellechose who was employed, from 1415 on, in the Duke's Palace, in the châteaux of Talant and Saulx, and in the Church of Saint-Michel at Dijon, where he painted an *Annunciation* and *Christ and the Apostles*. From a 1416 text we learn that Bellechose bought pigments "to finish off" an altarpiece at Champmol and some have, perhaps over-hastily, taken this to mean that he completed a picture Malouel had left unfinished; however, the impression of perfect unity conveyed by the picture seems to prove that it is entirely by the same hand. Its bright, sparkling hues are definitely illuminator's colors and resemblances with a Book of Hours owned by the Duke of Berry and the Moralized Bible made for Philip the Bold (MS fr. 166, Bibliothèque Nationale, Paris) take us back to the climate of the Limbourg brothers. Whether or not it was Bellechose himself who painted the *Communion* and the *Martyrdom of St Denis*, there is no question that the round *Pietà* in the Louvre, the *Pietà* in Troyes Museum and the dainty little panel of the *Virgin and Child* in the Beistegui Collection should be attributed to the same atelier.

On only one work is the artist's name inscribed and it is the only work indisputably by him we know of: the shutters of a reredos in the Carthusian House of Champmol, painted by Melchior Broederlam. A native of Ypres, Broederlam was taken up by Jean d'Arbois who initiated him into the secrets of Parisian art during his stay in Paris. Appointed "painter and *valet de chambre*" to Duke Philip the Bold, he was commissioned to paint the shutters of the reredos carved by the Flemish sculptor Jan de Baerze.

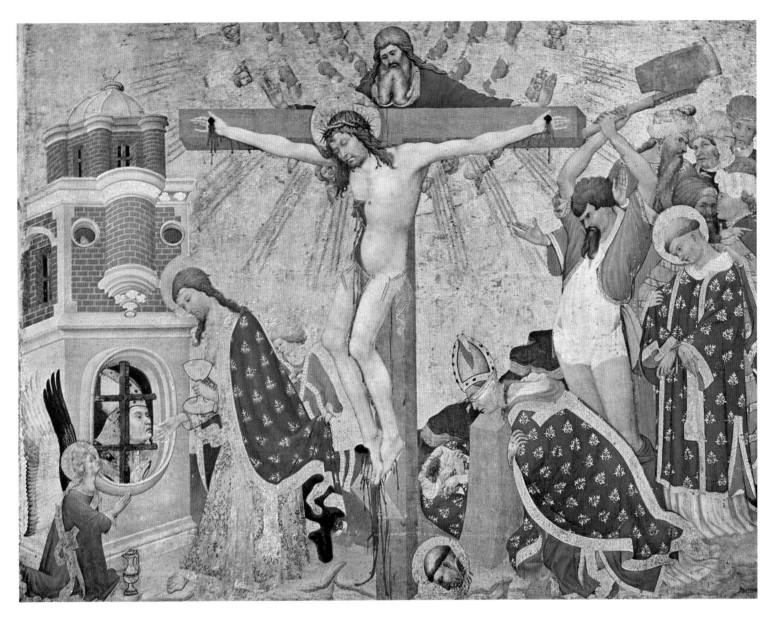

ASCRIBED TO HENRI BELLECHOSE. THE LAST COMMUNION AND THE MARTYRDOM OF ST DENIS.
CA. 1416. (63 ¼ × 82 ½″) LOUVRE, PARIS.

The two scenes, a *Presentation in the Temple* and *The Flight into Egypt*, were painted by Broederlam at Ypres between 1394 and 1399. His exceptionally rich style, provincial, racy of the soil, combining courtly grace with bourgeois realism, could easily accommodate itself to the influences that make their presence felt in his work: that of Sienese art, with its competent perspective, bright colors and fluent execution, and that of the Paris school with its clean-cut line and supple, elegant forms. A small polyptych whose panels are dispersed (in the Mayer van den Bergh Museum at Antwerp and the Walters Art Gallery, Baltimore) has stylistic affinities with Broederlam's work, but cannot be positively ascribed to him, as it contains reminiscences of the Parisian school.

UNKNOWN MASTER. THE NATIVITY. PANEL FROM A POLYPTYCH. ($13 \times 8\frac{1}{4}''$)
MAYER VAN DEN BERGH MUSEUM, ANTWERP.

UNKNOWN MASTER. ST CHRISTOPHER. PANEL FROM A POLYPTYCH. ($13 \times 8\frac{1}{4}''$)
MAYER VAN DEN BERGH MUSEUM, ANTWERP.

THE DUKE OF BERRY AND HIS ILLUMINATORS

Until the Renaissance there never was in France a court so magnificent, so lavish in its patronage of all forms of art as that of Bourges. The Duke of Berry was not only an enthusiastic collector but a great builder and owned no less than seventeen private residences, many of them imposing châteaux. The records of the orders given his architects and the art treasures he possessed prove that not only was he by far the most eminent of French art patrons in the Middle Ages but a peer of the world-renowned Italian connoisseurs and collectors of a slightly later period.

The object of the system of "appanages" practiced by John II ("the Good") was to delegate to junior members of the royal house some of his functions and, enlisting their co-operation in the government of the realm, to ensure their loyalty by a show of munificence. This ingenious tactic failed completely with the Burgundians, but was successful in his dealings with the Duke of Berry. A man of much shrewdness, the Duke had no illusions about the ultimate futility of politics and was wise enough to prefer the very real, if subtler satisfactions to be got from works of art to the semblance of an authority precarious at best. History has confirmed the wisdom of his choice; there is no question that the *Très Riches Heures* which bear his name have given it a luster far exceeding that of the exploits of his more political-minded brothers of Anjou and Burgundy. His ruling passion, his love of works of art, took precedence of even the gravest affairs of state. Thus he kept an English embassy waiting for an audience for no less than three weeks, because he was busy conferring with his court painter, André Beauneveu. He had no qualms about keeping a very young girl from Bourges in confinement in his castle at Etampes because one of his painters had a fancy for her company, and the fact of being the Duke's *premier historieur* saved Jacquemart de Hesdin, when involved in a murder case, from molestation by the police. The Duke's taste for beautiful objects became almost an obsession in his later years, and he spent much time feasting his eyes on his collection of precious stones: diamonds, rubies, pearls, toadstones, ophites, sapphires and emeralds. Nothing was too costly for this remarkable man, whose extravagances sometimes verged on eccentricity. Not content with collecting *objets d'art*, jewelry and illuminated books, he insisted on having his swans and bears accompany him when he traveled, and when eating strawberries he used crystal "picks" with gold and silver mounts.

When moving from one of his many châteaux to another he always took his tapestries with him, and these were so numerous that placed side by side they would have covered no less than four hundred yards of wall space. An illuminator (sometimes a whole team of craftsmen) was permanently employed in each of his residences, and he plied them with new projects, his "latest ideas." Often, before the local man had had time to finish the work in hand, the Duke would move on, taking with him the precious manuscript, and make it over for completion to the artist attached to the château whither he had moved. Etienne Langlier, Jean le Noir and Jean de Hollande

were employed by him at Bourges; André Beauneveu at Mehun-sur-Yèvre; Jacquemart de Hesdin at Poitiers; Jan Coene at Bicêtre. It is impossible to differentiate the share of each in certain works with any real certainty.

Illuminated manuscripts were this great art-lover's ruling passion; he supervised their making with loving care, and it is they that have immortalized his name. The Duke possessed no less than twenty Books of Hours, but this seeming devoutness was a mere pretext, in line with the conventions of the day, for having illustrations made of all that interested him and, to begin with, his own person. Indeed these Books of Hours are more like family albums in which we see the Duke alone, conversing with the Duchess, traveling, at table, or attended by his patron saints; and, it is always the same face that looks out at us, a heavy face of an ecclesiastical cast, that of a well-intentioned but self-centered man.

Jacquemart de Hesdin painted for him the *Grandes Heures* now in the Bibliothèque Nationale, Paris (MS latin 919), which was completed in 1409. Another of this artist's works is the *Très Belles Heures de Notre Dame*, part of which is in the Royal Library, Brussels (N°. 11060), and the other in the Maurice de Rothschild Collection. The *Petites Heures du Duc de Berry* (MS latin 18014, Bibliothèque Nationale) is also by his hand. True, Jacquemart de Hesdin was no innovator, in the direct line from Jean Pucelle; his indebtedness to the Belleville Breviary is plain to see not only in the drawing but in his choice of themes. But he brought illustration to a perfection hitherto unknown, and the delicate scrollwork in the margins is hardly less satisfying to the eye than his delightful color-schemes.

André Beauneveu of Valenciennes, known chiefly as a sculptor and employed by Charles V in this capacity, entered the service of the Duke of Berry in 1396. A many-sided man, painter, sculptor and architect, he was lured to Paris, like so many northerners, by the prestige of that city and the rich prizes it offered to the successful artist. Charles V commissioned him to make the statues in the tombs of John the Good and Philip VI, as well as those of himself and the queen, now in the Louvre. As the Duke's "master carver," he was commissioned to make the recumbent effigy of his patron (from the life). The window in the Sainte-Chapelle at Bourges, now in the cathedral crypt, was also his work. Finally, he was the maker of the famous Franco-Latin Psalter in the Bibliothèque Nationale (MS. fr. 13091). Froissart, his compatriot, acclaims him as the greatest artist of his day and stresses the friendly relations between him and the Duke. "The Duke stayed there (at Mehun-sur-Yèvre) for more than three weeks and talked much with Master Andrieu Beauneveu, who was his chief sculptor and painter, bidding him make new pictures; for in these crafts he took much delight and could never have enough of carvings and paintings. And he had chosen well his man, for than this Master Andrieu of whom I speak there was none better, nor was there his like in any land." There is a statuesque quality, due to his practice of sculpture, in the twenty-four illuminations depicting evangelists, apostles and prophets which adorn the opening pages of the Psalter. The lay-out is well-balanced and the figures have the monumental grandeur of the prophets in the niches of a cathedral porch. Drapery

JACQUEMART DE HESDIN. LES PETITES HEURES DU DUC DE BERRY.
THE DUKE OF BERRY PRECEDED BY HIS MACE-BEARER.
MINIATURE, MS LATIN 18014, FOLIO 288, BACK. (7 × 5″) BIBLIOTHÈQUE NATIONALE, PARIS.

falls in broad, softly modeled folds, and the monumentalism of the figures is enhanced by a very special use of color, a compromise between plain grisaille and the colors proper to illumination, the garments being rendered in monochrome, while the delicate flesh-tints have natural hues.

Supreme beyond question amongst illuminated books is the *Très Riches Heures* at Chantilly, painted in 1416, and this unique achievement suffices in itself to explain the contemporary and subsequent renown of the three brothers who made it: Pol, Jean and Armand de Limbourg. Their names tell us clearly enough where they came from, but nothing else is known about them except that they were probably Jean Malouel's nephews, that they came to study in Paris in their early youth, and that Pol was the Duke of Berry's *valet de chambre*. There is no evidence that they visited Italy, but what they saw of the work of Pietro da Verona and Jan Coene in Paris would have familiarized them with the new developments in Italy sufficiently to enable men so gifted to vie with the greatest of the Florentines. It is something of a shock to find in their miniatures a literal copy of one of Taddeo Gaddi's frescos, reminiscences of Orcagna, of Roman, Pisan and Florentine buildings and, most amazing of all, Abyssinian monks, who in those days were to be seen, north of the Mediterranean, in Venice alone. In no other mediaeval work do we find such vivacity and grace allied with such exquisite

ANDRÉ BEAUNEVEU. PSALTER OF THE DUKE OF BERRY.
A PROPHET. MINIATURE, CA. 1400. MS FRANÇAIS 13091, FOLIO 16. (9¾ × 6¼″)
BIBLIOTHÈQUE NATIONALE, PARIS.

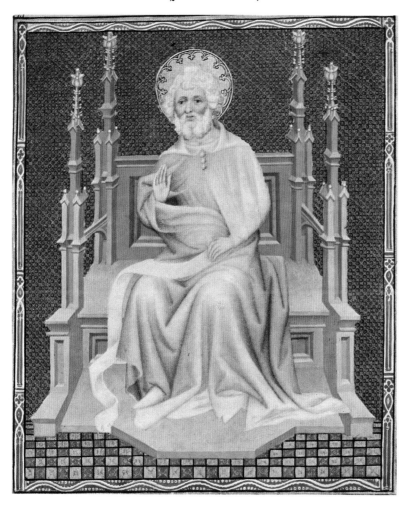

good taste. Following the Calendar pages, so often reproduced, are over a hundred and twenty delightful miniatures illustrating the Life of the Virgin and other biblical subjects. In all the Limbourgs' work masterly draftsmanship, perfect rendering of architecture and a technique as precise as that of the fashion-plate designer are complemented by a brilliant range of colors based on vermilion, vivid green and azure blue. No Italian painter had as yet produced anything so enchanting to the eye. Here, too, practically for the first time landscape is treated with loving care, bathed in the soft light of the Ile-de-France, and these backgrounds, though seemingly accessory to the central themes, are found to be self-sufficient pictures when isolated from their contexts. Thus one of the characteristics of these works is that we cannot take them in

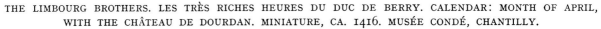

THE LIMBOURG BROTHERS. LES TRÈS RICHES HEURES DU DUC DE BERRY. CALENDAR: MONTH OF APRIL, WITH THE CHÂTEAU DE DOURDAN. MINIATURE, CA. 1416. MUSÉE CONDÉ, CHANTILLY.

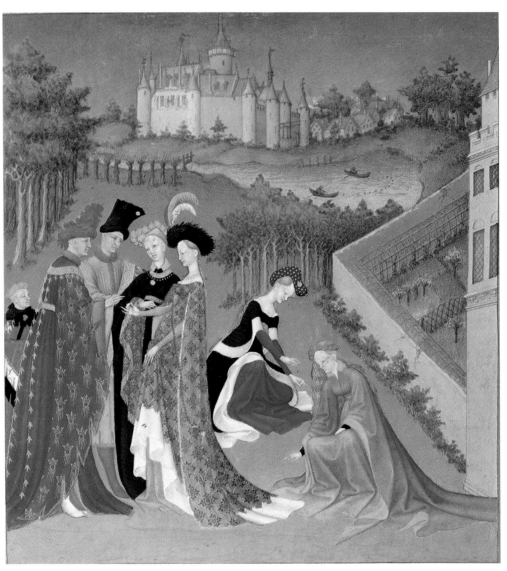

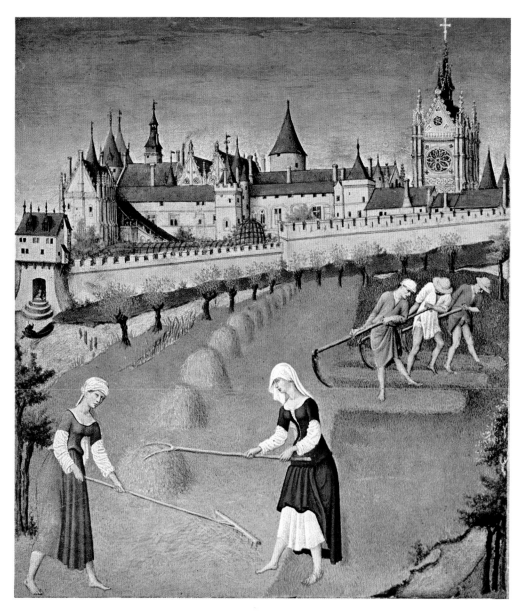

THE LIMBOURG BROTHERS. LES TRÈS RICHES HEURES DU DUC DE BERRY. CALENDAR: MONTH OF JUNE, WITH THE PALAIS DE LA CITÉ AND THE SAINTE-CHAPELLE, PARIS. MINIATURE, CA. 1416. MUSÉE CONDÉ, CHANTILLY.

at the first glance; the beholder is invited to co-operate with the artist, to linger over details and to share his pleasure in each successive *tour de force*.

When the Duke of Berry died in 1416 the book was still unfinished, and Pol de Limbourg survived him by a year at most. Meanwhile the Van Eycks had made their appearance on the scene and it is tempting to surmise that one of the two brothers was asked to complete the *Très Belles Heures de Notre Dame*. In any case the Turin Book of Hours, its sequel, may be regarded as the logical conclusion of the evolution of the illuminated book. But by now the Limbourgs' "modernism" had definitely made good and indeed inaugurated a new art era.

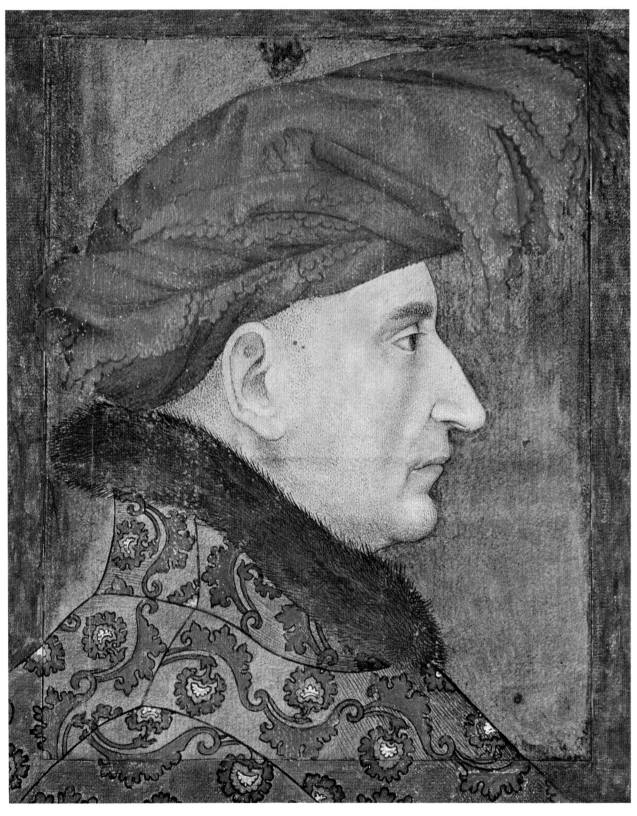

UNKNOWN MASTER. PORTRAIT OF LOUIS II OF ANJOU. WATERCOLOR DRAWING, CA. 1412. (11¾ × 8¼″)
BIBLIOTHÈQUE NATIONALE, PARIS.

THE ROYAL DOMAIN

The new approach to art distinctive of the *Très Riches Heures* was not confined to the Limbourgs. Many miniature painters followed their lead, with less talent perhaps, but with no less charming originality and a like concern for visual truth. The faculty of effortlessly assimilating the fashions of the day is, as experience tells us, a typically feminine trait and the part played in several family ateliers by the wives or daughters of the master artists has often been remarked on. Boccaccio's *De Casibus Virorum et Feminarum Illustrium*, translated into French in 1401 by Laurent de Premierfait, must have been illustrated by a woman, if we are to judge by the copy presented by the financier Jacques Raponde to Philip the Bold in 1403. In this fascinating book we are shown "the very noble paintress Thamar" at her easel painting a Virgin and Child, surrounded by her brushes, paint boxes and shells, while an apprentice grinds the pigments; "Cyrene, wife of Cratinus," coloring a statue; or, again, "Marcia," palette in hand, painting her own portrait while scrutinizing her reflected self in a mirror. Christine de Pisan, a typical "literary lady" of the day, before presenting her works to the Duke of Berry and Queen Isabella of Bavaria, commissioned Anastaise to illustrate them. She mentions this eminent woman-painter in her *Cité des Dames*. "Speaking of painting, I know a woman named Anastaise who has such skill and cunning in making vignettes for illustrated books and landscape scenes for tales that in Paris, where all such things are well paid heed to, none fails to commend her, nor is there any other who so sweetly and delicately limns as she, nor whose work is more esteemed, so rich and rare are the books to which she has set her hand." The manuscript of the *Cité des Dames* (MS fr. 607, folio 2, Bibliothèque Nationale, Paris) shows Christine de Pisan being visited by three noble ladies, Reason, Rectitude and Justice, who inspire and aid her in building her Ideal City. Though it must be admitted that this picture, perfectly in keeping with the text, rises little above the didactic, allegorical illustrations so much in vogue at the time, the artist has expressed with charmingly feminine naivety her desire to strike a "modern" note, while keeping within the bounds of due decorum.

Catering equally to contemporary taste are several pieces of tapestry produced at this time, for example the charming *Scene from a Novel* in the Musée des Arts Décoratifs, Paris. The texture—silk and gold interwoven with wool—might suggest that it was made at Arras, but the identity of some details with scenes of the *Month of May* in the Calendar of the *Très Riches Heures* points back again to the Duke of Berry's court. The eye-flattering decorative schemes and the use of motifs culled from some popular romance of knightly courtesy seem strangely incongruous with what was actually happening in France at the time: bloody conflicts between the Armagnacs and the Burgundians, and the loot of Paris by Cabochien insurgents. But in the midst of carnage and fire-raisings, the devastation of the fair realm of France, these obscure craftsmen working at their looms kept faith with the Gothic ideal of an art of living governed by Beauty, Gentleness and Amiability.

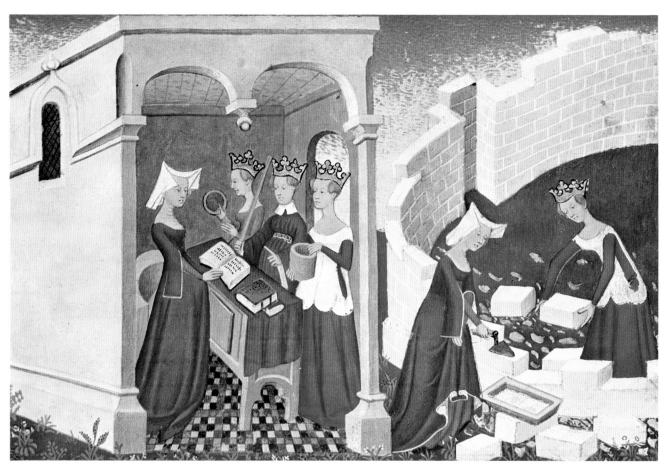

CHRISTINE DE PISAN, LA CITÉ DES DAMES. CHRISTINE DE PISAN IN HER STUDY AND THE BUILDING OF THE CITÉ DES DAMES. MINIATURE, MS FRANÇAIS 607, FOLIO 2. ($4\frac{3}{4} \times 7''$) BIBLIOTHÈQUE NATIONALE, PARIS.

In this connection reference may be made to the Castle of La Manta (near Saluzzo, in Piedmont), whose decorations illustrate the artistic and intellectual exchanges in progress between France and Italy. With its air of impregnability, this castle would correspond exactly to our notions of the mediaeval stronghold, had not later generations, enamored—unlike its builders—of light and air, opened up spacious windows in the walls. Nothing in the outer aspect of this domesticated fortress gives any inkling of the visions of beauty in the great feudal hall at its summit, which, it would seem, remained unnoticed for many centuries.

Arrayed on the long wall opposite the windows is a splendid company of kings and queens in gorgeous raiment. Silken, gold-brocaded fabrics, miniver and ermine, gems and jewels, gold crowns and garlands of flowers, silver armor, tabards painted with heraldic bearings, ceremonial weapons—nothing is lacking that could enhance the magnificence of the gathering. Haughtily erect as if on parade, between trees decked with their escutcheons, on a carpet of small, shining flowers stand the Nine Heroes and Nine Noble Heroines of the old legends, with a rhymed caption in French under each figure, extolling his or her great deeds and virtues. Such is the aristocratic flavor of the

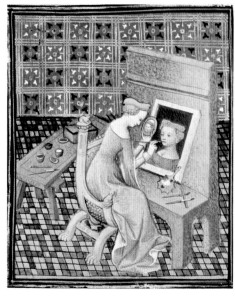

BOCCACCIO, LE LIVRE DES FEMMES NOBLES ET RENOMMÉES. MARCIA PAINTING HER SELF-PORTRAIT. MINIATURE, 1402. MS FRANÇAIS 12420, FOLIO 101, BACK. (2⅞ × 2⅜″) BIBLIOTHÈQUE NATIONALE, PARIS.

scene, permeated through and through with the glamour of the age of chivalry, and such the elegant distinction and charm of the figures that it had long been suspected they were the work of a French artist. The correctness of this view was demonstrated in 1905 by Pietro d'Ancona and again in 1919 by Lionello Venturi. Indeed one has a feeling that these lords and ladies have stepped forth from the pages of the *Très Riches Heures du Duc de Berry*; for this almost exaggerated insistence on *le dernier cri* of fashion is typical of the manners of the contemporary French court. The presence of such a work at Saluzzo would be somewhat baffling did we not know that the local magnate Alezan, an illegitimate son of Tomaso II, Marquis of Saluzzo, here depicted with his wife Clemenza Provana in the guise of Hector and Penthesilea, was in high favor with the King of France. Tomaso II was one of the many princes of the day who were attracted to Paris by the prestige of Parisian culture and the splendors of the royal court and it was there that he wrote, in French, his *Chevalier Errant* which furnished the thematic material of the La Manta frescos. This explains why the marquisate of Saluzzo was a center of French culture beyond the Alps. Such is the familiarity with French style and temperament evidenced in these frescos that one would imagine their painter to have been a member of the Limbourg atelier or else to have used its productions as his models. There are good reasons, following Lionello Venturi, to ascribe these paintings to Jacques Iverny of Avignon, a triptych signed by whom can be seen in the Pinacoteca of Turin, in the neighborhood of which city it

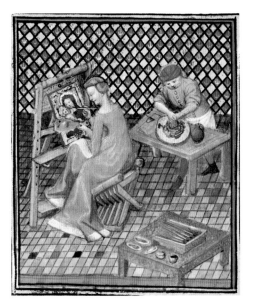

was made. For the Virgin in this triptych closely resembles one of the frescos in the castle, the *Madonna della Tosse*. Mention is made of this artist in the records of Avignon between 1411 and 1413, then, after a gap of thirteen years, from 1426 to 1438, the year of his death. The probable conclusion is that he spent the period unaccounted for in Piedmont—the La Manta decorations would have kept him busy for quite two years—and perhaps in Paris and Bourges as well. Some clue to his movements is given by a votive picture he made for the Church of St Agricol at Avignon in which the

BOCCACCIO, LE LIVRE DES FEMMES NOBLES ET RENOMMÉES. THAMAR, THE NOBLE PAINTRESS, MINIATURE, 1402. MS FRANÇAIS 12420, FOLIO 86. (2⅞ × 2½″) BIBLIOTHÈQUE NATIONALE, PARIS.

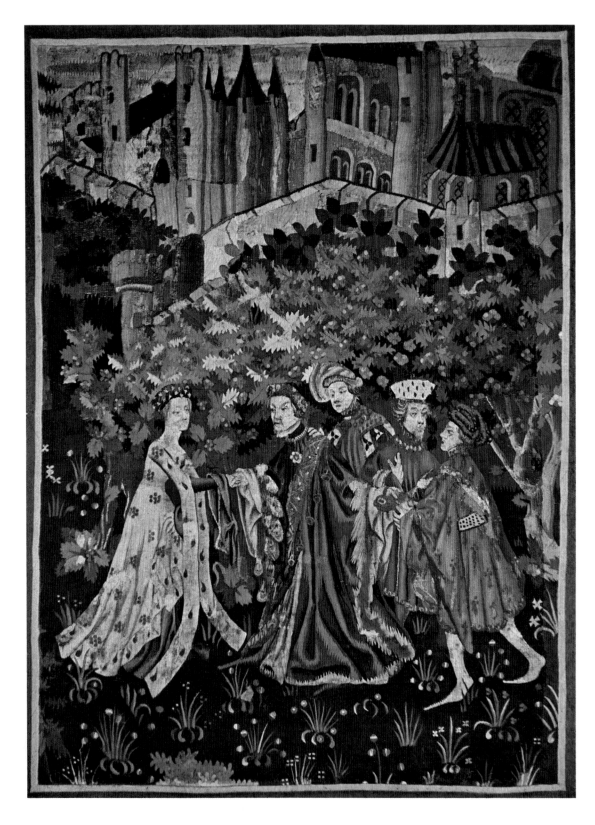

ARRAS TAPESTRY. SCENE FROM A NOVEL. CA. 1420.
MUSÉE DES ARTS DÉCORATIFS, PARIS.

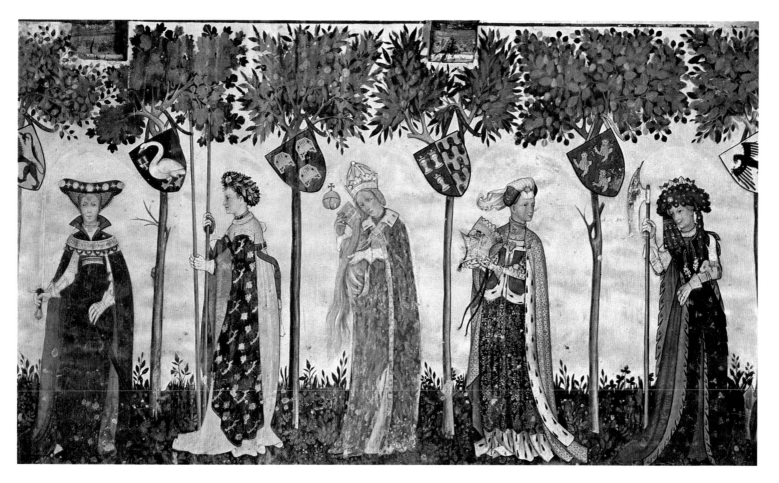

JACQUES IVERNY. FRIEZE OF THE NINE HEROINES. MURAL DECORATION, FRAGMENT. CA. 1420.
CASTLE OF LA MANTA, PIEDMONT.

Abbot of Sainte-Geneviève in Paris, François de Nyons, is shown praying before his patron saint. Also, the stylistic affinities between his work at La Manta and the "Trousseau" window in Bourges Cathedral suggest that he may have stayed in the province of Berry, whose capital was Bourges. This case of an Italian nobleman steeped in French culture calling in a traveling artist to decorate his castle is certainly not unique; it illustrates one of the ways in which French Court art was diffused in foreign lands during the first decade of the 15th century.

Meanwhile there were some few artists with more original temperaments who, disdaining romantic glamour, instilled into their work something of the rankling unrest of an age of internecine conflict. The Books of Hours of Boucicaut, Marshal of France, and the *Grandes Heures de Rohan*, while pertaining to what we name the Royal Domain, have an emotive intensity far to seek in most contemporary Parisian art. It was Yolande of Aragon, wife of Louis II of Anjou, who in 1425 commissioned the *Grandes Heures de Rohan*, probably for her son René. The almost line-for-line resemblances, in lay-outs and themes, with the *Belles Heures* and the Calendar of the *Très Riches Heures* can be accounted for by the fact that the two last-named works

had been acquired by the princess on the death of the Duke of Berry and the artist, perhaps Jan Coene, may well have had them under his eyes. The Historiated Bible (MS fr. 9561, Bibliothèque Nationale) that a prince of the House of Anjou had, it seems, brought back from Sicily, supplied the artist with other models which he copied no less faithfully. Thus the *Grandes Heures de Rohan* should be ascribed to an atelier of the court of Anjou, despite the name which the book has been given on the strength of armorial bearings added at a later date. To the same milieu may be attributed the Book of Hours of Isabel Stuart and that of King René. The striking beauty of these Angevin productions was due less to the personal taste of Duke Louis II than to that of his wife, Yolande of Aragon, daughter of Violante de Bar, "queen of the troubadours," grand-daughter of Yolande of Flanders, the splendor of whose court was the talk of western Europe. Presumably the Duchess saw to it that this tradition of knightly courtesy and culture was maintained at her court, whose elegantly sophisticated atmosphere makes its presence felt in the watercolor portrait of Louis II. This type of work sets the artist complicated problems, since it seems to deny him any personal expression. Yet here the artist has done better than "express"—he *suggests*; indeed the well-tempered realism of the face tells us more than Christine de Pisan's description of his sitter: "A paragon of virtue worthy of his high renown; exceeding wise and gifted with a quick command of words; worshipful and lordly in his mien; handsome in face and form; excelling other men in grandeur and heroic courage." True enough, so far as it goes; but the long, thin nose, faraway gaze and softly molded lips remind us, rather, of the dreamer who "collected" phantom kingdoms: Naples, Hungary, Poland, Moldavia-Walachia, the Dalmatic Provinces, Provence. The light yet ample modeling and clean-cut line are in the tradition of the profile portraits of the French Court, of John the Good and Charles V, and owe nothing to Italy. It was, rather, Italy that took her lead from France; the charming portrait of an elegant lady dressed in French style (in the National Gallery, Washington), dated to about 1415, pointed the way to Pisanello's famous *Ginevra d'Este*, painted in 1438.

The appearance of the portrait in French art, under the form of likenesses of royal personages inserted in illuminations, was a highly significant development, throwing light on the earlier humanism which preceded that of the Renaissance. True, painters had already portrayed their contemporaries, but always as anonymous, almost abstract figures: mere social types. It was only natural that when they ventured on the portrait proper they began by taking kings and princes as their models, owing to their sacred character. But in so doing they opened up a whole new realm of art, for when so faithfully depicting the physical or psychological traits of their sitters, they were led to paint less the monarch, the Lord's anointed, than the man himself with all his human flaws and failings, of which, living in his intimacy, they could but be aware. Thus the advent of the portrait spelt the end of the lingering conception of painting's quasi-magical function and pointed the way to that glorification of Man, divine or mortal— the Christ of the Avignon *Pietà* or Nicholas Rollin in the Autun *Virgin*—which was basic to the art of the 15th century.

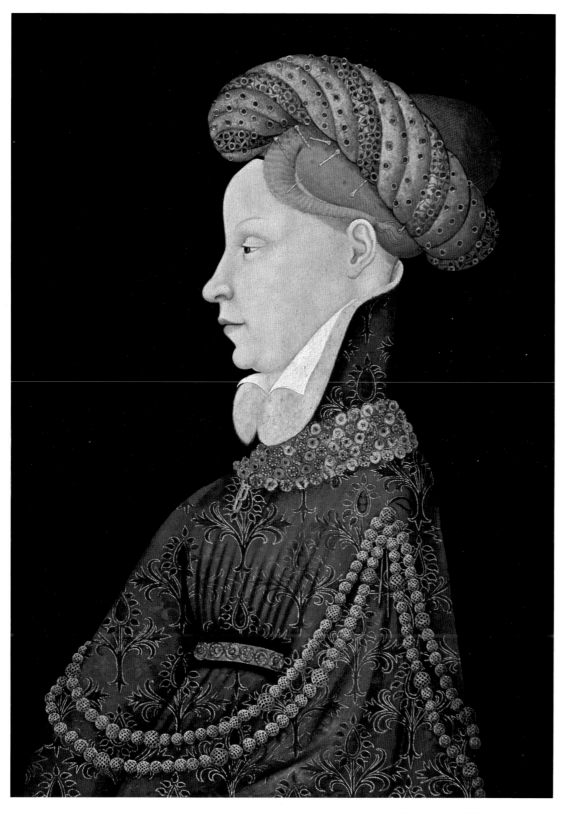

UNKNOWN MASTER. PORTRAIT OF A WOMAN, CA. 1415. (20½ × 14½″)
MELLON COLLECTION, NATIONAL GALLERY OF ART, WASHINGTON.

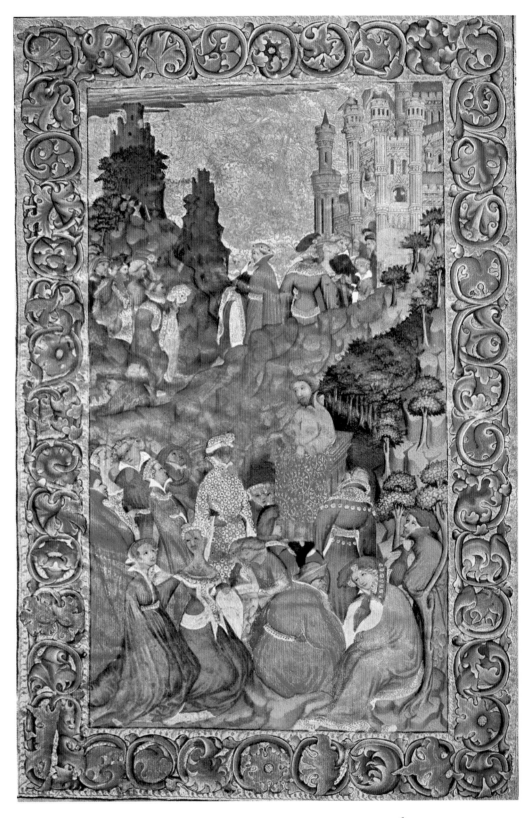

CHAUCER, TROILUS AND CRISEYDE. FRONTISPIECE. MINIATURE, MS 61, FOLIO 1, BACK.
(9¼ ×6″) CORPUS CHRISTI COLLEGE, CAMBRIDGE.

COURT ART IN ENGLAND

When towards the end of the 14th century the production of illuminated books was resumed in England, we no longer find any distinctively English traits. On the contrary, these works have a Germanic flavor, due perhaps to the presence at the court of the Bohemian painters who accompanied Anne of Bohemia, daughter of the Emperor Charles IV, to England on her marriage with King Richard II in 1382.

Naturally there were other influences; indeed that of Paris could hardly fail to operate even more strongly, given the relative proximity of that city and the political contacts between the two great kingdoms of the West. In the Wilton Diptych, now in the National Gallery, London, we have an exceptionally interesting example of the art of this period. It takes its name from Wilton House, residence of the family of the Counts of Pembroke who owned it for two hundred years. One of the most striking characteristics of this diptych is that it combines the meticulously perfect finish of the miniature with the luster of goldsmiths' work, thanks to the stamped gold background. It pertains to the category of those devotional objects for family use the best examples of which, the Bargello diptych and the Sachs *Annunciation*, were the work of Parisian artists. But here the kneeling prince is an Englishman, King Richard II, attended by his three patron saints: St John the Baptist, that pious monarch Edward the Confessor (holding a ring) and Edmund, King and Martyr, who was done to death by Danish bowmen in 870. No less typically English are the girls in blue dressed up as angels with paired wings and garlands of roses around their heads, each wearing the Plantagenet broom's-cod collar and the white hart emblem on her shoulder—remote and charming harbingers of the chaste damsels dear to the Pre-Raphaelites. Dressed like them, the Virgin carries the Child, who is stretching out a small plump arm towards the kneeling King. The back of the diptych, too, is gilt, on one side being the arms of Edward the Confessor and those of the Kingdom of England crowned with a helmet and a lion, and on the other a tame white hart, the King's device.

While there is no question of the King's identity, the exact significance of the angels wearing his emblem is harder to decide. There are eleven of them and some have seen in this an allusion to the King's age at his coronation (in 1377)—in which case this diptych would be singularly in advance of its period. Recently, however, Miss Clarke has pointed out that the armorial bearings of Edward the Confessor, the white hart emblem and broom's-cod collar were adopted somewhat later and suggests that this work should be dated to, approximately, 1395. But by that time the King was wearing a beard, and the reasons given for the artist's depicting him as a beardless boy do not seem to me conclusive.

In any case all the iconographic details of this delicately wrought diptych point to its having been made at the King's court or anyhow under his auspices, with a view to commemorating his coronation. Nevertheless none of the few surviving English paintings of the period has the least affinity to it. Neither in the lost frescos at

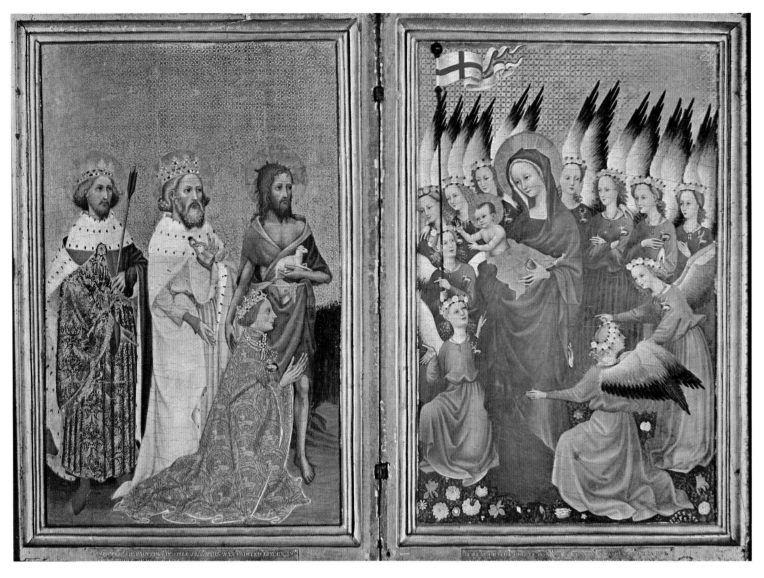

UNKNOWN MASTER. THE WILTON DIPTYCH, FRONT. RICHARD II OF ENGLAND WITH HIS PATRON SAINTS: EDWARD THE CONFESSOR, ST EDMUND AND ST JOHN THE BAPTIST. THE VIRGIN AND CHILD WITH ANGELS. CA. 1395. (EACH PANEL: 20¾ × 14½″) REPRODUCED BY COURTESY OF THE TRUSTEES, NATIONAL GALLERY, LONDON.

Westminster (known to us now by copies only), nor in the paintings in the Black Prince's tomb at Canterbury, nor in the portrait of Richard II in Westminster Abbey, do we find the same exquisite coloring and miniature-like delicacy. The Wilton Diptych, in fact, has more in common with contemporary French painting. Beauneveu has been suggested as its maker, on the strength of his Prophets and Apostles in the Duke of Berry's Psalter, while the composition has been likened to that of certain miniatures in the *Très Belles Heures* at Brussels. But these controversies regarding the nationality, French or English, of the painter seem beside the mark when we remember that in this period the English court was permeated with French culture; thus there is much to be said for the hypothesis that this delightful work was painted in England by an artist,

French or English, who had studied with the Duke of Berry's painters, most probably in Paris. French court art took root and prospered in many parts of the Continent: Spain, Bohemia, the Rhineland. But one of its finest flowers, undoubtedly, the Wilton Diptych, was nurtured on English soil.

Likewise the English illuminators of the period were far from being impervious to the glamour of Parisian art, as we can see from that magnificent frontispiece to Chaucer's *Troilus and Criseyde*, now in Corpus Christi College, Cambridge. Inside a sumptuous border decoration typically English in style we see Chaucer conversing in the open air with a group of elegant personages gathered around a prince attired in cloth-of-gold. Accompanied by her courtiers, the queen is coming out of a castle, an anglicized reproduction of one of the Duke of Berry's châteaux.

UNKNOWN MASTER. THE WILTON DIPTYCH, BACK. CA. 1395. (EACH PANEL: 20¾ × 14½″)
REPRODUCED BY COURTESY OF THE TRUSTEES, NATIONAL GALLERY, LONDON.

RISE OF THE SCHOOLS OF VALENCIA AND BARCELONA

One is sometimes conscious of a tendency to give the developments of Spanish art in the 13th and 14th centuries less than their due in studies of the painting of the Gothic age. Nevertheless during that period an authentically Spanish art took form under the alternate influences of France and Siena, and manifested itself under the auspices of such great painters as Ferrer Bassa, Luis Borrassá, Bernardo Martorell, the Valencia group. Meanwhile in the four Mediterranean provinces of Roussillon, Catalonia, Valencia and Majorca both geographical and political conditions led to the growth of an art which, without abandoning its native idiom, freely assimilated elements drawn from France and Italy.

No region better lends itself to seaborne commerce with the whole Mediterranean area than the eastern Spanish seaboard, with its great ports, Barcelona and Valencia, and it was an outpost of Greek colonial culture long before becoming Romanized. But, besides seaborne trade from port to port, there was heavy traffic on the coastal road, used in this period by merchants and pilgrims, as in earlier days by invading armies and the legions. Thus intercourse both cultural and commercial was constant between Barcelona and Marseilles, and via Marseilles with the Italian maritime cities.

Political changes at the end of the 13th century brought Montpellier, Palma and Perpignan under the sway of the kings of Majorca and this kingdom prospered for some seventy years (1276 to 1344). Thanks to its cloth-making industry and the enterprise of its merchants, who worked in close co-operation with the Catalans of the Kingdom of Aragon, Perpignan became so wealthy that the monarchs were able to live there in great state, attended by their court, in the newly built royal palace. The first infiltration of Gothic art into this region, where Romanesque traditions were still so firmly entrenched, took the form of a local style inspired by miniatures of the previous century. The Serdinya altarpiece (1342) is a striking illustration of the diffusion of French art in the south. Around the central scene (a Crucifixion) are set forth in eight compartments scenes of Christ's childhood and the life of the Virgin; these are partitioned off by vertical strips painted to resemble the rows of precious stones in the richly ornamented Spanish *retablos*. From the Romanesque period on, Catalan painters had sought to reproduce in paint the qualities of goldsmiths' work and here we see this practice combined with the fine precision of French figure-drawing.

Though Majorcan architecture was clearly inspired by the style then prevailing in France, the painters on the other hand seem to have been subject solely to Italian influences, transmitted presumably by one of Duccio's pupils. It is to him that the works preserved at Palma, such as the S. Guilleria *retablo* in the Archaeological Museum, owe their Sienese characteristics: the structure of the faces, skillful modeling, an intermingling of Byzantine, Romanesque and Gothic forms in the architectural setting.

The political changes which led to the downfall of the Kingdom of Majorca and the restoration of Catalonia to the King of Aragon put an end to French influence and

at the same time enlarged the sphere of influence of the royal atelier in Barcelona maintained by King Pedro IV. The commission given in 1345 for an altarpiece for the royal chapel at Perpignan—following on similar commissions for Saragossa, Lerida, Barcelona and Majorca (between 1340 and 1345)—is proof of this monarch's high esteem of his court painter Ferrer Bassa. Of the many works mentioned in records of the time none survives whose ascription to him is positive except the decorations in St Michael's Chapel in the Convent of the Nuns of St Clare at Pedralbes near Barcelona. These show him to have been one of the best 14th-century painters, on a par with the Lorenzettis, with whom he has much in common. Italian influence can be perceived in the elongated faces, large wide-open eyes and also in a certain almost sentimental tenderness; but the execution here is broader. This Catalan painter sees in terms of large, plain masses, and effortlessly imparts naturalness to attitudes and gestures. With his feeling for color and technical ability Ferrer Bassa stands out as an inspired precursor, but like many such he was too much in advance of his age for his lesson to take effect on his immediate successors.

Indeed as things turned out it was an anecdotal, descriptive painting stemming directly from the Sienese that now made headway in Spain, and Ramon Destorrent of Barcelona (who succeeded Ferrer Bassa as Court Painter to Pedro IV "El Ceremonioso") did much to popularize this form of art. To him is ascribed the Iravalles *retablo* at La Tour de Carol (on the French side of the Pyrenees). Dedicated to St Martha, this triptych shows the saint full face, a hieratic, monumental figure, in the central panel. Scenes from the lives of Martha and Mary are painted in three tiers on the wings, while a *Crucifixion* (on the same scale) figures at the top of the central panel. Though the general effect is pleasing, there is still some clumsiness in the handling of perspective and the grouping of the figures. Faces are conventional: slotted eyes, pointed noses, tiny mouths. Trained in Destorrent's studio, the Serra brothers kept to his methods. Combining the Sienese tradition in which they had been brought up with a French-inspired iconography, Jaime and Pere Serra often worked together; a collaboration to the benefit of both, Jaime being better at composition and Pere at drawing faces and details. Their stock scene of the Virgin and Child encircled by angels, a combination of the Sienese arabesque with Gothic elegance, may have been taken from Simone's *Virgin* in the porch of Notre-Dame-des-Doms at Avignon. The slanting posture, slightly drooping head, the big dark cloak picked out with gold, the suavity of the colors telling out on the gold ground—all were exactly to the taste of the religious-minded Spanish public. And when to this was added a miniature-like precision, the extraordinary popularity of the Serras' work and the host of imitations produced by their pupils are easily accounted for.

Meanwhile a group of more original painters was active at Perpignan. Professor Chandler Post had already drawn attention to a painter whom he styled, provisionally, the Master of Roussillon, maker of the big retable of St Andrew from Perpignan, now in the Metropolitan Museum, New York. Quite recently M. Marcel Durliat, after a close study of the St Nicholas altarpiece in the Church of Camélas (Pyrénées-Orientales),

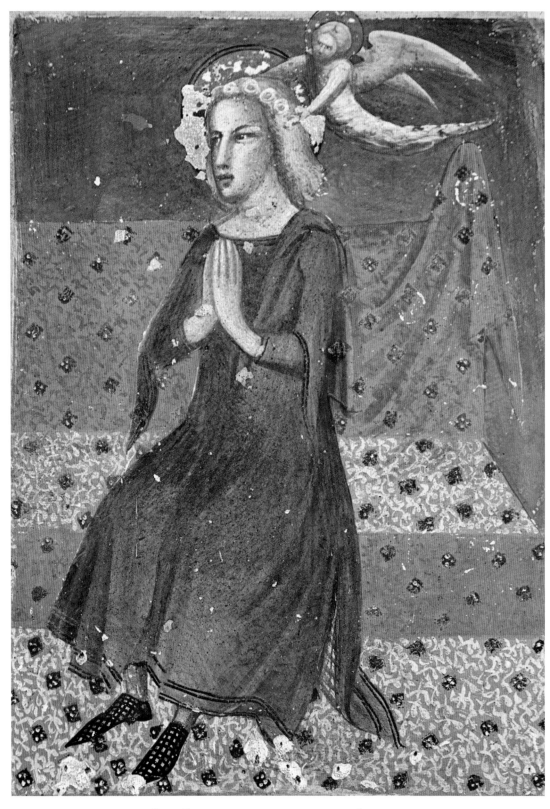

FERRER BASSA (?-1348). ST BONAVENTURA, 1345-1346. WALL-PAINTING IN OIL.
CONVENT OF PEDRALBES.

has attributed it to the same master, dating it to 1407. The differences between these works and those of the Serras are striking; notably in the colors employed. Those of the St Nicholas altarpiece remind us of a bouquet of gorgeous flowers and look as fresh as if they were painted only yesterday. Dominant are carmine reds stepped up to their highest intensity and set off by delicate greys, low-toned mauves, pale lilac. The lay-out of the scenes, moreover, and the gestures of the figures are more natural, owing perhaps to these artists' closer intercourse with France.

It was at Gerona that Luis Borrassá, pioneer of the International Style in Catalonia, was born. He came of a family of painters but nothing is known of his early years. We hear of him first at Barcelona whither he was summoned for the coronation festivities in 1388. This was the time when, thanks to the missionary zeal of the young queen, Violante de Bar, French culture was beginning to make headway at King Juan's court, soon to be a favorite resort of Provençal troubadours and a cultured élite.

In 1389 the Minorite Brothers of Tarragona commissioned him to make an altarpiece and next year he settled into a studio at Barcelona, where he lived until his death soon after 1424. The charm of his art is that it invites us into a familiar world, the world of real life. In previous paintings gestures had been stiffly, clumsily rendered; under his brush they become quite natural, and he shows us magnificently attired persons moving amidst palatial surroundings with an ease and elegance new to Spanish art. The polyptych, *Scenes from the Life of St John the Baptist*, attributed to his atelier (now in the Musée des Arts Décoratifs, Paris), is like a fascinating picture-book planned by a skillful story-teller. On the wings are scenes, placed one above the other, of events preceding the Baptist's birth or relating to his life: on one side, an angelic herald, the Visitation, the Birth of John; on the other, the Preaching in the Desert, the Baptism of Christ and Herod's Feast. Such is the beauty of this final scene (reminiscent no doubt of banquets the painter had witnessed at the Spanish court), enacted to the strains of a violin by a supremely elegant company, that we hardly feel the horror of the headsman's gesture, rendered though it is with ruthless realism, or of the blood spurting from the victim's throat. Perhaps, however, these gruesome details did not seem so harrowing to contemporary beholders, who probably were used to seeing public performances of this scene in mystery plays.

Last after Borrassá of this lineage of painters, Bernardo Martorell achieved celebrity under the name of "the Master of St George" before his real name was known. The *St George* in question frankly reproduces, down to the least details, the miniature illustrating the same theme in the Book of Hours of Boucicaut, Marshal of France (ca. 1402), now in the Jacquemart-André Museum, Paris. In his version of the miniature the painter has been at pains to render precisely all the natural features of the scene, undulations of the ground, tiny plants, the exact texture of walls and so forth, and also to locate each figure and object in its correct plane. For Martorell has assimilated the naturalistic tendencies of Flemish art before Van Eyck's arrival in Spain; thus he, too, may be regarded as an exponent of the International Style. Though he seems to disregard the geometric rules of space-presentation, this is because he seeks

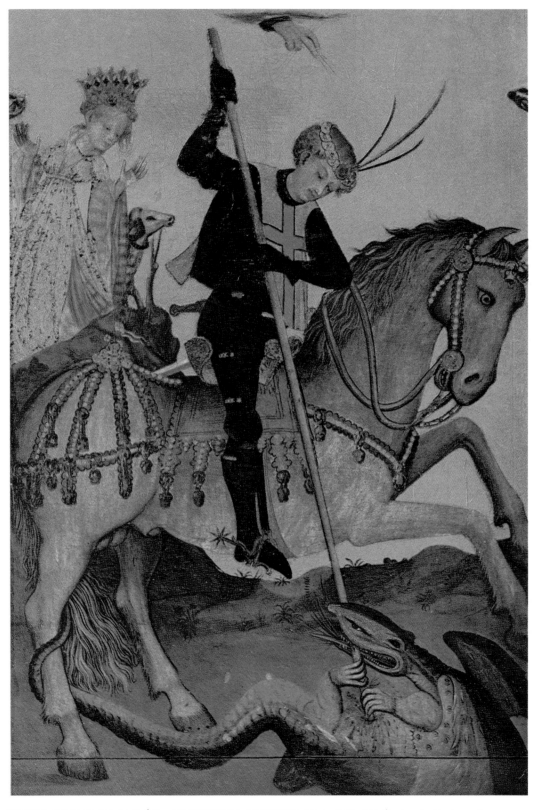

(?) ANDRES MARSAL DE SAX (FL. AT VALENCIA BETWEEN 1394 AND 1405). ALTARPIECE OF ST GEORGE.
SCENE FROM THE CENTRAL PANEL. CA. 1400. VICTORIA AND ALBERT MUSEUM, LONDON.

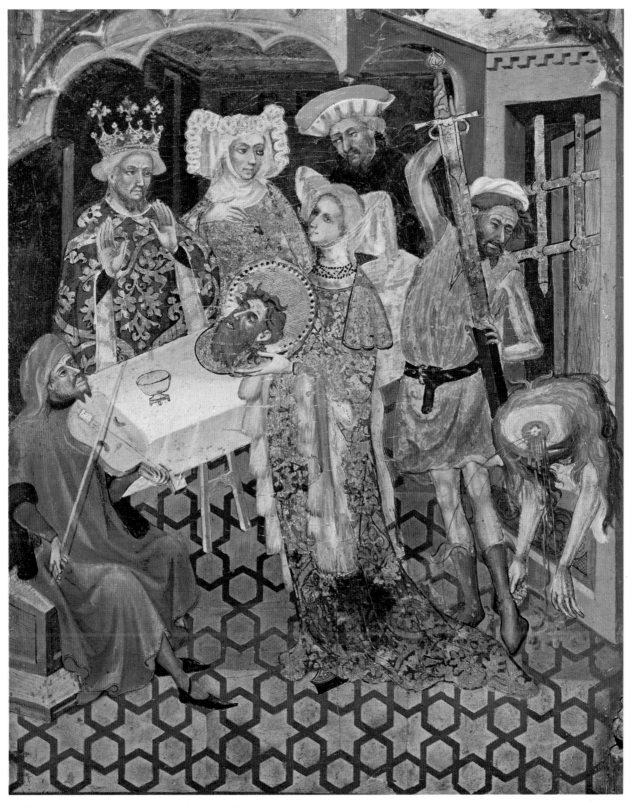

(?) ATELIER OF LUIS BORRASSÁ. HEROD'S FEAST. FRAGMENT OF A POLYPTYCH WITH SCENES FROM THE LIFE OF ST JOHN THE BAPTIST. $(27\frac{1}{2} \times 22'')$ MUSÉE DES ARTS DÉCORATIFS, PARIS.

to get the maximum effect from his method of composition in flat planes, figures and objects being echeloned accordingly. These bold conceptions and skillful innovations are ample proof of the vitality of Catalonian art at the time when Luis Dalmáu on his return from Bruges (in 1432) brought tidings of Van Eyck's epoch-making discoveries.

During the last decades of the 14th century, Valencian painting was much influenced by the work turned out in the studios of Barcelona, which, round about 1380, before returning to his hometown, Valencia, Lorenzo Zaragoza had frequented, and with which Berardo, an uncle of the Serras, had also been in contact before being banished from Barcelona. In his new home Berardo continued on the lines of Destorrent, but with a personal twist. The two visits of the Florentine Starnina (reputed to have been Fra Angelico's teacher) must have greatly interested these local painters, always eager for novelties. To Starnina is ascribed the Bonifacio Ferrer altarpiece in Valencia Museum. The *Crucifixion* is surrounded by small medallions depicting the Seven Sacraments and linked up by rays of light to the wounds of Christ, while the Baptism of Christ and the Conversion of St Paul (on the two wings), with their daring simplifications, strike an effective contrast with the central panel beneath which is a predella more typically Sienese in treatment. There are such differences in the execution of these scenes that maybe we have here the result of a collaboration between two painters, an Italian (or a Spaniard who had studied in Italy) and a Spanish artist of the school of Pedro Nicolau.

It would seem that Marsal de Sax, a painter of German extraction who some time between 1394 and 1405 founded a successful school, played a leading part in this group. He also collaborated with Pedro Nicolau in some large-scale works, in which it is next to impossible to distinguish between the respective shares of the two men, though logically, no doubt, we would be justified in attributing the more expressionistically treated figures to the German and to the Spaniard the passages handled in the traditional Valencian manner. Professor Post has come to the conclusion that to Marsal de Sax should be ascribed the *St George* altarpiece in the Victoria and Albert Museum, London, an *ex voto* commemorating the famous victory of King Pedro I at Albocacer.

It is to Gonzalo Perez that Sr. L. de Saralegui proposes to ascribe the famous altarpiece presented in 1443 by Berenguer Marti de Torres to the Monastery of Portacoeli. It consists of three panels on gold grounds. In the central panel St Martin is cutting his mantle in two; on his right is St Ursula carrying the arrows, instruments of her martyrdom; on his left, St Anthony Abbot. Purity of line, statuesque dignity combined with delicate grace, give the face of St Ursula its extraordinary charm. A white veil half covering her fair hair isolates her head and throat from the night-blue cloak, lined with violet, that flows about her body, and the figure shows up grandly on a field of patterned gold. The sobriety of the treatment and the broadly stated, simple forms differentiate this altarpiece from the majority of contemporary Valencian works. We find the same qualities in the big *Annunciation* (San Carlos Museum); some have thought, wrongly in my opinion, to detect Flemish influences in it. It is, rather, a final echo of the wistful, serene Virgins painted on gold grounds of early Italian art. And with these masterpieces of Valencian painting an era ended.

MASTER OF THE VYŠŠÍ BROD CYCLE. CHRIST IN THE GARDEN OF OLIVES, DETAIL.
PANEL FROM SCENES OF THE LIFE OF CHRIST. CA. 1350. NATIONAL GALLERY, PRAGUE.

THE COURT OF CHARLES IV AT PRAGUE

The historical and cultural destinies of Bohemia were determined by her geographical position as at once a frontier borderland between East and West and the final bastion of the Roman Empire against "the barbarians of the North." During the Middle Ages Bohemia acted as a sort of clearing-house for the very diverse cultures developing on all sides, both in the Slav countries and in the kingdoms of Western Europe. But it was not until John of Luxemburg, "the Blind," ascended the throne in 1310, and above all when his son Charles IV succeeded him (in 1333), that Bohemia came to play any active role in international politics. Though as a member of the ruling house of Luxemburg Charles was of German descent, his cultural background was French, for he had been brought up at the French court. Thus when in 1346 he became Emperor of Germany

MASTER OF THE VYŠŠÍ BROD CYCLE. CHRIST IN THE GARDEN OF OLIVES. PANEL FROM SCENES OF THE LIFE
OF CHRIST. CA. 1350. (37 ¼ × 33 ½ ″) NATIONAL GALLERY, PRAGUE.

he modeled his system of government on that of his uncle Charles V of France; that is to say, he based his administration on the support of the rich and cultivated urban middle class and fostered trade relations with other countries.

Since no work of pictorial art earlier than the 14th century has survived, it is impossible to know if a specifically Bohemian form of painting existed previously. The few illuminated manuscripts of Bohemian provenance that exist—dated to the beginning of the 13th century—are in the Romanesque tradition of South Germany, of the Schools of Regensburg and Salzburg. It was only in 1320 and in the following decades, when monks from the West, followed by the Knights Templars, settled at Prague that French art began to penetrate Bohemia (e.g. the *Breviary* and *Antiphonary* of Queen Elizabeth Rejcka and the *Passional* of Abbess Kunegonda). But before long French influence was countered and indeed superseded by Italian (e.g. the *Breviary* of Grand Master Leon of the Crusaders' Monastery at Prague, and the *Liber Viaticus* of Bishop John of Středa).

Illumination kept in line with panel painting, which was prolific to a degree unparalleled in any other European country. In the 14th century there were in Prague Cathedral no less than sixty altars or retables, twenty-four in the Church of Tyn and thirty-two in the Chapterhouse of Vyšší Brod. The prodigious development of this form of art was certainly due to the personal zeal of Charles IV. He was determined that the splendor of his capital should yield to none in Europe and, no local artists capable of furthering this ambition being available, he looked abroad for help, with the result that foreign artists flocked to Prague. During his journeys in France and Italy and his stay at Avignon he had come in contact with leading artists of the day, thanks to the good offices of his chancellor, Bishop John of Středa and of Bishop John of Draždice who lived in Avignon from 1318 to 1329. It was a Frenchman, Mathieu d'Arras, who made the blueprints for the Cathedral of St Guy at Prague (1344-1352), on the lines of the Cathedral of Narbonne. He was succeeded in this post by a German architect, Peter Pařlér, who had been trained in Cologne. Charles IV founded at Prague the first university of Central Europe (modeled on the University of Paris), and in the same year (1348) granted their statutes to the Corporation of Painters in his capital.

If art historians of the past had a regrettable tendency to confuse Bohemian with French art, this was natural enough, for it is certainly no easy matter distinguishing between its indigenous and imported elements. However, a careful study of outstanding works brings to light some very real differences. Most strongly marked in the illuminations, French influence soon gave way to that of Italy. Thus the panels of the *Life of Christ* in the Collegiate Church of Hohenfurth, the Glatz *Madonna* and the Roudnice predella (between 1340 and 1350) are clearly in the Duccio tradition. In the mid-century, however, we find an intermingling of local idioms with French and Italian procedures, in, for example, the group of tempera paintings figuring in the Vyšší Brod cycle. Though the nine panels illustrating the *Life of Christ* have obvious affinities with Italian art (this is especially true of the *Nativity*, so reminiscent of Giotto's at Padua), they have also much in common with the paintings of the Klosterneuburg altar. Devoid of depth,

the scenes are built up on grounds of stamped and patterned gold. Recession in space is ignored or, rather, is clumsily suggested by such makeshift devices as echeloned buildings, the division of the soil into lozenge-shaped patches, the arrangement of figures one above the other, the upper figures signifying rearward, the lower forward position. Movements are rigidly arrested, and Christ is given the hieratic aspect of an oriental Mage. None the less, these depersonalized figures have a grandeur of their own. Moreover this artist has been at pains to render certain details with extreme precision, though without departing from the traditional stylization. Faces are accurately drawn, the birds perching on the trees are lifelike, and in the color orchestration, with its well-defined patches of brilliant, jewel-like color, we see Bohemian art at its most spontaneous.

Italian influence made itself still more strongly felt in the second half of the 14th century when there was constant intercourse with Italy by way of Lower Austria, and became intensified when Tomaso da Modena settled at Prague. The decorations made in the king's new residence, the Castle of Karlstein, gave local artists an opportunity of familiarizing themselves with the Trecento aesthetic introduced by Tomaso, and also brought to the fore by Theodorich, an artist of very high originality, President of the Corporation of Painters at Prague. The Chapel of the Holy Cross (1367), planned on the lines of an elaborately adorned casket enshrining the Crown jewels and the relic of the "Holy Thorn," was one of the most impressive monuments of its kind, anyhow as regards the spirit of the decorations. In his portraits Theodorich shows a fondness for massive bodies, short torsos, thick-set faces, broadly treated drapery and, above all, eye-filling color. Indeed at times they remind us of the realistic portraits made by the French court painters. But these innovations were too far removed from the national tradition to have a direct or lasting influence on Czech art.

Far more in keeping with, and expressive of, the national genius were the paintings made by the Master of the Trebon Altar (1380). As far as execution is concerned, he still keeps very near that of the frescos painted earlier in Charles's reign, but he employs chiaroscuro more lavishly and boldly than any other painter of the day. The three panels, notably the scenes of the Mount of Olives and the Resurrection, have a singular emotive power, due in part to the strange, otherworldly light falling on the leading forms alone, in which Gothic naturalism is allied with a spirituality charged with mystical significance. Draped in a red cloak that, opening, reveals his scars, Christ appears to the soldiers at the tomb, who waken in amazement, while birds fly off across a purple background spangled with golden stars. Using high-keyed color and a richly worked pigment that seems to trap the glitter of the starry sky, the painter combines objective verisimilitude with ordered plastic structure.

We find this fusion of idealism and realism, which at the end of the 14th century was leading Bohemian painting towards the "grand style," in a number of large-scale works such as the Svata Barbora *Crucifixion* and that of Vyssí Brod. But the Master of Třebon was the last of his kind; after him Czech painting soon harked back to the conservatism of early Gothic, and lapsing into mannerism lost its vitality and grandeur.

MASTER OF THE TŘEBON ALTAR. THE RESURRECTION. PANEL FROM SCENES OF THE PASSION. CA. 1380. (52 × 36″) NATIONAL GALLERY, PRAGUE.

MEISTER BERTRAM (CA. 1345-CA. 1415). THE REST DURING THE FLIGHT INTO EGYPT. PANEL FROM THE MAIN
ALTAR OF ST PETER'S CHURCH, HAMBURG, THE SO-CALLED GRABOW ALTARPIECE. 1379. KUNSTHALLE, HAMBURG.

THE GERMAN AND AUSTRIAN SCHOOLS

Centered in thriving commercial towns, the cultural life of 14th-century Germany found expression in a forthright, matter-of-fact art. And since the country was traversed by the great trade routes from the Baltic, the Rhineland and the Danube, this was shaped by two conflicting tendencies, stemming from the East and from the West. Bruges and The Hague had taken over the torch from France and England, whose creative activities had flagged as a result of the Hundred Years' War. Henceforth the Rhine was the chief medium of communication between France and the Low Countries, while Danubian Germany was oriented towards Venice. Along the rivers and the Baltic coast, independent cities flourished under the administration of a rich and energetic merchant class. Continental Germany, however, still in course of being split up into a host of petty feudal states under the now purely fictitious suzerainty of the Empire, stood outside these cultural trends. Within the cities trade guilds had dislodged the once privileged classes and established a new order, businesslike and bourgeois.

Owing to the wide field of her commercial activities and the international traffic on her roads and rivers, Germany was now cross-fertilized by art trends from many sources: Burgundy, Avignon, Italy, Bohemia and Flanders. The artist was a mere artisan without personal aesthetic preferences and the work he turned out was vigorous enough, but lacking in refinement and imagination. In fact he was not expected to be creative; all he had to do was to give concrete, easily comprehensible form to the religious aspirations of the community. The devotional needs of the ordinary man were catered for by the mendicant orders who, in the cities, sided with the populace against the upper class. A special kind of piety prevailed, naïve and sentimental, suited to the tastes of the shopkeeper and the "little man," who had no time for soul-searchings; yet, on occasion, under the stimulus of some eloquent preacher, this simple faith could scale the loftiest heights of mysticism. Meanwhile the economic and political decentralization of Germany led to the development of independent ateliers disseminated through the country and flourishing schools developed in the Hanseatic towns, the Rhineland and Westphalia, Swabia and the Tyrol.

Theodorich of Prague is said to have accompanied Charles IV to Hamburg in 1375 and his presence there may account for the resemblances, too marked to be fortuitous, between Meister Bertram's work and his own. Born some time prior to 1350 in Westphalia, Meister Bertram is known to have been as early as 1367 at Hamburg where, about 1415, he died. Much influenced by the art of Bohemia, his paintings tend towards a visual realism, implemented by rounded, sculpturesque forms, still imperfectly realized, and attempts at rendering perspective by means of light. True, he failed to liberate his figures satisfactorily from the hieratic tyranny of an earlier age; nevertheless in the period between the altarpiece of St Peter's Church (Kunsthalle, Hamburg) and the Buxtehude altarpiece (some ten years later) he developed a freer style of composition, a new conception of space and a more personal expression.

During the second quarter of the 15th century Meister Francke, while generally keeping to the frankly Gothic style of Meister Bertram, struck out in new directions, displaying much originality and a new freedom in the treatment of his subject. But this individualistic art had no direct influence on the Hamburg group, which soon died out, following the decline of the Hanseatic League during the 15th century.

The influence of the Bohemian masters and the French and Italian trends they sponsored can be traced also in South Germany and Austria, where, in the absence of a powerful aristocracy and a cultivated middle class, the sole art patrons were the monasteries. Oldest of 14th-century paintings are the panels commissioned by Stefan von Siendorf, Abbot of the Klosterneuburg monastery, for the back of the altarpiece whose front bore the famous enamel-work panels made by Nicolas de Verdun in the 12th century. Despite Tuscan influences these paintings are brilliantly original. From another monastery, the Cistercian abbey of Heiligenkreutz in Lower Austria, came a charming early 15th-century painting on a gold ground which is now in the Vienna Museum. It depicts *The Annunciation* and *The Mystical Marriage of St Catherine* and its kinship with Parisian miniatures is unmistakable, though there are some personal touches such as the prominence given the forehead in the faces.

The evolution of painting in South Germany took the same course, if a little later: that of a movement away from idealistic line towards the eye-filling modeling of the "new art," and from the Gothic style to 15th-century naturalism. It was a transitional art combining the rusticity and ponderousness of its earlier phase with the recent achievements of France and Italy: close observation of reality and a feeling for perspective. To foreign influences, from Bohemia and especially Burgundy, were due the courtly-social traits that now emerged in the art of South Germany. At the same time these artists, ever amenable to new ideas, developed the technique of wood engraving, launched in the 14th century in the Cistercian abbeys of Burgundy, whence woodcuts were sent out along the road running from Dijon through Basel and Constance to the affiliated religious Houses in Bavaria and Swabia. Indeed before long German art became identified with that of the engravers, which from the 15th century on tended to impose an essentially linear aesthetic on painting in general.

Westphalian art found its ablest exponent in a master dwelling in the little town of Soest, chief art center of that part of Germany in the 13th and 14th centuries. Conrad von Soest broke with the traditional rustic Byzantinism of the provinces. His predilection for elegant forms and gestures and rich costumes with smoothly flowing drapery, for realistic detail and the expression of individual emotions, reveals the influence of the court of Burgundy and the picturesque naturalism of this Westphalian art contrasts with the rather mawkish mysticism of the Cologne School.

Cologne was the crossroads of the economic, intellectual and artistic activities of France, Germany and the Low Countries. "Rome of the North," this city had a special attraction for the mystics of the age, such men as Meister Eckhart, Johann Tauler and Heinrich Suso. Tauler, "the lovable," made the lofty speculations of an impassioned asceticism comprehensible to the masses, and saw in painting a useful ally. Hence

the vast number of altarpieces commissioned by 14th-century nunneries, always forcing-beds of mysticism. Finest of these is the altarpiece in Cologne Cathedral, originally painted for a Convent of St Clare (1370-1380). Here for the first time we see the Madonna with the oval face and rather full chin henceforth adopted by the School of Cologne as its ideal of feminine beauty. In the iconography of the Cologne School, with its taste for the picturesque and sentimental, the most favored theme was that of Christ's childhood, and the fertile, if puerile, imagination of these artists found its happiest expression

MASTER OF HEILIGENKREUTZ. THE ANNUNCIATION AND THE MYSTICAL MARRIAGE OF ST CATHERINE. PANELS FROM THE ALTAR OF THE CHURCH OF HEILIGENKREUTZ, LOWER AUSTRIA. EARLY FIFTEENTH CENTURY. (EACH PANEL: 28¼ × 17″) MUSEUM, VIENNA.

in visions of "celestial gardens." Thus the *Garden of Paradise* (Staedelsches Institut, Frankfort) shows the Virgin seated amongst angels in a meadow spangled with flowers and loud with the song of goldfinches; she is scanning the pages of a large red book, while a female saint teaches the Child Jesus to play the zither.

But when over-indulged in, idyllic fantasies of this kind tend to lose their first fine rapture and to degenerate into mannerism. This in fact was what befell the School of Cologne, whose *Dombild* (ca. 1440), the celebrated triptych of Stefan Lochner, illustrates the middle-class ideals of the 15th century and, while still infused with the Gothic spirit, is totally devoid of mysticism.

MASTER OF THE MIDDLE RHINE. THE GARDEN OF PARADISE. CA. 1420. (10 ¼ × 13″)
STAEDELSCHES INSTITUT, FRANKFORT.

ITALIAN MANIFESTATIONS
OF INTERNATIONAL GOTHIC ART

As pointed out in our general survey of the Gothic field, this form of art was not an isolated phenomenon but Europe-wide, and its name, "the International Style," is quite legitimate. In 15th-century Italy the Gothic spirit manifested itself under various forms in the work of several eminent artists whose personalities, however, were less strongly marked than those of the great Trecento pioneers. Nevertheless these demonstrations of the Gothic spirit, last gleams of the sunset of mediaevalism, despite their brilliancy and poetic charm, represent only one, and admittedly not the most important, of many aspects of the intense activity and rich diversity of Italian art during the early part of the 15th century. A new outlook on the world had been maturing in 14th-century Italy and other conceptions of the aims of art—purer, simpler and more virile than the sometimes over-sophisticated ideal of beauty inspiring International Gothic—had been given poetic expression.

At the beginning of the 15th century Giotto's discoveries and inventions were carried a stage further and the rationalistic attitude to life sponsored by the new humanist culture was brilliantly expressed in the work of Brunelleschi, Donatello and Masaccio. Thus we must never lose sight of the great part played by Italy in the general evolution of the world's art, when studying other works of the period and in particular those which still link up with International Gothic, and with which we conclude our survey of the Gothic age.

A full account of that momentous phase of art history, the first half of the Quattrocento, would exceed the scope of the present work; we should need to investigate the inter-relations, conflicts and conjunctions of the very diverse tendencies which give that period its rich complexity. So we shall confine ourselves to brief but, we trust, adequate descriptions of such Italian artists and outstanding works as seem to fall within the domain of International Gothic. Like so many convenient but over-simplified generalizations, this term, International Gothic, describing as it does a "climate" shared by many works of art in many countries, is far from easy to define. What is the common ground between forms of art so different as those of Giovannino de' Grassi and Pisanello, the Limbourg brothers and the Bohemian painters—to name but a few instances? What they have in common is not so much any specific style as a tendency to give free play to fantasy. Characteristic of this world of fancy-free imagination is a subtle, sometimes precarious balance between two often contradictory elements: sophisticated line and color tending towards decorative abstraction on the one hand, and on the other realistic observation, insistence on the picturesque detail, a minutely precise rendering of natural appearances. Nevertheless the "Gothic" artist's gaze merely skims the surface of things and does not strike down to the hard core of reality. For this is an essentially aristocratic art, fine flower of the culture of an age of chivalry, rejoicing in smoothly flowing arabesques, lyrical effusion, the brilliant colors, gorgeous costumes,

pomp and splendor of the great courts of Europe. Living in a world of exquisite dreams, these artists treated their subjects, sacred and secular, as so many charming fairy-tales.

Obviously this poetic, fanciful art, at once frankly illustrative and decorative to the point of abstraction, would seem to derive from 13th-century French-Gothic illuminations, and thus to be totally at variance with Giotto's whole conception of the artist's function no less than with Masaccio's. But, as we have seen, this art period cannot be adequately defined in terms of the antagonism or compromises between these two extremes; Italy, too, played an active part in the development and diffusion of International Gothic. We have already drawn attention to the importance of Simone Martini and the art center of Avignon, and to the significance of Vitale da Bologna and the Bolognese painters and illuminators who, even before the middle of the 14th century, promoted in northern Italy a form of art quite different from that of Tuscany and akin to the Gothic painting outside Italy. We will now turn to the art of Lombardy, for it was here that, in the court of the Visconti, there developed an aristocratic, elegant style closely linking up with that of other European art centers. The objective, anecdotal depiction of everyday reality, of local manners and family life, which had already been the most personal trait in the work of Giovanni da Milano, found many exponents in the second half of the century, especially in illuminations and in the various codices of the *Tacuinum Sanitatis*. In the best versions of this work, we find realistic observation allied with a keen sense of rhythm, and it was on these lines that Lombard illuminators illustrated both romantic tales and sacred texts. Their productions were very popular and found their way even to France, where they were known as "Lombardy work"—a description covering books produced as far away as Verona, whose artists, from the 14th century on, had kept in close touch with their colleagues in Milan. "Lombardy work" owed its success to its vivacity, realistic touches and adroit renderings of nature under all her aspects.

Some of these codices, above all the first copies of the *Tacuinum*, have affinities with the work of Giovannino de' Grassi, the most eminent *fin-de-siècle* Lombard artist. A many-sided man, architect, sculptor, painter and illuminator, he took part from 1389 on in the building of Milan Cathedral, that monument of Late Gothic whose work-yards, like those of Cologne Cathedral and San Petronio at Bologna, were a meeting-place for artists and craftsmen from all over Europe. Giovannino died in 1398. In such few works by him as have survived, northern Gothic influence is manifest. Indeed his illuminations in the famous Book of Hours of Gian Galeazzo Visconti (ca. 1385) may be regarded as the high-water mark in Italy of this aristocratic, ornate, almost ultra-refined type of art. The saying that "all art aspires to the condition of music" comes to mind when we gaze at one of these exquisitely painted pages, with their harmonies of delicate color, their melodiously rhythmic line, their languorous, faintly decadent appeal. Typical is the full-page illustration of the *Magnificat*, in which the sacred theme is handled lightly, almost frivolously, the central figure being surrounded by a bevy of young girls playing ball, while the entire composition forms a symphony of gem-like hues, sudden glints of gold and richly decorative details.

STEFANO DA ZEVIO (CA. 1375-1451). MADONNA AND CHILD IN THE ROSE GARDEN.
EARLY FIFTEENTH CENTURY. (50¾ × 37¼″) MUSEO DI CASTELVECCHIO, VERONA.

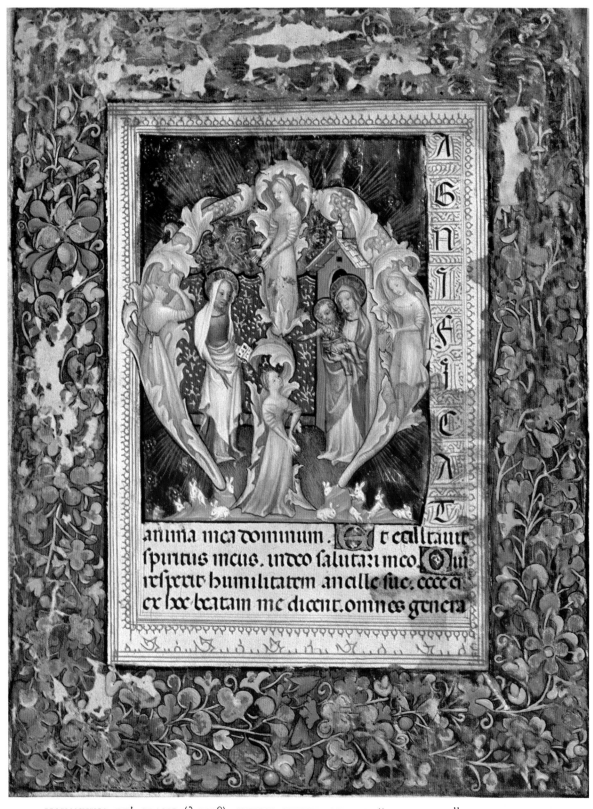

GIOVANNINO DE' GRASSI (?-1398). INITIAL LETTER OF THE "MAGNIFICAT." BOOK OF HOURS OF GIAN GALEAZZO VISCONTI. CA. 1385. LIBRARY OF DUKE VISCONTI DI MODRONE, MILAN.

LORENZO MONACO (1370 OR 1371-1425). SCENE FROM THE LIFE OF ST NICHOLAS OF BARI.
PANEL OF A PREDELLA. GALLERIA DELL'ACCADEMIA, FLORENCE.

That gift of transmuting the facts of concrete reality into the stuff that poetry is made of, by the use of intricate, subtly suggestive line (it is even more conspicuously present in his Bergamo book of designs), was not peculiar to Giovannino de' Grassi. We find it in the work of several other artists of the period, all highly accomplished draftsmen: amongst them Michelino da Besozzo, Stefano da Zevio and Pisanello. All had a keen eye for natural appearances and a taste for exactitude of statement. Nevertheless, by the use of a light, sensitive line, they dematerialized the object as it were, converted it into pure rhythm, emotive evocation.

In Milan at the end of the 14th century and at the beginning of the 15th this tradition was carried on by Michelino da Besozzo, who probably owed much of his success to the exotic nature of his work. Indeed a painting at Siena signed by him seems hardly to belong to Italian art. For he carried to its extreme limit a disintegration of reality into tenuous patterns of evanescent line and color, visual transpositions of musical effects. Space is abolished with a thoroughness not to be found in all Trecento art, even in Simone Martini's most linear, anti-spatial compositions. In the illuminated codex (1403) containing a homily of Gian Galeazzo Visconti (Bibliothèque Nationale, Paris) we find the soft, slow rhythms of Giovannino de' Grassi and his feeling for decorative values, but also a translucency of color akin to that in certain Franco-Flemish illuminations and some works of the School of Cologne. The basic incompatibility between a highly mannered linear style tending to pure abstraction and a minutely realistic attention to detail passes unnoticed in the work of Michelino da Besozzo, thanks to his intuitive solution of the problem. Naturalistic touches, flights of sheerest fancy and sophisticated decoration form an harmonious whole in his illuminations and above all in his drawings—which in some respects anticipate those of Pisanello.

The close contact between Lombard art and that of Verona is demonstrated by the affinities between the works of Michelino and those of a more skillful artist, Stefano da Zevio. Their kinship is manifest, as is their common debt to Franco-Burgundian art. We see this when we compare Michelino's paintings at Siena with Stefano's masterpiece, *Madonna and Child in the Rose Garden* (Castelvecchio Museum, Verona), one of the most striking manifestations of the Gothic spirit. With the Child on her knees the Virgin is seated beside St Catherine in a flower-strewn meadow. This extremely beautiful picture has the glamour of an ecstatic vision, a poet's dream; indeed so immaterial seems its very fabric that one almost feels it could dissolve at any moment into thin air, leaving not a trace behind.

Such is the impact of this unique work on our imagination that one can hardly believe the Trecento ever existed or that at this very time the Renaissance was getting under way in Tuscany. Its poetic quality lies not so much in the treatment of the leading figure as in the exquisite, beautifully balanced rendering of the flying angels. Within the confines of this small enchanted world they hover light as thistledown, hardly touching the soil or ruffling the petals of the flowers, weave around the Virgin to form a circle at her feet, float up against the gold background or glide down to pick the flowers. Indeed the Virgin and saint seem like casual visitors, almost intruders, in this fairyland peopled with angelic presences, aerial beings without weight or substance. Here no action, no human emotion finds expression; only the fragile grace of celestial figures conjured up by a poet's dreaming fancy and fated to vanish when he opens his eyes, regretfully, on the workaday world.

This same dreamworld is evoked in Stefano's other masterworks, such as the angels in the Church of San Fermo at Verona, the *Madonna* in the Galleria Colonna in Rome and his superb drawings, which rank among the best of the entire century.

During the first half of the 15th century Lombardy continued to be one of the chief centers of the international spirit. In the space at our disposal we must confine ourselves to mentioning a few outstanding artists: Franco and Filippolo de Veris, Michelino's son Leonardo da Besozzo, who worked in southern Italy, the Zavattari who in 1440 painted, with a slightly affected elegance but to gorgeous effect, some frescos on non-religious themes in a chapel of Monza cathedral. An unknown artist was responsible for one of the first decorations in private houses of the Lombard aristocracy: the frescos, now unhappily almost entirely destroyed, in the Borromeo mansion. Meanwhile sumptuous illuminated books kept in line with the painting of the period: for example the productions of Belbello of Pavia, one of the greatest Lombard illuminators of the first half of the century, who was gifted with a prodigious, somewhat eccentric imagination showing Nordic influence, and a marked ability for vivid illustration.

At the beginning of the 15th century Emilian art, though less influenced than Lombard painting by contemporary developments in other countries, carried a stage further the free fantastic style of the illuminated manuscripts, of Vitale da Bologna, and of that remarkable man who painted the Pisa Camposanto. Outstanding work was also produced by Jacopo di Paolo (predella of the Bolognini altar in the Church of San Petronio

GIOVANNI DA MODENA (FIRST HALF OF FIFTEENTH CENTURY). JOURNEY OF THE MAGI, DETAIL.
FRESCO. CA. 1420. CHURCH OF SAN PETRONIO, BOLOGNA.

at Bologna), Michele di Matteo (polyptych in the Academy of Venice) and Giovanni da Modena who made the decorations in the Bolognini Chapel of the Church of San Petronio at Bologna. In *The Last Judgment* (ca. 1420) the last-named painter shows considerable imaginative power, while *The Journey of the Magi* on the opposite wall is distinguished by the artist's spirited, original handling of a somewhat hackneyed theme, the richness of the color orchestration, its forceful line and a wealth of episodes and details. In this art, too, we find a mixture of realistic observation and conventional mannerism, though without the studied, aristocratic elegance of Lombard art. In fact there is a rustic, almost homely vigor in his work; he has little use for fine shades or suavity, his line is emphatic, stressed to the point of grotesqueness. But he is an engaging story-teller and his work abounds in vivacious, amusing touches.

In the workyards of the Church of San Petronio at Bologna forgathered a number of artists from all parts of the country; typical of this milieu is the work of Giovanni da Modena. While making use of motifs deriving from that fusion of Tuscan and Nordic elements which was basic to Emilian painting, he kept more in line with the main stream of Italian tradition than did the Veronese and the Lombards.

Naturally this allegiance to tradition was more operative in Tuscany; none the less, in the last years of the 14th century and at the outset of the next, certain new, Gothic trends began to emerge in Florentine art. Traces of these can be seen in Orcagna's last works; also in those of Agnolo Gaddi, Starnina and Spinello Aretino. In *Scenes of the Life of St Benedict* (San Miniato) painted by Aretino, who had previously been employed in the Pisa Camposanto, we find an extreme emphasis on rhythm anticipating that of Lorenzo Monaco, while his unusual handling of certain forms in the Palazzo Pubblico at Siena (1407-1408) would certainly have met with the approval of Giovanni da Modena.

But the most brilliant Tuscan exponent of this last Gothic phase was undoubtedly Lorenzo Monaco. The refulgent glow of his color, his subtle, smoothly flowing rhythms, the magic, otherworldly light bathing his landscapes and the neat precision of the scenes in his predellas remind us of the achievements of the Lorenzetti brothers and Simone Martini, but carried a stage further. Sometimes the nervous energy of his line suggests that he had become acquainted with the art of the North, doubtless by way of the miniature—for we must not forget that he was also a fine illuminator. Though Florence was the scene of his activities he was of Sienese origin and he never lost that feeling for classically ordered rhythm which was his birthright; thus he integrated within an harmonious symmetry, a dovetailed pictorial structure, even the most extravagant or the most stylized Gothic idioms.

It was at Florence, too, that Gentile da Fabriano, who ranks alongside Pisanello as the most brilliant Italian practitioner of International Gothic, spent the last years of his life and produced some of his masterpieces. He was born at Fabriano in the Marches, a region of Italy much frequented by Emilian, Umbrian, Tuscan and Venetian painters, and the homeland of some eminent artists, amongst them Lorenzo da Sanseverino, whose frescos in the Oratory of the Church of St John at Urbino (1416) are noteworthy for the refinement of their color, and Ottaviano Nelli who in a slightly provincial manner

imparted to his renderings of sacred scenes the pomp and splendor of the princely courts. Gentile da Fabriano's work is on a different, loftier plane. It was probably by way of Lombardy that in his youth he came in contact with the French art of his day. Moreover he assimilated elements of the Sienese tradition and, in his last works, such features of contemporary Florentine art as were congenial to his many-sided genius.

Like all the artists of this milieu he had a keen eye for the forms and colors of the outside world, the delicate, ever-changing lights and shadows that flicker across the surface of things, and he was equally interested in rendering the finest shades of human feeling. Nor did his technical means fall short of his poetic vision; his luminous, jewel-like colors perfectly reflect the glittering splendor of the courtly-social life of 15th-century Italy. His delicate modeling, conditioned by the incidence of light, brings out the subtlest deviations in the contours of forms, while his fluent rhythm—in which is nothing of the sometimes slightly arbitrary stylization of Lorenzo Monaco—adjusts itself readily to the smallest details of his themes. The same light as that illuminating the figures gives their exact values to the tiniest objects, a flower, a blade of grass in the foreground, no less than to the distant meadows. Even the gold horizon acquires a mellow luster, seen beyond hills touched with the last gleams of sunset. No other exponent of the International Gothic style achieved this poetic synthesis of elements which in the work of many other painters of the day tended to clash. No other artist so successfully combined decorative patterning, verging on abstraction, with such accurate observation of nature; and an atmosphere of fantasy with such meticulous fidelity to fact. Indeed the poetic quality of Gentile's art derives from this fusion of seemingly incompatible elements; to it is due his power of creating with the forms, light and colors of everyday life a world of gay enchantment.

Unfortunately his three largest works no longer exist: those in the Ducal Palace at Venice (1409), at Brescia, and in the Church of St John Lateran in Rome, where during the last years of his life (1427-1428) he was working on the famous fresco sequence that Pisanello subsequently took over. For the entire work was destroyed when the church was renovated in the Baroque style. That this must have been one of the finest Late Gothic works is demonstrated by two paintings that have survived: *The Adoration of the Magi* (1423) and the Quaratesi Polyptych (1425). The former is undoubtedly the supreme example of Gentile's style in its maturity. By this time he had completely harmonized all its basic elements—Sienese, French and Lombard—and could give the full measure of his richly poetic genius. Present in this work are all the most vital manifestations of the Gothic spirit, from its Sienese beginnings to its final flowering when, unaffected by the Renaissance then developing in Tuscany, Gentile was coming into line with the Limbourgs, the Flemish artists, the Van Eycks. And what a wealth of charming details can be found in *The Adoration of the Magi*: that wonderful landscape vista at the top of the picture (as in the predella); the long procession winding its way across the countryside along the road leading to the castle; the bay where the travelers are disembarking. In *The Flight into Egypt* is another far-flung landscape in which the artist has wonderfully rendered the vibrancy of light and the gradual diminution of

the colors' tonal values in the distance, where they are lightly touched in with the tip of the brush. Movement paths are adjusted to a smoothly flowing rhythm and, despite a plethora of figures, the composition is perfectly balanced. Gentile's work is uniformly light, mellifluous; yet occasionally (notably in his depiction of the Prophets) we feel he is trying to impart to it a note of gravity in keeping with the new spirit of the time as revealed in the art of Masolino.

Traces of this can be seen in the Quaratesi Polyptych (1425). True, Masaccio's world was a sealed book to Gentile, whose whole conception of art ran counter to it; still it was only natural he should be conscious of affinities with Masolino who, though steeped in the new culture, had not yet broken with the Gothic spirit; and also with

GENTILE DA FABRIANO (CA. 1370-1427). THE ADORATION OF THE MAGI, DETAIL. 1423.
UFFIZI, FLORENCE.

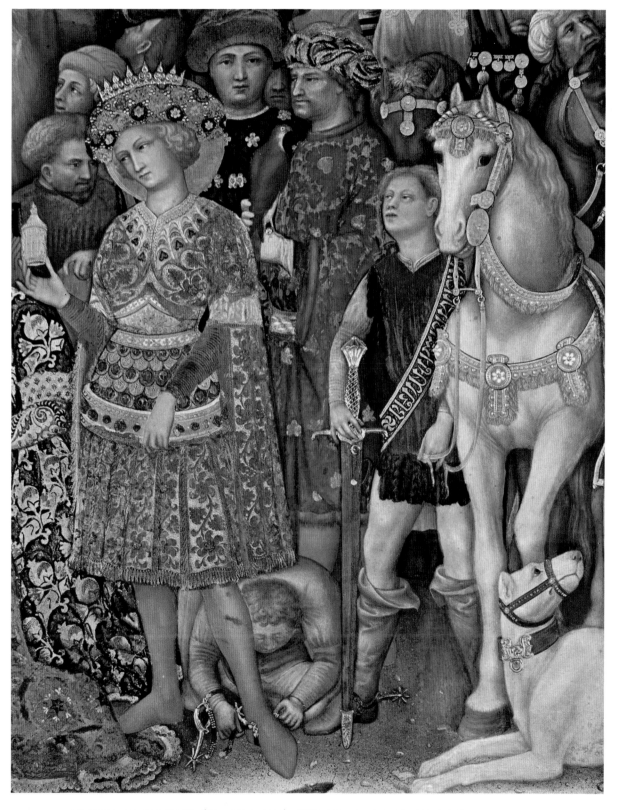

GENTILE DA FABRIANO (CA. 1370-1427). THE ADORATION OF THE MAGI, DETAIL. 1423.
UFFIZI, FLORENCE.

Sassetta whom he may have met during his last stay at Siena. In the predella of the Quaratesi Polyptych (now dispersed in Florence, London, Washington and the Vatican) are some of Gentile's most poetic scenes and as a whole it gives us an idea of his style at the time when he was about to embark on his big work, the fresco in the Church of St John Lateran (1427-1428). As already mentioned, this fresco (no longer extant) was completed by Pisanello, who some years previously (between 1415 and 1422) had done the same for one of Gentile's paintings in the Ducal Palace, Venice.

Though belonging to a younger generation and very different in temperament and style, Antonio Pisano, commonly known as Pisanello, must have learnt much from these contacts with his elder's work. His art is even more representative than Gentile's of the cosmopolitan culture of the day, athirst for new discoveries, eager to welcome innovations. Frontiers were no barriers, intellectual and artistic commerce between the nations was unrestricted, and a ferment of new ideas was active throughout Europe. But whereas we are not conscious of any inner conflict in Gentile's art, Pisanello seems to have been unable to achieve a synthesis and integrate into an organized vision of the world—to which none the less he constantly aspired—the profusion of emotions, impressions, visual experiences that life proffers to the artist.

It is not only because so few of his works have come down to us that a survey of Pisanello's art produces the effect of the images in a kaleidoscope: charming to the eye but incoherent, bits and pieces of a world that falls asunder before it has had time to fulfill itself. A very accomplished draftsman, Pisanello stemmed from the Lombard tradition sponsored by Giovannino de' Grassi, Michelino da Besozzo and Stefano da Zevio, who perhaps was his first teacher, preceding Gentile da Fabriano. He observed nature indefatigably and recorded all her many aspects, but, more than Gentile, he sought to pierce beneath the surface of appearances and to detect an underlying formal pattern. With rare imaginative power he transfigured, sublimated, every subject that he touched, no matter what it was: a female nude, an ancient statue, a woman's finery, the enigma of a face, the beauty of a clean-cut profile, the harmonious structure of a bird's, a horse's, a wild creature's body.

What his contemporaries most admired in Pisanello was his skill as a maker of medals, a painter of landscapes, faces and animals, in which fields he was regarded as a "specialist." In fact there has always been a tendency to appraise his work not as a whole but piecemeal. For he did not, like Masaccio, submerge all details in the ensemble, or, like Van Eyck, treat them as structural elements of the pictorial architecture. A composition by Pisanello does not impress us as an organic whole, something more than a sum of the component parts taken separately. In short he is neither a Masaccio or a Van Eyck. Even in *St George and the Princess* at the Church of Sant'Anastasia at Verona (ca. 1435), the only one of his large frescos that has survived, one feels this lack of synthetic vision. Indeed it has much of that kaleidoscopic quality to which allusion has been made. It is full of well-observed details, charming fragments, and images that have welled up from the artist's teeming imagination: the fair-haired knight shown full face, with his faraway, baffling gaze; the princess in profile, a vision of ethereal

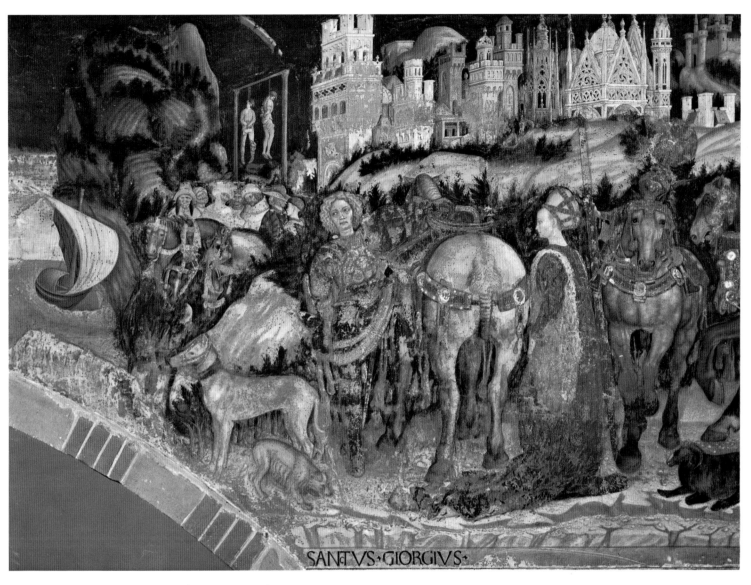

SANCTVS·GIORGIVS·

PISANELLO (1395-CA. 1455). ST GEORGE AND THE PRINCESS. FRESCO, CA. 1435.
CHURCH OF SANT'ANASTASIA, VERONA.

loveliness; two huge horses, white and grey respectively; all sorts of animals in the foreground; horsemen of various nationalities, the differences of facial structure being brought out with extreme precision; a dark mountain, pale sky and a green expanse of landlocked sea; the fretted towers of a snow-white city rising behind a hill and, in front, gibbets with hanged men. The artist's preliminary designs for these figures are extant and they show how carefully Pisanello noted down the exact attitudes of persons who had suffered this form of death. In short he had an eye, and a keen one, for details; even the brushwork in this large-scale work is all in delicate touches, such as we find in the illuminated pages of a Book of Hours. Indeed not only the texture, but the whole lay-out of this big composition is exactly that of a miniature.

Needless to say, this in no wise detracts from the poetic appeal of this vision of reality transposed into a dreamworld of poetic fancy, a world which, unlike Gentile's, is faintly tinged with melancholy, wistful regret for the days that are no more. For it is in the work of Pisanello, more than in that of any other painter of the time, that one gets an impression of what might be called the twilight of the Middle Ages and, in particular, the passing of the Gothic epoch. Thus this great period ended in the nostalgic contemplation of a golden age of chivalry and courtesy, a beauty too frail, too delicate to last. Yet at the same time we can trace in Pisanello's art the first faint stirrings of that modern spirit which was to liberate men's minds from the thrall of mediaevalism, though as yet it had not come into the open or clarified its aims.

Hence the basic inconsistency in Pisanello's art; always he searches after wholly realistic presentation, yet sublimates his visual experience into an unreal, dreamlike atmosphere. Thus in his work space is never rendered, only hinted at with that pregnant vagueness which is the poet's standby. His world is peopled with unforgettable figures, incarnations of aristocratic elegance, of mundane grace and charm: for example the angel in the Church of San Fermo at Verona, the princess in the frescos in the Church of Sant'Anastasia, St George in the picture at the National Gallery, London. No less delightful are his portraits of the great lords and ladies of his day: Leonello d'Este, Margarita Gonzaga, the Emperor Sigismund. (The delicate precision and psychological veracity of the *Sigismund* portrait are worthy of Van Eyck.) Yet behind this seeming objectivity and aloofness we sense a rankling unrest; except perhaps in his work as a medalist Pisanello never seems to have experienced that peace of mind which comes to the artist who has completely found himself and integrated his personality into an harmonious unity. This is no doubt one of the reasons for the singular fascination of his work, its faintly melancholy cast, so different from the carefree clarity of Gentile da Fabriano and the triumphal self-assurance of Masaccio. For while Pisanello was for ever following up his Gothic dream of a remote, exquisite beauty, Masaccio had already renewed contact with the great classical tradition and bodied forth on the walls of the Brancacci Chapel in Florence his "modern" vision, governed by reason and a sense of moral responsibility. The representation of space which during the Trecento was hampered by preoccupations of a metaphysical order could now, thanks to the new conception of perspective sponsored by the Renaissance, incorporate all the data of visual experience. Thus the entire phenomenal world, in its infinite diversity, was drawn into an orbit of which man, measure of all things, was the center. Nevertheless it was the Gothic age that witnessed not only the first emergence but the full flowering of that passionate interest in reality, combined with spiritual fervor, which led these Italian artists to study closely and to represent not only the manifold aspects of the visible world but life as it really is and the whole range of man's emotions. To this is due the very real grandeur of that vast art movement whose manifestations we have dealt with in the foregoing pages and which, after establishing itself in all parts of Europe, continued to give rise to noble works of art even after the triumph of the "modern" outlook and the dawn of a new era.

PISANELLO (1395-CA. 1455). ST GEORGE AND THE PRINCESS, DETAIL. FRESCO, CA. 1435.
CHURCH OF SANT'ANASTASIA, VERONA.

BIBLIOGRAPHY

INDEX OF NAMES AND SUBJECTS

LIST OF COLORPLATES

BIBLIOGRAPHY

GENERAL

MICHEL, André. *Histoire de l'art*, vols. II and III, Paris 1906-1907.

EVANS, J. *Life in Mediaeval France*, Oxford 1925.

CALMETTE, J. *Le monde féodal*, Paris 1934.

FOCILLON, H. *Art d'Occident*, Paris 1938.

DU COLOMBIER, P. *Histoire de l'art*, Paris 1942.

PIRENNE, J. *Les grands courants de l'histoire universelle*, vol. II, Paris 1944.

MUMFORD, Lewis. *Technics and Civilization*, Boston 1934.

PERNOUD, R. *Histoire du peuple français : des origines au moyen âge*, Paris 1951.

RENUCCI. *L'aventure de l'humanisme européen au moyen âge*, Paris 1953.

PANOFSKY, Erwin. *Early Netherlandish Painting, its Origins and Character*, 2 vols. Harvard University Press, Cambridge, Mass., 1953.

FRANCE

PAINTING

Exhibition of French Primitives at the Pavillon de Marsan and the Bibliothèque Nationale (catalogue by H. Bouchot, L. Delisle, J. Guiffrey, F. Marcou, P. Vitry, preface by G. Lafenestre), Paris 1904.

BOUCHOT, H. *Les primitifs français*, Paris 1904.

DIMIER, L. *Les primitifs français*, Paris 1911.

MAETERLINCK, L. *L'énigme des primitifs français*, Ghent 1921.

GILLET, L. *La peinture française. Moyen âge et Renaissance*, Paris 1928.

RÉAU, L. *La peinture française aux XIVᵉ et XVᵉ siècles*, Paris 1931.

LEMOISNE, P. A. *La peinture française à l'époque gothique, XIVᵉ et XVᵉ siècles*, Leipzig 1931.

LABANDE, L. H. *Les peintres primitifs français, peintres et verriers de la Provence occidentale*, Marseilles 1932.

DUPONT, J. *Les primitifs français*. Paris 1937.

STERLING, C. *La peinture française : Les Primitifs*, Paris 1938; *Les peintres français du moyen âge*, Paris 1941.

RING, Grete. *A Century of French Painting, 1400-1500*, London 1949.

Exhibition of Mediterranean Primitives (prefaces to the catalogue by L. Venturi, Ricart, Gudiol, J. Dupont), Bordeaux 1952.

MINIATURES

VITZTHUM, G. *Die Pariser Miniatur-Malerei*, Leipzig 1907.

MARTIN, H. *Les Miniaturistes français*, Paris 1906; *La miniature française du XIIIᵉ au XVᵉ siècle*, Paris-Brussels 1923.

FIERENS-GEVAERT. *Les Très Belles Heures du Duc de Berry*, Brussels 1924.

PORCHER, J. *Two Models for the Heures de Rohan*, Journal of the Warburg and Courtauld Institutes, No. 8, London 1945.

Exhibition of Masterpieces by the Painter-Illuminators of the Duke of Berry and the School of Bourges (introductions to the catalogue by J. Favière and J. Porcher), Bourges 1951.

VERDIER, P. *Autour de 1400. Jean le Magnifique, duc de Berry*, Médecine de France, No. 15.

PORCHER, J. *Paris 1250. St. Louis et l'art gothique*. Médecine de France, No. 25.

GRODECKI, L. *Autour de Jean Pucelle*, Médecine de France, No. 27.

STAINED GLASS

WESTLAKE. *History of Design in Painted Glass*, London 1880-1894.

GRUBER, J. J. *Quelques aspects de l'art et de la technique du vitrail en France* (Papers by students of art history at the Faculté des Lettres, Paris), Paris 1928.

VERRIER, J. *Etude sur le vitrail*. Congrès Archéologique, vol. II, Paris 1934.

Exhibition of "Vitraux de France" at the Pavillon de Marsan (catalogue by L. Grodecki), Paris 1953.

LAFOND, J. *Le Vitrail*, in Lefrançois-Pillon's *L'art au XIVᵉ en France*, Paris 1954.

TAPESTRY

GUIFFREY, J. *Histoire de la tapisserie*, Paris 1886.

GÖBEL. *Wandteppiche. Frankreich. I.*

MARQUET DE VASSELOT, J. J., and WEIGERT, R. A. *Bibliographie de la Tapisserie*. Archives de l'Art français, vol. XVIII, 1935.

Exhibition of the Angers Apocalypse, Basel 1950.

Exhibition of Mediaeval Art in Artois, Arras 1951.

PLANCHENAULT, R. *L'Apocalypse d'Angers*. Bulletin Monumental, 1953.

GERMANY

PAINTING

HEIDRICH, E. *Die altdeutsche Malerei*, Jena 1909. Revised edition by MÖHLE Jena 1941.

RÉAU, L. *Les primitifs allemands*, Paris 1910.

FORSTER, D. H. *Die Kölner Malerschule vom Meister Wilhem bis Stephan Lochner*, Cologne 1923.

WORRINGER, W. *Die Anfänge der Tafelmalerei*, Leipzig 1924.

GLASER, C. *Les peintres primitifs allemands*, Paris 1931.

STANGE, A. *Deutsche Malerei der Gotik*, Berlin 1934.

PINDER, W. *Vom Wesen und Werden deutscher Formen, Geschichtliche Betrachtungen*. Vol. II: *Die Kunst der ersten Bürgerzeit*, Leipzig 1937.

WINKLER, F. *Altdeutsche Tafelmalerei*, Munich 1942.

Du Colombier, P. *L'art allemand*, Paris 1945.

Hulftegger, A. *Evolution de la peinture en Allemagne et dans l'Europe Centrale*, Paris 1949.

MINIATURES

Haseloff. *Eine thüringisch-sächsische Malerschule des XIII. Jahrhunderts*, Strasbourg 1897.

Goldschmidt. *Die deutsche Buchmalerei*, Florence 1928.

Sukarzenski, H. *Die lateinischen illuminierten Handschriften des XIII. Jahrhunderts am Rhein, Main und Donau*, Berlin 1937.

BOHEMIA

Kramář, V. *La peinture et la sculpture au XIVᵉ en Bohême*, in *L'Art Vivant*, 1928.

Matějček, A. *La miniature tchèque*, in *L'Art Vivant*, 1928.

Kvet, J. *Illuminatori Kralovny Rejčky*, Prague 1929.

Friedl, A. *Passionál Mistrů Vyžebrodských*, Prague 1934.

Matějček, A., and Pešina, J. *La peinture gothique tchèque*, Prague 1950.

SPAIN

Sanpere, Miquel S. *Los quatrocentistes catalanes*, Barcelona 1905-1906.

Gudiol y Cunill. *El pintor Lluis Borrassá*, Barcelona 1925.

Post, Chandler Rathfon. *A History of Spanish Painting*, Cambridge, Mass., 1930 ff.

Trens, M. *Ferrer Bassa : les peintures de Pedralbes*. Institute of Catalonian Studies, Barcelona 1936.

Gudiol, J. *Spanish Painting*, Toledo, Ohio, 1941.

Saralegui, L. de. *Pedre Nicolau y El Maestro de Los Marti de Torres*. Boletín de la Sociedad española de excursiones, 1941-1942.

Mayer, A. L. *Historia de la pintura española*, 2nd Ed., Madrid 1942.

Gudiol-Ricart. *La pintura gotica en Cataluña*, Barcelona, n.d. (1944?).

Lafuente Ferrari, E. *Breve historia de la pintura española*, Madrid 1946.

Gudiol-Ricart and Lasarte. *Huguet*, Barcelona 1948.

Serullaz, M. *Evolution de la peinture espagnole*, Paris 1948.

Guinard, P. and Baticle, J. *Histoire de la peinture espagnole du XIIᵉ au XIXᵉ siècle*, Paris 1950.

Lassaigne, J. *Spanish Painting : From the Catalan Frescos to El Greco*, Geneva 1952.

ENGLAND

MINIATURES

Warner, G. F. *Illuminated Manuscripts in the British Museum*, London 1899-1903.

Cockerell, S. G. *The Gorleston Psalter*, London 1907.

James, M. R. *The Trinity College Apocalypse*, London 1910.

Herbert, J. A. *Illuminated Manuscripts*, London 1911.

Millar, E. G. *English Illuminated Manuscripts from the 10th to the 13th Century*, Paris 1926; *English Illuminated Manuscripts of the 14th and 15th Centuries*, Paris 1928.

Saunders, D. E. *English Illumination*. Florence 1930.

Harrison, F. *English Manuscripts of the 15th Century*, London 1938.

ITALY

GENERAL

Cavalcaselle and Crowe. *A New History of Painting in Italy*, London 1864 ff.

Thode, H. *Franz von Assisi und die Anfänge der Kunst der Renaissance*, Berlin 1885 and 1904; *Giotto*, Berlin 1899 and 1926.

Berenson, B. *Italian Painters of the Renaissance*, London 1894-1907.

Schubring, P. *Altichiero und seine Schule*, Leipzig 1898.

Courajod, L. *Leçons professées à l'Ecole du Louvre*, Paris 1901.

Hill, G. P. *Pisanello*, London 1903.

Siren, O. *Lorenzo Monaco*, Strasbourg 1905.

Suida, W. *Florentinische Maler des 14. Jahrhunderts*, Strasbourg 1905.

Venturi, A. *Storia dell'arte italiana*, vol. V, Milan 1907; vol. VII, 1st part, Milan 1911.

Venturi, L. *Le origini della pittura veneziana*, Venice 1907.

Siren, O. *Giottino*, Leipzig 1908.

Colasanti, A. *Gentile da Fabriano*, Bergamo 1909.

Rintelen, F. *Giotto und die Giotto-Apokryphen*, Munich 1912 and 1923.

Toesca, P. *La pittura e la miniatura nella Lombardia*, Milan 1912.

Venturi, L. *A traverso le Marche*, in *L'Arte*, XVIII, p. 1 ff., 1915.

Siren, O. *Giotto and Some of his Followers*, Cambridge 1917.

Berenson, B. *Essays in the Study of Sienese Painting*, New York 1918.

Venturi, L. *Introduzione all'arte di Giotto*, in *L'Arte*, V. p. 49, 1919.

Schlosser, J. *Oberitalienische Trecentisten*, Leipzig 1921.

Rosenthal, *Giotto in der mittelalterlichen Geistesentwicklung*, Augsburg 1924.

Van Marle, R. *Italian Schools of Painting*, Paris 1924 ff.

Sandberg Vavalà, E. *La pittura veronese del Trecento e del primo Quattrocento*, Verona 1926.

D'Ancona, P. *La miniature italienne*, Paris 1926.

Venturi, L. *Il gusto dei primitivi*, Bologna 1926.

Offner, R. *Studies in Florentine Painting*, New York 1927.

Molaioli, B. *Gentile da Fabriano*, Fabriano 1927.

DVORÁK, M. *Geschichte der italienischen Kunst im Zeitalter der Renaissance*, Munich 1927.

TOESCA, P. *Storia dell'arte italiana*, Vol. I: *Il Medioevo*, Turin 1927.

LONGHI, R. *Frammenti di Giusto da Padova*, in *Pinacoteca*, p. 133, 1928.

CECCHI, E. *I Trecentisti senesi*, Rome 1928.

FREY, D. *Gotik und Renaissance als Grundlagen der modernen Weltanschauung*, Augsburg 1929.

TOESCA, P. *La pittura fiorentina del Trecento*, Bologna 1929.

SANDBERG VAVALÀ, E. *Vitale delle Madonne e Simone dei Crocefissi*, in *Rivista d'Arte*, p. 429, 1929; p. 1, 1930.

SINIBALDI, G. *La pittura del Trecento*, Florence 1930.

CECCHI, E. *Pietro Lorenzetti*, Milan 1930.

WEIGELT, C. H. *La pittura senese del Trecento*, Bologna 1930.

OFFNER, R. *A Corpus of Florentine Painting*, New York 1930.

BERENSON, B. *Studies in Medieval Painting*, New Haven 1930.

COLETTI, L. *Sull'origine e sulla diffusione della scuola pittorica romagnola del Trecento*, in *Dedalo*, XI, pp. 197 and 291, 1930-1931; *Studi sulla pittura del Trecento a Padova*, in *Rivista d'Arte*, XII, p. 223, 1930; XIII, p. 303, 1931.

FIOCCO, G. *Le primizie di Maestro Paolo Veneziano*, in *Dedalo*, XI, p. 877, 1930-1931.

SALMI, M. *La scuola di Rimini*, in *Rivista del R. Istituto di Archeologia e Storia dell'Arte*, 3rd year, p. 226, 1931-1932; 4th year, p. 195; 5th year, p. 98.

EDGELL, C. H. *A History of Sienese Painting*, New York 1932.

COLETTI, L. *Tomaso da Modena*, Bologna 1933.

SINIBALDI, G. *I Lorenzetti*, Siena 1933.

BRANDI, C. *Die Stilentwicklung des Simone Martini*, in *Pantheon*, p. 225, 1934; *Lo stile di Ambrogio Lorenzetti*, in *Critica d'Arte*, I, p. 61, 1935; *Catalogo della Mostra della Pittura Riminese del Trecento*, Rimini 1935.

LONGHI, R. *La pittura padana del Trecento; Il tramonto della pittura medioevale in Italia.* University lectures, Bologna 1935-1936.

DE RINALDIS, A. *Simone Martini*, Rome 1936.

ZOCCA, E. *Assisi, Catalogo delle cose d'arte*, Rome 1936.

LAVAGNINO, E. *Il Medioevo*, Turin 1936.

SALMI, M. *L'Abbazia di Pomposa*, Rome 1936.

GRONAU, H. *Andrea Orcagna und Nardo di Cione*, Berlin 1937.

BRANDI, C. *Vitale da Bologna*, in *Critica d'Arte*, p. 148, August 1937.

CECCHI, E. *Giotto*, Milan 1937.

FIOCCO, G. *Giotto e Arnolfo*, in *Rivista d'Arte*, p. 221, 1937.

SALMI, M. *Le origini dell'arte di Giotto*, in *Rivista d'Arte*, 1937.

COLETTI, L. *Esordi di Giotto*, in *Critica d'Arte*, June 1937.

SALVINI, R. *Giotto, Bibliografia* (a complete bibliography of Giotto up to 1937), Rome 1938.

FOCILLON, H. *Art d'Occident. Le moyen âge roman et gothique*, Paris 1938.

BRANDI, C. *Giotto*, in *Le Arti*, October 1938 and January 1939.

WEISE, G. *Die geistige Welt der Gotik und ihre Bedeutung für Italien*, Halle 1939.

OFFNER, R. *Giotto - Non Giotto*, in *Burlington Magazine*, June-September 1939.

VENTURI, A. *Pisanello*, 1939.

LONGHI, R. *Fatti di Masolino e di Masaccio*, in *Critica d'Arte*, V, pp. 145 ff., 1940.

COLETTI, L. *I primitivi*. Vol. I: *Dall'arte benedettina a Giotto*, Novara 1941; Vol. II: *I Senesi e i Giotteschi*, Novara 1946; Vol. III: *I Padani*, Novara 1947.

HETZER, T. *Giotto*, Frankfort 1941.

TOESCA, P. *Giotto*, Turin 1941.

SINIBALDI, G. and BRUNETTI, G. *Pittura italiana del Duecento e Trecento. Catalogo della Mostra Giottesca di Firenze del 1937*, Florence 1943.

CARLI, E. *Capolavori dell'arte senese*, Siena 1944.

BETTINI, S. *Giusto dei Menabuoi*, Padua 1944.

DEGENHART, B. *Pisanello*, Turin 1945.

CARLI, E. *Vetrata duccesca*, Florence 1946.

TOESCA, P. *Gli affreschi della vita di S. Francesco nel Santuario di Assisi*. Artis monumenta photografice edita, III, Florence 1946; *Gli affreschi dell'antico e del nuovo Testamento nel Santuario di Assisi*. Idem, IV, Florence 1947; *Gli affreschi della Cappella di S. Silvestro in S. Croce*. Idem, Florence 1947.

LONGHI, R. *Giudizio sul Duecento*, in *Proporzioni*, II, p. 5, 1948.

ARCANGELI, F. *Un Vitale e un Jacopo da Bologna*, in *Proporzioni*, II, p. 63, 1948.

COLETTI, L. *Gli affreschi della Basilica di Assisi*, Bergamo 1949.

LONGHI, R. *La Mostra del Trecento bolognese* (with an appendix in the form of an anthology), in *Paragone*, I, p. 5, 1950.

FIOCCO, G. *Disegni di Stefano da Verona*, in *Proporzioni*, p. 56, 1950.

VENTURI, L., and SKIRA-VENTURI, R. *Italian Painting*. Vol. I: *The Creators of the Renaissance*, Geneva-Paris 1950.

TOESCA, P. *Storia dell'arte italiana*. Vol. II: *Il Trecento*, Turin 1951.

BRANDI, C. *Duccio*, Florence 1951.

LONGHI, R. *Stefano Fiorentino*, in *Paragone*, II, p. 18, January 1951.

VOLPE, C. *A. Lorenzetti e le congiunture fiorentine senesi*, in *Paragone*, II, p. 40, January 1951; *Proposte per il problema di P. Lorenzetti*, in *Paragone*, II, p. 13, November 1951.

LONGHI, R. *Giotto spazioso*, in *Paragone*, III, p. 18, July 1952.

BARONI, C., and SAMEK LUDOVICI, S. *La pittura lombarda del Quattrocento*, Messina 1952.

SALVINI, R. *Giotto*, Milan 1952.

GRASSI, L. *Gentile da Fabriano*, Milan 1953.

INDEX OF NAMES AND SUBJECTS

Aix-en-Provence, Museum, *Saint Louis of Toulouse* 131.
ALCHERIO Giovanni 141.
ALEZAN, Marquis of Saluzzo 159.
ALTICHIERO 123, 124; *The Beheading of St George* 122, 124.
Amiens, cathedral 11.
ANASTAISE, woman painter 157.
ANCIAU DE SENS 41.
ANCONA Pietro d' 159.
ANDREA DA BOLOGNA 120; *Scenes of the Life of St Catherine* 119.
ANGELICO Fra 174.
Angers, castle 138; Musée des Tapisseries 136/138, 140.
ANJOU, Family of 79, 145, 150, 162.
ANNE OF BOHEMIA 165.
Antiphonary of Queen Elizabeth Rejcka 177.
ANTOINE DE BOURGOGNE 141.
Antwerp 135; Mayer van den Bergh Museum, *Nativity, Saint Christopher* (polyptych) 147/149; Musée Royal des Beaux-Arts 85/88, 131, 144.
Argilly, castle 146.
ARNOLFO DI CAMBIO 50, 52, 53, 60; *Saint Reginald of Orléans* 53; *Story of the Rule* 53; *Tomb of Cardinal de Braye* (Orvieto) 53.
Arras, tapestry 138, 157; Atelier, *Scene from a Novel* 160.
Assisi 60, 73, 74, 79, 89, 92, 93, 102, 107, 108, 111; Basilica of San Francesco 107; Lower Church of San Francesco 81, 82, 84, 85, 93/95, 120; Chapel of St Martin 80, 81; Chapel of the Magdalen 92; Chapel of San Nicola 92; Upper Church of San Francesco 48, 50/52, 54/60, 65, 69, 71, 74, 79; *Life of Christ* 56; *Life of Joseph* 56; *Life of Isaac* 56, 60, 74.
Aubusson 138.
Austria 178, 181/183.
AVANZI Jacopo 124.
Avignon 54, 85, 88, 109, 130/133, 141, 145, 159, 162, 177, 181, 186; Church of St Agricol 159; Palace of the Popes 88, 130, 131; Chapel of St Stephen 130; Robe Room 131; Notre-Dame-des-Doms 130, 131, 169; Chapel of St John 132; Chapel of St Martial 132.

BACON Roger 14.
Baltimore, Walters Art Gallery 147.
BANDOL Jean de (Hennequin de Bruges) 138, 140; *The Apocalypse* 136/138, 140.
BAERZE Jan de 146.
Barcelona 125, 128, 168, 169, 171, 174.
Bargello Altarpiece 142/143, 145, 165.
BARNA 109; *Asciano Madonna* 110.
BARONZIO Giovanni 112.
BATAILLE Nicolas 140; *The Apocalypse* 136/138, 140; Atelier 140; *The Nine Heroes* 139.

BEAULIEU Geoffroy de 36.
BEAUMETZ Jean de 146; Pierre 140.
BEAUNEVEU André 30, 146, 150, 151, 166; *Très Belles Heures du Duc de Berry* 140, 161, 166; *Psalter of the Duke of Berry* 151, 153, 166.
BEAUVAIS Vincent de 15.
BELBELLO of Pavia 189.
BELLECHOSE Henri 146, 147; *Annunciation* 146; *Christ and the Apostles* 146; *Communion and Martyrdom of St Denis* 146.
BENEDICT XI 130.
BENEDICT XII 15, 131.
Bergamo 189.
Berlin Museum 88, 131, 144.
BERRY JEAN, Duke of 135, 140, 141, 144/146, 150/155, 157, 162, 166, 167.
BESOZZO Leonardo da 190; Michelino 189, 190, 196.
Bestiary (British Museum) 19.
Bibles: *Bible of Robert de Billyng* (or *Bible of Pucelle*) 41, 43; *Historiated Bible* (MS fr 9561) 162; *Historiated Bible of Charles V (Bible of Jean de Vaudétar)* 135, 140; *Historiated Bible of Charles VI* 43; *Bible of Jean de Sy* 43; *Latin Bible* 116; *Moralized Bible of Philip the Bold* (MS fr 166) 146; *Winchester Bible* 19.
Bicêtre, castle 134, 138, 151.
BILLYNG Robert de 41, 43.
BLANCHE OF CASTILE 18, 27/29.
BLOIS Henry of 19, 22.
BOCCACCIO 53, 129; *De Casibus Vivorum et Feminarum Illustrium* 157, 159.
Bohemia 14, 128, 130, 165, 167, 175, 177, 178, 181, 182, 185.
BOILEAU Etienne, *Book of Crafts* 134.
Bologna 14, 110/112, 115, 116, 119, 120, 123, 124, 186; Church of San Domenico, *Arca di San Domenico* 53; *Cope* 119; Santa Maria dei Servi 119; San Petronio 186, 190/192; Pinacoteca 114, 116, 117; University 116.
Bolzano, Church of San Domenico 117, 120.
Books of Hours: *Grandes Heures du Duc de Berry* 151; *Petites Heures du Duc de Berry* 151; *Très Riches Heures du Duc de Berry* 144, 146, 150, 153/155, 157, 159, 161; *Très Belles Heures du Duc de Berry* 140; *Book of Hours of Boucicaut, Marshal of France* 161, 171; *Hours of Marguerite d'Orléans* 145; *Très Belles Heures de Notre-Dame* 151, 155, 166; *Petites Heures de Pucelle* 41; *Book of Hours of King René* 162; *Grandes Heures de Rohan* 161, 162; *Book of Hours of Isabel Stuart* 162; *Turin Book of Hours* 155; *Book of Hours of Gian Galeazzo Visconti* 186, 188, 189.

BORRASSÁ Luis 168, 171, 173; Atelier of Luis Borrassá, *Polyptych: Scenes from the Life of St John the Baptist* 171, 173.
Bourges 27, 145, 146, 150, 151, 159, 161; Cathedral, *Trousseau Window* 161; Sainte-Chapelle 151.
BOURION Robert 134.
Brescia 193.
Breviaries: *Belleville Breviary* 38, 39, 41, 151; *Breviary of Charles V* 135; *Breviary of Grand Master Leon* 177; *Breviary of Queen Elisabeth Rejcka* 177; *Breviary of Philip the Fair* 41.
BROEDERLAM Melchior 146, 147; *The Flight into Egypt, Presentation in the Temple* 147.
Bruges 128, 135, 141, 174, 181.
BRUNELLESCHI 185.
Brussels, Royal Library 151, 155, 166; Musée du Cinquantaire, *Presentation in the Temple* 140.
BUONAIUTI DA FIRENZE Andrea 109; *Frescos in the Spanish Chapel*, Florence 109.
Burgundy 144, 146, 150, 157, 181, 182, 190; Dukes of 145, 150.
Bury, St Edmund's abbey 19.

Cambrai 146; Library (MS 482) 140.
Cambridge, Corpus Christi College 164, 167; Pembroke College 19; Trinity College 20.
Camélas, Church of (French Pyrenees) 169.
Canterbury 19; Chapel of the Trinity 27; Christ Church 19; St Augustine 19.
CASTAGNO Andrea del 93.
Catalonia 132, 168, 169, 171, 174.
CAVALLINI Pietro 50, 56, 111.
Chantilly, Musée Condé 16/18, 22, 27, 153, 154, 155.
CHARLES IV, King of Bohemia 14, 125, 165, 175, 177, 178, 181.
CHARLES V, The Fair 43/46, 134, 135, 140, 141, 144, 145, 151, 162, 177.
CHARLES VI 43, 141, 144.
CHARLES OF ANJOU, King of Sicily 127.
Chartres, cathedral 11, 27, 30, 31, 33.
CHAUCER 129, 167; *Troilus and Criseyde* 164, 167.
CHEVRIER Jean 41.
Chronicles: *Chronicle of the Cloister of Saint-Martin-des-Champs* 18; *Grand Chronicles* (Charles V) 135; *Grandes Chroniques de France* 40/43; *Chronicles of Saint-Denis* 138; *Saxon Chronicle of Gotha* (Sachsenspiegel) 14.
CIMABUE 50, 51, 55, 56, 73, 78, 89; *Madonna* 73.
CLARKE Miss 165.
CLEMENT V (Bertrand de Gouth) 15, 130.
CLEMENT VI 131.
CLEMENT VII 130.

Codices: *Codex of Gian Galeazzo Visconti* 189; *Codex of St Georges* 88, 131; *Tacuinum Sanitatis* 186.
COENE Jan 141, 151, 153, 162.
COLARD DE LAON 134.
Cologne 177, 182, 184, 189; Cathedral 183, 184.
Conflans-lès-Paris, castle 138, 146.
CONRAD VON SOEST 182.
COSTE Jean 134.
COURAJOD L. 144.
COURÇON Robert de 15.

DADDI Bernardo 108, 109.
DALMASIO Cristoforo 120; Lippo 120.
DALMAU Luis 174.
DANTE 50, 51, 53, 69, 71, 116, 129, 135; *Divine Comedy* 55.
DESTORRENT Ramon 169, 174.
Dijon 145; Church of Saint-Michel 146; Monastery of Champmol 145, 146.
DOCHO OF SIENA 131.
DONATELLO 185.
DOURDIN Jacques 140.
DRAŽDICE John of 177.
DUCCIO DI BUONINSEGNA 47, 54, 73, 74, 77, 78, 89, 90, 92, 96, 106, 145, 168, 177; *Coronation* 74; *Madonna of the Franciscans* 72, 74; *Madonna Rucellai* 73.
 Maestà 74, 77, 79, 105; *The Adoration of the Magi* 75; *The Temptation* 77; *The Prayer on the Mountain* 77; *The Entrance into Jerusalem* 77; *St Peter's Denial* 74, 76; *Jesus before Annas* 74, 76, 77; *The Crucifixion* 77; *The Deposition* 77; *The Three Marys at the Tomb* 77; *Noli me tangere* 77; *The Way to Emmaus* 77.
DUPUY Pierre 130.
DURANT Guillaume, manuscript of 137.
Durham, cathedral 19.
DURLIAT Marcel 169.

EDWARD I 26.
EDWARD II 26.
EDWARD III (The Confessor) 26, 165.
Emilia 110/112, 115, 120, 123, 190, 192.
England 9, 13, 15, 18, 19, 22/24, 26, 43, 127/130, 132, 140, 150, 165, 166, 167, 181.
Etampes, castle of 138, 150.
EUDES DE CHATEAUROUX 15.
Evangeliar of St Edmund's Abbey at Bury 19.
EVRARD D'ORLÉANS 138.

FERRER Bassa 168, 169; *Iravalls retablo* 169; *St Bonaventura* 170.
FERRER Bonifacio 174.
Flanders 15, 43, 46, 49, 80, 127, 128, 135, 137, 141, 144/146, 171, 174, 189, 193.
Florence 47, 50, 52, 73, 96, 98, 102, 103, 105/109, 120, 128, 132, 153, 174, 192, 193; Brancacci Chapel 198; Cathedral (Santa Maria del Fiore) 52, 54; Santa Maria Novella 56; Spanish Chapel 109; Strozzi Chapel 108; San Miniato 192; Santa Croce 54, 70, 71; Bardi Chapel 71, 106; Peruzzi Chapel 71, 106; Chapel of St Sylvester 107; Rinuccini Chapel 119, 120. Galleria dell'Accademia 189; Palazzo del Bargello 142, 143, 145, 165; Uffizi 11, 73, 80, 83, 88, 89, 91, 103, 108, 120, 194, 195, 196.
FRANCESCO DA FIRENZE 132.
FRANCESCO DA RIMINI 112.
Francis St 53, 55, 56, 58, 60, 62, 65.
Frankfort, Staedelsches Institut 184.
FROISSART 151.
FROMENT Nicolas 30.

GADDI Agnolo 109, 192; Taddeo 108, 153; *Madonna* 108.
GENTILE DA FABRIANO 88, 123, 144, 192/194, 196, 198; *The Adoration of the Magi* 193/195; *Quaratesi Polyptych* 193, 194, 196.
Germany 13/15, 127, 138, 165, 174, 175, 177, 181, 182.
Germolle, castle 146.
Gerona (Spain) 171.
Ghent 128, 135, 137; Saint-Aubert convent 137; Saint-Bavon 137.
GHIBERTI 106, 109.
GIOTTINO, Tomaso di Maestro Stefano, *San Remigio Pietà* 108.
GIOTTO 11, 47, 51/71, 73, 74, 77/79, 83, 89, 92, 97, 98, 100, 105/108, 111, 112, 124, 177, 185/186; *Crucifixion* 56; Cycle of the Life of St Francis (Assisi): *The Devils cast out of Arezzo* 58, 60; *The Death of St Francis* 62; *Ser Geronimo doubting the Miracle of the Stigmata* 62; *The Death of the Nobleman of Celano* 60; *Christmas at Greccio* 57, 60; *St Francis giving his Mantle to a Poor Man* 59, 60; *St Francis renouncing the World* 60; *The Vision of the Burning Chariot* 48, 60; *The Vision of Brother Pacifico* 60. Cycle of the Virgin (Padua): *The Wedding Procession of Mary* 62, 63, 69; *Story of Anna and Joachim* 65; *The Annunciation to St Anne* 61, 65; *Joachim's Dream* 67; *The Visitation* 52; *The Meeting at the Golden Gate* 63, 66; *The Meeting of Mary and Elizabeth* 64, 69. Cycle of the Life of Christ (Padua): *Annunciation* 52; *Nativity* 52; *The Massacre of the Innocents* 69; *The Flight into Egypt* 52; *The Kiss of Judas* 71; *The Resurrection of Lazarus* 68, 69; *Deposition* 56, 71. *The Obsequies of St Francis* (Florence) 70, 71.
GIOVANNI D'AREZZO 132.
GIOVANNI DI LUCCA 132.
GIOVANNI DA MILANO 108, 120, 123, 186; *Scenes of the Life of the Virgin* 119; *Pietà* 120; *Prato polyptych* 120.
GIOVANNI DA MODENA 192; *Journey of the Magi* 191, 192; *The Last Judgment* 192.
GIOVANNI DA RIMINI 112; *Mercatello Crucifixion* 112.
GIOVANNINO DE' GRASSI 120, 185, 186, 189, 196; *Book of Hours of Gian Galeazzo Visconti* 186, 188.

GIRARD D'ORLÉANS 46, 134; *Portrait of John II* 135.
GIUSTO DI MENABUOI 108, 123.
Glatz Madonna 177.
Gratian's Decretum 37, 41, 43.
GREGORY XI 130.
GRODECKI L. 30.
GRUBER J. J. 30.
GUARIENTO 123.

Hamburg 128, 181, 182; St Peter's Church 180, 181; Kunsthalle 181.
Heiligenkreutz Abbey of 182, 183.
Hohenfurth, Collegiate Church, *Life of Christ* 177.
HOHENSTAUFEN 127; Frederick II 13.
HONORÉ 37, 41.
Hungary 162.
Hortus Deliciarum 14.
HUSS John 130.

INNOCENT III, pope 15.
ISABELLA OF BAVARIA, Queen 141, 144, 146, 157.
ISIDORE OF SEVILLE, *Origines* 19.
IVERNY Jacques 159; *Mural decoration, Castle of La Manta* 159, 161; *Triptych of Turin* 159.

JACOPINO DA BOLOGNA 115, 119, 120.
JACOPO DI PAOLO 120; *Bolognini Altar* 190.
JACQUEMART DE HESDIN 30, 150, 151; *Grandes Heures du Duc de Berry* 151; *Petites Heures du Duc de Berry* 151, 152; *Très Belles Heures de Notre-Dame* 151, 155, 166.
JEAN D'ARBOIS 141, 146.
JEAN DE LA CROIX 141.
JEAN DE HOLLANDE 150.
JEAN LE NOIR 45, 150.
JEAN D'ORLÉANS 134, 145, 146.
JEAN DE THORY 134.
JEAN DE TROYES 134.
JEANNE DE BOURBON 44, 46.
JOHN XXII, pope 130.
JOHN the Fearless 141, 145.
JOHN II, the Good 42, 134, 135, 138, 150, 151, 162.
JOHN OF LUXEMBOURG, the Blind 175.
JUAN I of Aragon 171.

Karlstein, castle of, Chapel of the Holy Cross 178.
Klosterneuburg, abbey of 182; *Altarpiece* 34, 178, 182.

LANDSBERG Herrade of, *Hortus Deliciarum* 14.
LANGLIER Etienne 134, 150.
Last Judgment, fresco (Pisa, Campo santo) 110.
LATINI Brunetto 134; *Trésor* 15.
Lausanne, cathedral 12.
Lerida (Spain) 169.
Leugemeete, chapel of 137.
Liber Viaticus of Bishop John of Středa 177.
LIMBOURG Brothers 26, 105, 146, 153/155, 159, 185, 193; Pol 145, 153, 155; *Très Riches Heures du Duc de Berry* 146, 153/155, 157.
Lincoln, cathedral 27.

Liverpool, museum 88.
Lives of the Hermits (Pisa, Camposanto) 110.
Livy of Charles V 43.
LOCHNER Stefan, *Dombild* 184.
Lombardy 115, 120, 123, 144, 146, 186, 190, 192, 193, 196.
LOMBART Jean 131.
London 128, 140; Westminster Abbey 22, 166; British Museum 19, 22/26; National Gallery 196, 198; *Wilton Diptych* 165/167; Victoria and Albert Museum 172, 174; Society of Antiquaries 21.
LORENZETTI Ambrogio 47, 53, 54, 78, 89, 92, 96/100, 102/106, 109, 141, 169, 192; *The Annunciation* 104; *The Effects of Good Government* 98/104; *Episodes in the Life of St Nicolas* 103; *Vico l'Abate Madonna* 96, 97; *Madonna del Latte* 98; *Madonna with Saints and Angels* 104; *Maestà* (Massa Marittima) 104; *Maestà* (Sant'Agostino) 104; *The Presentation in the Temple* 104; *St Dorothy* 104; *View of a Town* 97.
LORENZETTI Pietro 47, 53, 54, 78, 89, 90, 92, 93, 96, 97, 99, 100, 102, 104, 105, 106, 141, 169, 192; *Cortona Madonna* 89, 90, 92, 96; *Crucifixion* 89, 93/95; *Deposition* 96; *Madonna* (Uffizi) 89, 93; *The Madonna with St Francis and St John the Evangelist* 96; *Nativity* 93; *Carmine Altarpiece* 89, 90, 92, 93, 100; *St Humilitas Altarpiece* 89, 91, 93; *Polyptych of Arezzo* 92, 93.
LOUIS I, Duke of Anjou 138; LOUIS II, Duke of Anjou 144, 161, 162; *Portrait* 156, 162.
LOUIS VIII 13.
LOUIS, Duke of Orléans 141, 144, 146.
LOUIS, saint (LOUIS IX) 11, 13, 18, 27, 34/37, 40, 41, 46.
LOYSEAU Guillaume 134.
LUXEMBOURG House of 175.

MACI Jaquet 41.
MAHAUT D'ARTOIS, Countess 137, 138.
Maître aux Boqueteaux 43; works attributed to: *Bible of Jean de Sy* 43; *Poems of Guillaume de Machaut* 43; *Livy of Charles V* 43; *Historiated Bible of Charles VI* 43; *The Golden Legend by Jacopo Voragine* 43, 45; *Grandes Chroniques de France* 40/43, 45.
Majorca 168, 169.
MALOUEL Jean 144, 146, 153.
MANDEVILLE Jehan de, *Travels* 135.
Mans, Le 138; cathedral 30.
Manta La, castle 158, 159, 161.
Marches (Italy) 192.
MARGARET OF BURGUNDY 18.
MARSAL DE SAX Andres 174; *Altarpiece of St Georges* 172, 174.
MARSI Giovanni di 141; Nicolo 141.
MARTI DE TORRES Berenguer 174.
MARTIN Henry 45.
MARTINI Simone 47, 53, 54, 78/81, 83, 85, 88, 89, 92, 93, 102, 105/110, 116, 131, 132, 144, 186, 189, 192; Polyptych of Cardinal Orsini 131,
144; *Annunciation* 85/88, 131; *Nativity* 131; *The Way to Calvary* 144; *Annunciation* (Uffizi) 54, 80, 83, 85; *Episodes from the Life of St Augustine* 80, 83, 85, 88; *Guidoriccio da Fogliano* 78, 80, 81; *Maestà* 78, 79, 89; *St George slaying the Dragon* 131; *Saint Louis of Toulouse* 80, 131; *Virgin and Child* 131, 169; Cycle of the Life of St Martin 80: *The Knighting of St Martin* 81; *The Vision of St Martin* 81; *St Martin abandoning the Profession of Arms* 81, 82; *The Investiture of St Martin* 83; *St Martin raising a Child from the Dead* 85; *The Death of St Martin* 83; *The Obsequies of St Martin* 83, 84.
MARTORELL Bernardo (Master of St George) 168, 171.
MASACCIO 105, 185/186, 194, 196, 198.
MASO 106/108; *Episodes in the Life of St Sylvester* 106, 107.
MASOLINO 194.
MASTER of the Bologna School, *The Triumph of Death* 117.
MASTER OF FLÉMALLE 145.
MASTER OF HEILIGENKREUTZ, *The Annunciation and the Mystical Marriage of St Catherine* 182, 183.
MASTER OF ISAAC 56, 65.
MASTER OF THE MIDDLE RHINE, *The Garden of Paradise* 184.
MASTER OF MOULINS 30.
MASTER of the Rimini School, *The Earthquake at Ephesus* 112, 113.
MASTER OF ROUSSILLON, *Retable of St Andrew* 169; *St Nicolas Altarpiece* 169, 171.
MASTER OF ST GEORGE, see under MARTORELL.
MASTER OF TŘEBON 178; Altarpiece 179.
MASTER OF THE VYŠŠÍ BROD CYCLE, *Scenes from the Life of Christ* 175/178.
MATHIEU D'ARRAS 177.
MATTEO GIOVANETTI of Viterbo 131, 132.
Mehun-sur-Yèvre 151.
MEISTER BERTRAM 181, 182; *Buxtehude Altarpiece* 181; *Grabow Altarpiece* 180.
MEISTER ECKHART 182.
MEISTER FRANCKE 182.
MEISTER THEODORICH 178, 181.
Metz, library 138.
MICHEL BERNARD D'ARRAS 140.
Milan 141, 186, 189; Biblioteca Ambrosiana 88; Borromeo mansion 190; Cathedral 141, 186; Library of Duke Visconti di Modrone 188.
Minnesingers' manuscripts 14.
MONACO Lorenzo 109, 192, 193; *Scene from the Life of St Nicholas of Bari* 189.
Montpellier 168.
Monza, cathedral 190.

Namur, seminary 140.
Naples, court of the King of Anjou 79, 162.
Naples, Pinacoteca 80.

Narbonne, Cathedral of Saint-Just 45, 177.
NARDO DI CIONE 108, 109.
NELLI Otaviano 192.
NERI DA RIMINI 112.
New York, Metropolitan Museum of Art 139, 169; Morgan Library, *Adoration of the Magi, Death of the Virgin* 132.
NICOLAS 37.
NICOLAS DE VERDUN 34, 182.
NICOLAU Pedro 174.
NICOLO OF FLORENCE 132.
Norwich 23.
NYONS François de 161.

ODOFREDUS OF BOLOGNA 36.
ORCAGNA Andrea 108/110, 153, 192.
Orléans, University 15.
Orvieto, Church of San Domenico 53.
Oxford, University 14.

Padua 74, 77, 123, 177; Chapel of San Felice del Santo 123; Scrovegni Chapel (Arena Chapel) 52, 54, 60, 61, 63/68, 71, 96, 124; Oratory of San Giorgio 122, 123.
Palma, Archaeological Museum, *St Guilleria retablo* 168.
PAOLO of SIENA 131.
PAOLO VENEZIANO 123; *Episodes from the Life of St Mark* 121, 123.
Parement de Narbonne (altar-hanging) 44/46, 135, 145.
Paris 14, 15, 18, 23, 27, 37, 41, 43, 46, 128, 132/135, 137, 138, 140, 141, 144/147, 151, 153, 157, 159, 161, 165, 167; Abbaye de St-Denis 27, 30; Church of St-Eustache 37; Church of St-Magloire 141; Notre-Dame 27; Sainte-Chapelle 12, 55, 79; Sainte-Geneviève 161; Hôtel de Ville 37; Hôtel Saint-Pol 134; Montagne Sainte-Geneviève 37; University 14, 15, 36, 177; Louvre 37, 44/46, 88, 112, 131, 132, 134, 135, 138, 144/147, 151, 162; Musée des Arts Décoratifs 157, 160, 171, 173; Musée de Cluny 23, 46; Musée Jacquemart-André 171; Bibliothèque de l'Arsenal 27/29, 137; Bibliothèque Nationale 18, 34/43, 46, 116, 141, 146, 151/152, 157/159, 162, 189; Cabinet des Manuscrits 135.
PARISOT Jean 134.
PAŘLĚR Peter 177.
Passional of Abbess Kunegonda 177.
Pedralbes (Spain), Convent 169, 170.
PEDRO I of Aragon 174.
PEDRO IV, El Ceremonioso 169.
PEREZ Gonzalo 174.
Perpignan 168, 169.
PETIT Jean 146.
PETRARCH 53, 78, 79, 129, 131, 135; *Portrait* 135.
PHILIP AUGUSTUS 15, 18.
PHILIP IV, The Fair, King of France 37, 41, 127, 128, 130.
PHILIP VI, The Bold 127, 140, 141, 144/146, 151, 157.
PIERRE DE BRUXELLES 138.

Pietà (Louvre) 146.
Pietà d'Avignon (Louvre) 162.
PIETRO DA RIMINI 112; *Crucifixion* 112; *Deposition* 112.
PIETRO DA VERONA 141, 153.
PIETRO DA VITERBO 132.
PINDER Wilhelm 30.
Pisa 50/54, 80, 92, 153; Camposanto 190, 192; *The Last Judgment* 110; *Lives of the Hermits* 110; *The Triumph of Death* 110, 111.
PISAN Christine de 157, 162; *Cité des Dames* 157, 158.
PISANELLO 123, 185, 189, 193, 196/198; *Emperor Sigismund* 198; *Ginevra d'Este* 162; *Lionello d'Este* 198; *Margarita Gonzaga* 198; *St George and the Princess* 196, 197, 199.
PISANO Andrea 52/54, 105; Giovanni 50, 52, 53, 92; Nicola 50/53; *Fountain of Perugia* 51/53; Giovanni and Nicola, *Pulpit of Siena* 53.
Poems of Guillaume de Machaut 43.
Poitiers, castle 134, 151.
Pomposa (Italy), Abbey 120.
Portacoeli (Spain), Carthusian Monastery of 174.
Post Chandler R. 169, 174.
Prague 125, 128, 132, 140, 175, 177, 178, 181; Cathedral of St-Guy 177; Chapterhouse of Vyšší Brod 177; Church of Tyn 177; Crusader's Monastery 177; University 129, 177. National Gallery 175, 176, 179; *Roudnice Predella* 177; *Svata Barbora Crucifixion* 178.
PREMIERFAIT Laurent de 157.
Private Collections: BEISTEGUI, *Virgin and Child* 146; GAIGNIÈRES 138; Martin LE ROY 120; Maurice de ROTHSCHILD, *Très Belles Heures de Notre-Dame* 151; Arthur SACHS (Cleveland), *The Annunciation* 126, 132, 145, 165.
Psalters: *Psalter of Blanche of Castile* 27/29; *Psalter of the Duke of Berry* 151, 153, 166; *Psalter of Henry of Blois* 19; *Psalter of Queen Ingeborg* 16/18, 23, 27; *Psalter of Isabella of France* 18; *Psalter of Queen Jeanne de Navarre* 18; *Psalter of Robert de Lindesey* 20; *Psalter of Marguerite de Provence* 18, 36; *Psalter of Queen Mary* 23, 25, 26; *Psalter of Robert, Baron de Lisle (Arundel)* 22, 24; *Psalter, Royal* MS 2A XXII 23; *Psalter of St Louis* 18, 34/37, 46; *Psalter of Utrecht* 19.
PUCELLE Jean 41/43, 141, 145, 151; *Belleville Breviary* 38, 39, 41; *Bible of Robert de Billyng* 41, 43; *Petites Heures* 41.

RAPONDE Jacques 141, 157.
Ravenna 111; Church of Santa Chiara 112.
RENÉ D'ANJOU 161.
Rheims, cathedral 11, 30; Church of St-Remi 32.
RICCONE D'AREZZO 132.
RICHARD II, King of England 165, 166.
RICHARD DE VERDUN 41.

Rimini 111, 112, 115, 119; Church of St Augustine, Campanile Chapel 111/113; *Christ enthroned between the two Saints John* 111; *The Earthquake at Ephesus* 112, 113; *Scene from the Life of St John the Evangelist* 111; *Virgin in Glory* 111; Sala dell'Arengo, *The Last Judgment* 111.
RIZZUTTI Filippo 141.
ROBERT Le Sage 131, 138.
ROLLIN Nicolas 162.
Romagna 111.
Roman de la Rose 15.
Rome 14, 15, 19, 50, 52, 127, 128, 130, 153, 182; Church of St John Lateran 193, 196; Galleria Colonna 190.
Roosebeke, Battle of 128, 140.
Rouen, cathedral 27, 131.
RUBROUCK William of 36.

SACCO Pietro 141.
Saint-Albans (England) 19.
Saint-Swithun's (England) 19.
San Giminiano (Tuscany), Collegiate Church 110.
SANSEVERINO Lorenzo da 192.
Saragossa (Spain) 169.
SARALEGUI L. de 174.
SASSETTA 196.
Saulx, castle 146.
SAUVAL 134.
Sens 27, 131.
Serdinya Altarpiece 168.
SERRA Jaime and Pere 169, 171, 174.
Sicily 13, 138, 141, 162.
Siena 52/54, 73, 74, 77, 92, 96, 102, 105, 106, 108/110, 112, 116, 128, 131/133, 141, 145, 147, 168, 169, 174, 189, 190, 193, 196; cathedral 51, 52, 74, 93; Church of Sant'Agostino 104; San Francesco 100, 102; Church of Santa Maria del Carmine 89, 90, 92; Opera del Duomo 75, 76; Palazzo Pubblico 78/80, 98/104, 102; Pinacoteca 72, 74, 89, 90, 92, 97, 104.
SIENDORF Stefan von 182.
SIMONE DEI CROCEFISSI 120.
SLUTER Claus 146; *The Well of Moses* 146.
Songe du Vergier, Le 138.
Sorgues 130, 132.
Spain 13/15, 127, 167, 174.
SPINELLO ARETINO 109, 192; *Scenes from the Life of St Benedict* 192.
STARNINA 174, 192; *Bonifacio Ferrer Altarpiece* 174.
STEFANO 108.
STEFANO DA ZEVIO 189, 190, 196; *Madonna* 190; *Madonna and Child in the Rose Garden* 187, 190.
STEPHEN, King of England 19.
STREDA John of, Bishop 177.
SUGER, Abbot of Saint-Denis 30.
SUSO Heinrich 182.

Talant, castle 146.
Tarragona (Spain) 171.
TAULER Johann 182.
Thouzon Altarpiece (Louvre) 132.
TOMASO II 159; *Chevalier Errant* 159.

TOMASO DA MODENA 120, 123, 178; *Scenes of the Life of St Ursula* 118, 120; *The Holy Doctors* 120.
Tour de Carol, La (French Pyrenees) 169.
Tournai 135, 137, 145.
Tours 27.
Treviso, Dominican Chapterhouse 120; Museo Civico 118.
Triumph of Death (Pisa, Camposanto) 110, 111.
Troyes 146; Museum, *Pietà* 146.
Turin, Pinacoteca 159; Library 155.
Tuscany 54, 106, 108, 110/112, 115, 116, 119, 120, 122, 182, 186, 190, 192, 193.

URBAN V 15.
URBAN VI 130.
Urbino, Gallery 112; Oratory of the Church of St John 192.

Valencia 125, 168, 174; San Carlos Museum, *Annunciation* 174; *Bonifacio Ferrer Altarpiece* 174.
VALOIS, House of 134, 141, 144, 145.
VAN EYCK 11, 105, 134, 135, 145, 155, 171, 174, 193, 196, 198.
VASARI Giorgio 108.
Vatican, Pinacoteca 196.
VAUDÉTAR Jean de 140.
Vaudreuil castle 134.
Venetia 108, 115, 120, 123.
Venice 123, 128, 153, 181, 192; Academy 192; Ducal Palace 193, 196; Church of San Marco 121; *Pala d'Oro* 123.
VENTURI Lionello 159.
VERIS Filippolo de 190; Franco de 190.
Verona 123, 141, 186, 190, 192; Church of Sant'Anastasia 123, 196/199; Church of San Fermo 190, 198; Museo di Castelvecchio 187, 190.
Vienna, Museum 182, 183.
VIGNAY Jean de 43.
VILLARD DE HONNECOURT 137.
Villeneuve-lès-Avignon 132; Chapel of St John the Baptist 132.
Villers-Cotterêts 138.
VIOLANTE DE BAR 162, 171.
VITALE DA BOLOGNA 115/117, 120, 186, 190; *Mezzaratta Frescos* 114, 119.
Vivier 138.
VORAGINE Jacopo, *The Golden Legend* 43, 45, 131.

Washington, National Gallery of Art 196; *Portrait of a Woman* 162.
WILLIAM IV of Bavaria 141.
Winchester, cathedral 19, 26.
WYCLIFFE 130.
WYMONDUSWOLD Thomas de 43.

YOLANDE OF FLANDERS 45, 162.
YOLANDE OF ARAGON 161, 162.

ZARAGOZA Lorenzo 174.
ZAVATTARI 190.

THE COLORPLATES

Grandes Chroniques de France. Philip I and Queen Bertha. Before 1380. Miniature, MS Français 2813, Folio 182. (2¹/₂ × 2¹/₂″) Bibliothèque Nationale, Paris. 11

Psalter of Queen Ingeborg. The Entombment and the Three Marys at the Tomb. Ca. 1200. Miniature, Folio 28, back. Musée Condé, Chantilly . 16

Psalter of Queen Ingeborg. The Visit of the Magi to Herod and the Adoration of the Magi. Ca. 1200. Miniature, Folio 17. Musée Condé, Chantilly. 17

Psalter of Robert de Lindesey. Crucifixion. Miniature, Peterborough, before 1222. MS 59, Folio 35, back. (6⁵/₈ × 4⁵/₈″) Society of Antiquaries, London 20

Apocalypse. Ca. 1230. Miniature, Royal MS 16.2, Folio 22. (9³/₄ × 8⁵/₈″) Trinity College, Cambridge 21

Unknown Master. Scenes from the Life of the Virgin. Retable, Righthand Panels, ca. 1350. Musée de Cluny, Paris . 23

Psalter of Robert, Baron de Lisle. Six Scenes from the Life of Christ. Miniature, East Anglia, before 1339. Arundel MS 83, Folio 124. British Museum, London 24

Queen Mary's Psalter. Jesus teaching in the Temple. First Half of 14th Century. Miniature, Royal MS 2 B. VII, Folio 151. (7 × 4¹/₂″) British Museum, London 25

Psalter of Blanche of Castile. Christ appearing to Mary Magdalen and St Thomas touching the Wounds of Christ. Ca. 1230. Miniature, MS Français 1186, Folio 26. (7³/₄ × 5″) Bibliothèque de l'Arsenal, Paris. 28

Psalter of Blanche of Castile. Crucifixion and Descent from the Cross, between the Church and the Synagogue. Ca. 1230. Miniature, MS Français 1186, Folio 24. (7³/₄ × 6″) Bibliothèque de l'Arsenal, Paris. 29

The Good Samaritan, fragment. First Quarter of 13th Century. Third Window in the South Aisle of the Nave, Chartres Cathedral . 31

Crucifixion. Ca. 1190. (11 ft. 10 inches × 7 ft.) Church of Saint-Remi, Rheims 32

Notre-Dame de la Belle-Verrière. Center, 12th Century; Sides, 13th Century. (16 ft. × 7 ft. 8½ inches) First Window in the Aisle of the Choir, South Side, Chartres Cathedral 33

Psalter of Saint Louis. Abraham entertaining the Angels. 1256. Miniature, MS Latin 10525, Folio 7. (5 × 3½″) Bibliothèque Nationale, Paris 34

Psalter of Saint Louis. Jacob's Ladder. 1256. Miniature. MS Latin 10525, Folio 13. (5 × 3½″) Bibliothèque Nationale, Paris . 35

Psalter of Saint Louis. Joshua bidding the Sun stand Still. 1256. Miniature, MS Latin 10525, Folio 46. (4⁵/₈ × 3¹¹/₁₆″) Bibliothèque Nationale, Paris 36

Psalter of Saint Louis. The Trumpets of Jericho. 1256. Miniature, MS Latin 10525, Folio 42. (4³/₄ × 3⁵/₈″) Bibliothèque Nationale, Paris 37

Jean Pucelle. The Belleville Breviary. 1343. Miniature. MS Latin 10483, Folio 24, back. (9 × 6¼″) Bibliothèque Nationale, Paris . 38

Jean Pucelle. The Belleville Breviary. 1343. Miniature, MS Latin 10484, Folio 12. (9 × 6¼″) Bibliothèque Nationale, Paris . 39

Grandes Chroniques de France. Six Episodes from the Life of Saint Louis. Before 1380. Miniature. MS Français 2813, Folio 265. ($8^1/_2 \times 5^1/_2$") Bibliothèque Nationale, Paris 40

Grandes Chroniques de France. Clotaire rescuing his Son Dagobert. Before 1380. Miniature. MS Français 2813, Folio 66, back ($2^9/_{16} \times 2^7/_{16}$") Bibliothèque Nationale, Paris 41

Grandes Chroniques de France. The Death of Brunehaut. Before 1380. Miniature. MS Français 2813, Folio 60, back. ($2^1/_2 \times 2^7/_{16}$") Bibliothèque Nationale, Paris 41

Grandes Chroniques de France. The Vision of Archbishop Turpin. Before 1380. Miniature. MS Français 2813, Folio 123, back. ($2^5/_{16} \times 2^7/_{16}$") Bibliothèque Nationale, Paris 41

Grandes Chroniques de France. John the Good founding the Order of the Star. Before 1380. Miniature. MS Français 2813, Folio 394. ($6^1/_2 \times 5^1/_2$") Bibliothèque Nationale, Paris 42

Grandes Chroniques de France. The Murder of the Marshals of Clermont and Champagne. Before 1380. Miniature. MS Français 2813, Folio 409, back. ($3^9/_{16} \times 2^7/_{16}$") Bibliothèque Nationale, Paris 43

Le Parement de Narbonne, fragment. Ca. 1375. The Crucifixion between the Church and the Synagogue, with King Charles V and Queen Jeanne de Bourbon. Grisaille on Silk. Louvre, Paris . . . 44

Giotto (1267?-1337). The Vision of the Burning Chariot, detail. Fresco, before 1300. Upper Church of San Francesco, Assisi. 48

Giotto (1267?-1337). Christmas at Greccio, detail. Fresco, before 1300. Upper Church of San Francesco, Assisi . 57

Giotto (1267?-1337). The Devils cast out of Arezzo, detail. Fresco. before 1300. Upper Church of San Francesco, Assisi. 58

Giotto (1267?-1337). St Francis giving his Mantle to a Poor Man. Fresco, before 1300. Upper Church of San Francesco, Assisi. 59

Giotto (1267?-1337). The Annunciation to St Anne. Fresco, 1304-1306. Scrovegni Chapel, Padua . 61

Giotto (1267?-1337). The Wedding Procession of Mary. Fresco, 1304-1306. Scrovegni Chapel, Padua 62

Giotto (1267?-1337). The Meeting at the Golden Gate. Fresco, 1304-1306. Scrovegni Chapel, Padua 63

Giotto (1267?-1337). The Meeting of Mary and Elizabeth, detail. Fresco, 1304-1306. Scrovegni Chapel, Padua . 64

Giotto (1267?-1337). The Meeting at the Golden Gate, detail. Fresco, 1304-1306. Scrovegni Chapel, Padua . 66

Giotto (1267?-1337). Joachim's Dream, detail. Fresco, 1304-1306. Scrovegni Chapel, Padua . . 67

Giotto (1267?-1337). The Resurrection of Lazarus, detail. Fresco, 1304-1306. Scrovegni Chapel, Padua 68

Giotto (1267?-1337). The Obsequies of St Francis, detail. Fresco. Church of Santa Croce, Florence 70

Duccio (?-1319). The Madonna of the Franciscans. ($9^1/_4 \times 6^1/_4$") Pinacoteca, Siena 72

Duccio (?-1319). Scene from the Predella of the Maestà: The Adoration of the Magi. 1308-1311. Opera del Duomo, Siena . 75

Duccio (?-1319). Scenes from the back of the Maestà: St Peter's Denial and Jesus before Annas. 1308-1311. Opera del Duomo, Siena 76

Simone Martini (1284?-1344). Guidoriccio da Fogliano. Fresco, 1328. Palazzo Pubblico, Siena . 78

Simone Martini (1284?-1344). The Knighting of St Martin, detail. Fresco, between 1320-1330. Lower Church of San Francesco, Assisi 81

Simone Martini (1284?-1344). St Martin abandoning the Profession of Arms, detail. Fresco, between 1320-1330. Lower Church of San Francesco, Assisi 82

Simone Martini (1284?-1344). The Obsequies of St Martin, detail. Fresco, between 1320-1330. Lower Church of San Francesco, Assisi 84

Simone Martini (1284?-1344). St Martin raising a Child from the Dead, detail. Fresco, between 1320-1330. Lower Church of San Francesco, Assisi 85

Simone Martini (1284?-1344). The Angel of the Annunciation. After 1339. ($9^1/_4 \times 5^3/_4''$) Musée Royal des Beaux-Arts, Antwerp. 86

Simone Martini (1284?-1344). The Virgin of the Annunciation. After 1339. ($9^1/_2 \times 6''$) Musée Royal des Beaux-Arts, Antwerp. 87

Pietro Lorenzetti (?-1348). Sobac's Dream. Panel from the Predella of the Carmine Altarpiece, 1328-1329. Pinacoteca, Siena 90

Pietro Lorenzetti (?-1348). Panel from the St Humilitas Altarpiece. 1341. Uffizi, Florence . . . 91

Pietro Lorenzetti (?-1348). Crucifixion, detail. Fresco, before 1329. Lower Church of San Francesco, Assisi . 94

Pietro Lorenzetti (?-1348). Crucifixion, detail. Fresco, before 1329. Lower Church of San Francesco, Assisi . 95

Ambrogio Lorenzetti (?-1348). View of a Town. 1335-1340. ($8^1/_2 \times 12^1/_2''$) Pinacoteca, Siena . . 97

Ambrogio Lorenzetti (?-1348). The Effects of Good Government, fragments. Fresco, 1337-1340. Palazzo Pubblico, Siena 98, 99, 100, 101, 102, 103
(These six fragments are reproduced in the order in which they appear on the wall, from left to right.)

Maso (First Half of 14th Century). The Miracle of St Sylvester. Fresco. Panel from the right wall of the Chapel of St Sylvester. Church of Santa Croce, Florence. 107

Andrea Buonaiuti da Firenze (?-1377). Fresco Fragment from the Spanish Chapel, 1365. Church of Santa Maria Novella, Florence 109

Unknown Master. The Triumph of Death, fragment. Fresco, ca. 1360. Camposanto, Pisa 110

Unknown Master of the Rimini School. The Earthquake at Ephesus, fragment. Fresco, ca. 1330-1340. Church of Sant'Agostino, Rimini 113

Vitale da Bologna (Fl. 1330-1360). The Nativity. Fragment of the Mezzaratta Frescos, ca. 1345. Pinacoteca, Bologna . 114

Unknown Master of the Bologna School. The Triumph of Death, fragment. Fresco. Church of San Domenico, Bolzano . 117

Tomaso da Modena (Fl. 1345-1375). Scenes of the Life of St Ursula, fragment. Fresco from the Dominican Chapter-House, 1352. Museo Civico, Treviso 118

Giovanni da Milano (Fl. 1345-1370). The Birth of the Virgin. Fragment of Scenes of the Life of the Virgin. Fresco, 1365. Rinuccini Chapel, Church of Santa Croce, Florence 119

Paolo Veneziano (?-ca. 1360). Episodes from the Life of St Mark, fragment. 1345. Back of the Pala d'Oro. Church of San Marco, Venice 121

Altichiero (?-ca. 1390). The Beheading of St George. Fresco, ca. 1385. Oratory of San Giorgio, Padua 122

Unknown Master. The Annunciation, ca. 1390. ($13^1/_4 \times 9^3/_4''$) Arthur Sachs Collection, Cleveland 126

Unknown Master. The Bearing of the Cross, with Two Donors. Ca. 1390. Painting on Parchment. (15 × 11″) Louvre, Paris 133

Jean de Bandol and Nicolas Bataille. The Apocalypse. Fragment: One of the Seven Bishops of the Church of Asia. Tapestry, 1375-1381. Musée des Tapisseries, Angers. 136

Jean de Bandol and Nicolas Bataille. The Apocalypse. Fragment: Four Scenes of the Apocalypse. Tapestry, 1375-1381. Musée des Tapisseries, Angers 137

Atelier of Nicolas Bataille. The Nine Heroes. Fragment: Two of Thirteen Figures on a Balcony. Tapestry, ca. 1385. Metropolitan Museum of Art, The Cloisters, New York 139

Unknown Master. The Adoration of the Magi. So-called Bargello Altarpiece, left shutter, ca. 1390. (19¹/₂ × 12″) Palazzo del Bargello, Florence 142

Unknown Master. Crucifixion. So-called Bargello Altarpiece, right shutter, ca. 1390. (19¹/₂ × 12″) Palazzo del Bargello, Florence 143

Ascribed to Henri Bellechose. The Last Communion and the Martyrdom of St Denis. Ca. 1416. (63¹/₄ × 82¹/₂″) Louvre. Paris 147

Unknown Master. The Nativity. Panel from a Polyptych. (13 × 8¹/₄″) Mayer van den Bergh Museum, Antwerp. 148

Unknown Master. St Christopher. Panel from a Polyptych. (13 × 8¹/₄″) Mayer van den Bergh Museum, Antwerp. 149

Jacquemart de Hesdin. Les Petites Heures du Duc de Berry. The Duke of Berry preceded by his Mace-bearer. Miniature, MS Latin 18014, Folio 288, back. (7 × 5″) Bibliothèque Nationale, Paris. . 152

André Beauneveu. Psalter of the Duke of Berry. A Prophet. Miniature, ca. 1400. MS Français 13091, Folio 16. (9³/₄ × 6¹/₄″) Bibliothèque Nationale, Paris 153

The Limbourg Brothers. Les Très Riches Heures du Duc de Berry. Calendar: Month of April, with the Château de Dourdan. Miniature, ca. 1416. Musée Condé, Chantilly 154

The Limbourg Brothers. Les Très Riches Heures du Duc de Berry. Calendar: Month of June, with the Palais de la Cité and the Sainte-Chapelle, Paris. Miniature, ca. 1416. Musée Condé, Chantilly 155

Unknown Master. Portrait of Louis II of Anjou. Watercolor Drawing, ca. 1412. (11³/₄ × 8¹/₄″) Bibliothèque Nationale, Paris 156

Christine de Pisan. La Cité des Dames. Christine de Pisan in her Study and the Building of the Cité des Dames. Miniature, MS Français 607, Folio 2. (4¹/₄ × 7″) Bibliothèque Nationale, Paris . . 158

Boccaccio. Le Livre des Femmes Nobles et Renommées. Marcia painting her Self-Portrait. Miniature, 1402. MS Français 12420, Folio 101, back. (2⁷/₈ × 2³/₈″) Bibliothèque Nationale, Paris . . . 159

Boccaccio. Le Livre des Femmes Nobles et Renommées. Thamar, the Noble Paintress. Miniature, 1402. MS Français 12420, Folio 86. (2⁷/₈ × 2¹/₂″) Bibliothèque Nationale, Paris 159

Arras Tapestry. Scene from a Novel. Ca. 1420. Musée des Arts Décoratifs, Paris 160

Jacques Iverny. Frieze of the Nine Heroines. Mural Decoration, fragment. Ca. 1420. Castle of La Manta, Piedmont . 161

Unknown Master. Portrait of a Woman. Ca. 1415. (20¹/₂ × 14¹/₂″) Mellon Collection, National Gallery of Art, Washington . 163

Chaucer. Troilus and Criseyde. Frontispiece. Miniature, MS 61, Folio 1, back. (9¹/₄ × 6″) Corpus Christi College, Cambridge . 164

Unknown Master. The Wilton Diptych, front. Richard II of England with his Patron Saints: Edward the Confessor, St Edmund and St John the Baptist. The Virgin and Child with Angels. Ca. 1395. (Each Panel: $20^3/_4 \times 14^1/_2''$) National Gallery, London 166

Unknown Master. The Wilton Diptych, back. Ca. 1395. (Each Panel: $20^3/_4 \times 14^1/_2''$) National Gallery, London . 167

Ferrer Bassa (?-1348). St Bonaventura, 1345-1346. Wall-Painting in Oil. Convent of Pedralbes, Catalonia . 170

(?) Andres Marsal de Sax (Fl. at Valencia between 1394 and 1405). Altarpiece of St George. Scene from the Central Panel. Ca. 1400. Victoria and Albert Museum, London 172

(?) Atelier of Luis Borrassa. Herod's Feast. Fragment of a Polyptych with Scenes from the Life of St John the Baptist. ($27^1/_2 \times 22''$) Musée des Arts Décoratifs, Paris 173

Master of the Vyšší Brod Cycle. Christ in the Garden of Olives, detail. Panel from Scenes of the Life of Christ. Ca. 1350. National Gallery, Prague 175

Master of the Vyšší Brod Cycle. Christ in the Garden of Olives. Panel from Scenes of the Life of Christ. Ca. 1350. ($37^1/_4 \times 33^1/_2''$) National Gallery, Prague 176

Master of the Třebon Altar. The Resurrection. Panel from Scenes of the Passion. Ca. 1380. ($52 \times 36''$) National Gallery, Prague 179

Meister Bertram (ca. 1345-ca. 1415). The Rest during the Flight into Egypt. Panel from the Main Altar of St Peter's Church, Hamburg, the so-called Grabow Altarpiece. 1379. Kunsthalle, Hamburg 180

Master of Heiligenkreutz. The Annunciation and the Mystical Marriage of St Catherine. Panels from the Altar of the Church of Heiligenkreutz, Lower Austria. Early 15th Century. Each Panel: $28^1/_4 \times 17''$) Museum, Vienna 183

Master of the Middle Rhine. The Garden of Paradise. Ca. 1420. ($10^1/_4 \times 13''$) Staedelsches Institut, Frankfort 184

Stefano da Zevio (ca. 1375-1451). Madonna and Child in the Rose Garden. Early 15th Century. ($50^3/_4 \times 37^1/_4''$) Museo di Castelvecchio, Verona 187

Giovannino de' Grassi (?-1398). Initial Letter of the " Magnificat. " Book of Hours of Gian Galeazzo Visconti. Ca. 1385. Library of Duke Visconti di Modrone, Milan 188

Lorenzo Monaco (1370 or 1371-1425). Scene from the Life of St Nicholas of Bari. Panel of a Predella. Galleria dell'Accademia, Florence 189

Giovanni da Modena (First Half of 15th Century). The Journey of the Magi, detail. Fresco, ca. 1420. Church of San Petronio, Bologna 191

Gentile da Fabriano (ca. 1370-1427). The Adoration of the Magi, detail. 1423. Uffizi, Florence . . 194

Gentile da Fabriano (ca. 1370-1427). The Adoration of the Magi, detail. 1423. Uffizi, Florence . . 195

Pisanello (1395-ca. 1455). St George and the Princess. Fresco, ca. 1435. Church of Sant'Anastasia, Verona . 197

Pisanello (1395-ca. 1455). St George and the Princess, detail. Fresco, ca. 1435. Church of Sant'Anastasia, Verona . 199

The stained-glass window in the Church of Saint-Remi at Rheims, representing The Crucifixion *(page 32), is reproduced by courtesy of* Bulletin d'Informations Pratiques, Applications de l'Electricité, Paris, *and the panels from the Vyšší Brod cycle and the Třebon altarpiece (pages 175, 176, 179) by courtesy of Artia, Prague, who obligingly lent us the color-separations already published in* Antonin Matějček's La Peinture Gothique Tchèque.

PRINTED BY

IMPRIMERIES RÉUNIES SA

LAUSANNE

BINDING BY

H. + J. SCHUMACHER AG

SCHMITTEN (FRIBOURG)

The works reproduced in this volume were photographed by Louis Laniepce, Paris (pages 11, 16, 17, 20, 21, 23, 34, 35, 36, 37, 38, 41, 42, 43, 86, 87, 136, 137, 142, 143, 148, 149, 152, 153, 154, 155, 156, 158, 159, 160, 164, 166, 167, 172, 173), by Claudio Emmer, Venice (pages 48, 57, 58, 59, 61, 62, 63, 64, 66, 68, 70, 75, 76, 81, 82, 84, 85, 94, 95, 97, 109, 110, 114, 117, 118, 121, 122, 161, 187, 188, 191, 194, 197, 199), by Hans Hinz, Basel (pages 31, 72, 90, 91, 98, 99, 100, 101, 102, 103, 113, 189, 195), by the photographic service of the British Museum, London (pages 24 and 25), by the photographic service of the Bibliothèque Nationale, Paris (pages 28 and 29), by Photo Giraudon, Paris (page 44), by Frank Lerner, New York (page 126), by Henry B. Beville, Alexandria, Va. (page 163), by Ralph Kleinhempel, Hamburg (page 180), by Karl Meyer, Vienna (page 183), and by Hermann Harz, Frankfort (page 184).

Photographs were obligingly lent us by Artia, Prague (pages 175, 176, 179), by Bulletin d'Informations Pratiques, Applications de l'Electricité, Paris (page 32), and by the Metropolitan Museum of Art, New York (page 139).

PRINTED IN SWITZERLAND